LUOGHI

ANDREA BRANZI

THE COMPLETE WORKS

First published in the United States of America in 1992
by Rizzoli International Publications, Inc.
300 Park Avenue South, New York, NY 10010

ISBN 0-8478-1504-8
LC 91-50875

Editorial conception:
Passigli Progetti, Milan, Italy
Art direction:
Silvia Garofoli Kihlgren
English language translation:
Huw Evans
Iconographic research:
 Palma Giarratano
Translation of foreword:
Joachim Neugroschel

Printed and bound in Italy

On the jacket *front*: International
competition for the west waterfront
of Manhattan, New York (1988)
back: "Mama O" Kettle, Alessi, (1992).
Collaborator Andrès Salas.

LUOGHI

ANDREA BRANZI

THE COMPLETE WORKS

Foreword by Germano Celant

RIZZOLI
NEW YORK

ANDREA BRANZI, THE RAMIFICATION OF DESIGN

by Germano Celant

In surveying Andrea Branzi's oeuvre, we must first try to understand not only the relationship between the artistic and the literary vocations of an architect but also the overall history of design and environmental planning. Amid their thorough interweavings, we find constant interferences which cannot be unraveled and in which it is difficult to pinpoint dreams and realizations, inspirations and implementations because the poetic dimension allows for impalpable yet real testimony. One might say that with Branzi and his generation, design and architecture have brought a different kind of communication for planning something that has a literary and pictorial form, a status of fable and legend, an exemplary, indeed paradigmatic invention.

The overall experience is integrated in the ideological system, which was already tested by the historical avantgardes, from Futurism to Dadaism, from Neo-Plasticism to Surrealism. Hence, that experience was laid out according to a precise pattern and a determined strategy that sanction the priority of the poetic calling. With its fecets of gesture and spectacle, with its disposition for fiction, disguise, and unreality, for the functional and instrumental non-relationship to the other, this poetic calling involves a quest for unceasing metamorphosis. It makes creativity, whether in art or in design, a continuous "playacting," a public gesture based on visual and physical stimulus and provocation.

In architecture, these dynamics are to be found in the utopian tradition, from Sant'Elia to Vesnin, from Marchi to Leonidov, from Rinsterlin to Kiesler, and in fantastic design, from Depero to Rodchenko, from van der Leck to Baldessari, from Delaunay to Mollino. This is a miracle of marvelous and unconscious transmission of forms and constructions – a transmission outside the traditional channels, outside the reality of constructing technological groups. For them, acting means affirming a value with a "negative" sign, confirming a lack as well as negating the value. And it is within several lacks in architecture and design that Andrea Branzi has moved, intent as he is on overcoming earlier congenital losses that are destined not to be made up for.

It is easy to verify the extent to which his world is born not from a negation of the values of planning, but from their inversion; and the extent to which this inversion produces a substitution, a confirmation of inverted values. In 1966, during the era of Archizoom, Branzi began rejecting a productive and finalized architecture that was virtually Franciscan and primary; he replaced it with a magnificent and sumptuous planning, a bombastic and dispersed design that slid from reality to allegory and symbolism. Upon this tendency toward unrealization, this lack of reality, Branzi grafted a fantastic sublimation modeled on the escape from the prison of tradition. One of his goals was to leave the environmental residential cell, which is cold and functional in its fixated and retrogressive culture. He wanted to go into a Center of Eclectic Conspiracy or a Center of Eclectic Meditation, 1968, where the fabulous culture of the creative hero, with his solitary trials, began a process of object-oriented poetry, where the dull and banal instruments of dwelling were redeemed in a futuristic and comic-strip-like imagination characteristic of an infantile culture that wanted to explode once more.

Renouncing the construction of uniform spaces that resembled prisons, Branzi and Archizoom came up with multiform and literary residential projects. In their initiatory metaphor that is typical of an "Easy Rider" culture, "Shipwreck of Roses", "Presage of Roses", and "Rose of Araby", 1967, opened the door to rehabilitating the design adventure that tries to abandon a rigid and repetitive ideological system.

Other architects and designers, such as Ettore Sottsass and Walter Pichler, Superstudio and Archigram, might admire a certain use of mythology and primitivism, a return to infancy and fairy tales. However, Branzi, sometimes ironical, sometimes fiercely critical, seemed to take on the role of a multiple figure, who slipped from one role to the next, gathering and summarizing all the figurations: he became a primitive and a child, a narrator and a theorist, in order to flee all definitions and continue transforming non-values into values.

The evolutions of an open and nuclear movement with multiple centers is in the preliminary condition of a city without realistic connotations, the infinite city, "No-Stop City", 1970 – an urban structure that is likewise dreamt and imagined, that lives on the upheaval and overturning of the limited and narrow world. Here, the urban figure reproposes an open schema, a mirror relationship of life as an *ad infinitum* extension of production and motion, of

circulation and exchange. It is a city that lives on transcending boundaries and prohibitions, a planning artifice that turns the sovereign moment of urbanism into a failure and leads everything back to the singularity of and possession of life. Thus, the homogeneity of its landscapes, its obsessive unity and its schematization allow it to reveal its aspect of anti-naturalism and anti-life – an aspect based on the gratuitous existence of the Supermarket and the Factory. Resistance is offered only by the standards and systems of aeration and illumination, which take control of the inhabitants, while leaving them a maximum "freedom." This is an attempt at integrating into the society of Maximum Quantity in order to verify its damage and destruction.

Thus, "No-Stop City" is involved in the problems of negation, in which everything becomes an object, even subjectivity. "No-Stop City" registers and takes to its utmost consequences the form of the routine of life, outside the romantic expectations that gave birth to the modernist dream. Here, the danger is boredom and the dreadful crescendo of the coldly technological profile of machines and motors, which turn life into a profession. With its monotony and meticulous organization, the no-stop city flees any improvisation, any free flow of the imagination.

Everything is preplanned and predisposed for an anonymous condition of existence, subordinated to the use of complex instruments for dwelling. Organization was studied for colossal masses of humans and materials that have to win the war of life. A debilitating situation that had to be analyzed in its infinite webs of defense and assault, for which Branzi's and Archizoom's design and planning aimed at a typically anatomical investigation, the vivisection of an urban body, which had to be explained and exposed down to its last cell. "No-Stop City" then became a gigantic display of means and methods, whose existence, surging toward superrationalist paradox, led to a virtual homicide of architecture and urbanism. These latter fields, laid bare in their systems of repetition and structuration, henceforth had to seek a more motivated and more personal future.

In 1969-70, the declaration of the death of architecture was replaced by its "liberation." Designers and architects tried to leave the colony of Modernism; disowning the cultural arrogance of its styles, they felt authorized to employ the Baroque disguise of images and the metamorphosis of planning. They created an imaginary and productive world that used the forms of architecture and design to channel gesture and exhibitionism, the fondness for remakes and disguises, the pleasure of set design and costume design, of verbality and material, with a consequent rethinking of design, which took on a broader sense, a chiefly psychological and sensual meaning.

The abandonment of monotony exalted the individual alchemy of the designer and the architect, who, putting themselves to the test, began seeking a state of exception and excitation of their disciplines. At the outset, this planning could be called "naive" and "surrealistic"; nevertheless, it became an autonomous procedure, triggering the internal combustion of the Modernist silence and giving voice, a howling voice, to the experience and funambulism of post-industrial civilization.

As of 1969, Branzi and his fellow voyagers approached design as a privileged form of expression, dismantling and reassembling the mechanism of planning – from the outset essentially the roles of functionality and artistry, transferring the real into the imaginary, reconciling construction and trickery, the solitary gesture and the collective designation. They thus accepted and represented the profound antinomies and the schizophrenic components of a world of objects, sounds, and materials – the artificial tools of life, whereby life undergoes a subsequent inversion and continuous disguising. "Mies", the elastic seat produced by Poltronova, accepted the deep antinomies and twofold components between rationalism and flexibility, between rationalism and organicness in the design of the era. They played a double and paradoxical role, creating an effect of alienation and surprise.

The same applies to the doubling of "clothes" produced in 1971 – the perfectly mirrorlike and complementary couple of a body that is not only a work tool but also an instrument of imaginary, magical, and theatrical identification. Here, clothing is once again a site of contraries, a play between reality and fiction, between male/female contrast and integration; it reflects a stage rehearsal that takes place in everyday life. The assumption is always that of an exit from the closed and narrow venue of design through an appearance and a *vanitas*, which, with dazzling light, invade the darkness of the rational and industrial product.

The surfaces, aside from cities and objects, likewise welcome the rites of the imagination – rites based on the twofold value

of mimicry and symbolism. Thus, after touching the maximum alienation through an endless urban vortex, we realize that the limits of a completely planned society are identical with those of an unplanned society. In both of them, architecture and design perform a certain function that is no longer progressive or radical, it exists solely as a scenic rite and an analytical discourse, an ironical or serious decoding of an expressivity activated through forms and materials. The great plan starts to vanish, leaving space for extremely coagulated and concentrated contributions that articulate the present time.

This is a process of introjection, whereby the utopian ceremony is replaced by a reflection of today's technological and material circularity. The "Reli-Techs", designed by Branzi for Abet Luminati in 1979, neither imitate reality nor identify with it; instead, they enter into a relationship of resemblance, mimesis, and playacting. They fuction as a dynamic scene mediated by "No-Stop City", to organize a microlandscape that possesses an almost secret, indeed clandestine communicational force. As if the designer and the architect realized that, after decades and centuries of microscopic work, the planning system now had to devote itself to studying the invisible and the impalpable. This is not a negation or a crisis of architecture or design; rather, it spells their extreme empowerment through the reaffirmation of the iconic and figural character of their fibers and nervous systems. The result is "primary design," which deals with the throng of microstructures and microclimates and works on the miniaturized structures and infinitesimal mechanisms of sound and light conditioning. It is interested in the system of aeration and heat conditioning, it gives form and image to their "absence." During the nineteen-sixties, Branzi worked on a fluid dimension of design, on the vertigo of transitive systems without form or image. He then tried to mold them even though it became difficult to know where they begin and where they end. His planning then approached "non-demarcation" – the vague and equivocal frontier of the object. He attempted to materialize the insubstantial object, to give reflection and solidity to vaporized courses and their mirages.

Thus, after planning the surfaces of objects, Branzi, with Mendini, began working out the "mirage of architecture." In 1978, he did the architectural decoration of a building in Giulianova, where the act of design reflection involves the plane of architectural appearance. The reflection of forms and colors extends, rounds off, and expands the façade of the building. It completes it, giving it a "fullness," which is a mirage and a reflected reality. It is as if an impalpable fog with its elusive vapors were placed on the surface of architecture, coagulating two opposite consistencies. The effect is that of sensual advance, decorative penetration, and metamorphic progression, almost as if architecture would henceforth have to knuckle under to the cycle of seasonal changes in fashion and consumerism. The design is tied not so much to its solidity as to its freshness. It speaks about a creative act and its ingenuousness, its relative non-solidity, its still virginal sculptural load. It is a fruitfulness of possession that makes design more desirable and intense, because it arises from the antinomy of rigid and lively, fluid and compact, fixed and ephemeral.

We are dealing here with the register of the sensuality of design, which, from 1979 to 1984, brought Branzi, with Studio Alchymia and Sandro Mendini, to submit everyday objects to a continuous transformative play. Together they created a playful and joyful world that sparkled and glittered with shapes and colors. It was an explosion of festivities, moving from tapestries like "Metropolitan Couple", 1977, and "Gallery of Copyism", 1979, to furniture, like the "Libera" bookshelf, 1979, the "Milano" bar, 1979, and the "Ginger" chair, 1980. Everything bears a patently libidinous stamp, almost as if the product were the result of a desire to feed the single fantastic world. Design becomes radiant, alive with sensual and material reflections. Leaving its protective envelope, it discovers itself in perpetual motion, which is no longer a break, but a continuity with the fullness of "sensations."

In the early nineteen-eighties, people spoke of excess and overflowing deviation in designs when the Memphis group transformed objects from anonymous instruments into puffed-up peacocks. Its revelation of the exterior perception of a thing, sensually modulated in tumescences and colorations, swept away the drabness and weariness of Minimalist design, which had interfered with the delights of seeing and touching. The result, savored to the dregs, was an intoxication with the gamut of imaginary satisfactions and an ecstatic dissipation of the metamorphosis of materials and forms. A thoroughly enjoyed sculptural and environmental palpitation in creating a landscape whose perception

was linked to the dimension or "change." Transformation causes the splendor of things to circulate, creating vitality. For Memphis, Branzi produced several dizzying and at times overwhelming objects, including the "Century" sofa, 1982, the "Labrador" gravy boat, 1982, and the "Magnolia" bookshelf, 1984. He gave the object a full range of freedom, almost anarchy. He organized irregular, unforeseeable circuits, so that the shapes of objects became evasive terms, a kind of glissando, which turned function into radiant variability. Thus, the supporting structure of the bookshelf changes into tree-lined nature and the gravy boat into a fickle geometry – sketches of a different existence. What he constructed with these objects was a process of mobility and fluidity, in which the precious becomes unstable, creating imaginary combinations and mobilizations – a stream of events that ultimately body forth a computerized Giotto. Here the stalactites and stalagmites are meant to create a network of services and equipment, which, interweaving and interacting, produce a landscape for dwelling.

This brings us to the "Remote-Controlled House", designed by Andrea Branzi in 1986 for Milan's 17th Triennale. Here, everything unites, elongates, and turns into lines, passes over and under, intertwines in a lace pattern whose ins and outs, shaped like a maze of webbed and leafy branches, move around the dweller by means of simple remote control. The imaginary effort of the weave aims at bending the interwoven space of objects and rooms around an existential focal point. A kind of nest in which one can huddle and employ the most heterogeneous and infinitesimal materials, partial and microscopic fragments of a gradually reconstituted uniformity.

Within Andrea Branzi's career, after decades of centrifugal designs, "Remote-Controlled House" is a unifying gesture, triggering a continuity of diversity and fragmentation. Beneath its covering shell, one feels the need for an absolute fusion of disparate things, a reabsorption of differences, and a cordiality of similar things. This way of reading the house is matched by a flowering of objects that spur modalities of development and double existence. They are the "Domestic Animals", 1985 – something like vegetable mobiles that unfold as plants from an essential and reduced structure. Fronds and branches whose loss of leaves does not depend solely on an imaginary operation, but that also merits a functional and constructive attention. The branch bends and rises into a corporal dwelling, it turns into a nervous system and a sculptural undulation that is both penetrable and comfortable. A kind of vegetation with the properties of a sofa, a chair, a lamp. The multiple widening of the branches, trunks, and stones allows the emergence of various types of fancies. Its status, linked but also dispersed, leads to a wavy and leafy design, which produces a soft and sensuous wrapping.

In 1988, the vegetable constellation gave shape to the networks of sensual material in "Axale", "Eucidi", and "Berione", which take on a savage value in their fluidity and animality. The constructive mode impels Branzi to think of a "house in bloom," a Dolce Stil Novo, in which the floral and carnal theme contains a kind of sinuous and disturbing hybrid, in which flesh and blossom, body and architecture unfold and triumph. This is the peak of a maturation, whereby the house goes through a subsequent blossoming, becoming and expanding. However, this came in "Folly 10", designed for the "International Exhibition of Greenery" in Osaka in 1991: here, Branzi created a space defined by three symbolic walls evoking "the desirable depth and intimacy" of architecture. Inside the rigid and geometric wall-corolla, he placed the pistils and stamens of a dream or an appeal, a flight or an ungraspable focus – all of them represented by portions of a tree, rock, a human figure. Architecture displays its desires or its fragments of intimacy. It conjures up the motifs of a now cellular life, it brings forth from its "cement" an effervescence of regular buds and sprouts, of essential tenderness. Nevertheless, the ensemble of desires has risen to the surface, it is an empty and decorative effusion, a faded potion and a dross of memory. A kind of hanging wall from which petrified nature blossoms as does gushing life of the dweller. When read in the positive sense, this design strives to a desired and fantastic content. The walls open, producing fruits, projecting concrete images. The Value of "Folly 10" remains twofold, like all of Branzi's designs. It is a jet, a spurt that liberates and waters, sensualizes and refreshes, manifesting all the sensual essence of the unleashed imagination which appears unexpectedly. It is a continuous wave that dances according to a wild and domestic, heretical and productive, oblique and linear animality, in order to create a universe of design that is not flat, that emerges and arises, full of unforeseeable exuberance and rainbow-colored surprises.

The members of the group Archizoom Associati (1966-1974) are portrayed here in front of the studio's second premises on the via di Ricorboli, after the transfer from the Villa Strozzi.
From the left: Paolo Deganello, Lucia Bartolini, Massimo Morozzi, Natalino Torniai (collaborator), Dario Bartolini, Gilberto Corretti, Andrea Branzi (Florence, 1968).

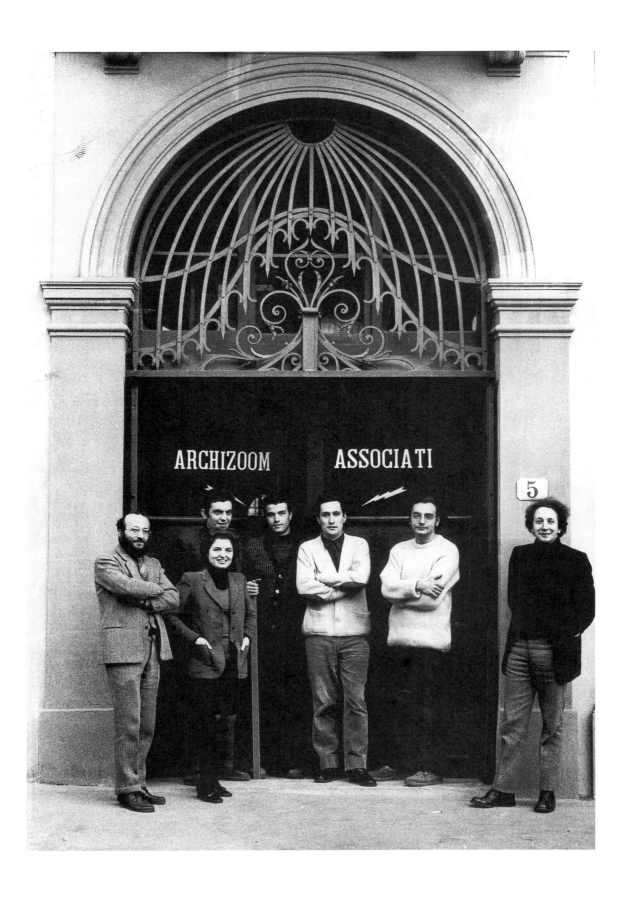

MAKING THE WORLD HABITABLE

I have assembled in this book what is (for me at least) the most significant part of my work. Like all autobiographical books, it is an immodest one, and intended for an ideal reader: myself.

To look for a meaning, to find the thread that runs through one's own work, is in fact an indispensable premise for communication (subsequently) with others. This search for an internal logic, for an overall strategy, perhaps derives from a way of working that is obsolete in an age (as I myself have postulated) based on discontinuity and permanent diversification. Let us say, then, that the guiding thread that I am seeking in my work is not a matter of form or composition; it is a question rather of the presence, more or less explicit, of a preconceived idea, that is to say a deliberate direction that precedes and justifies the projects and makes it possible to draw a comparison between them.

This preconceived idea lies in the "humanistic foundation" of the act of design itself. In having, in other words, the human being (and not the architecture, the design) as the main focus of my work. This means using architecture and design as tools at my disposal, and not as an end in themselves.

One often hears talk of a city or architecture "on a human scale:" personally I have never understood just what that means, and it is in any case very far away from my aims and my interests.

If by "on a human scale" is meant prudence, the preservation of medieval technologies, and cities no larger than a village, it seems to me that all this should be rejected as offensive, offensive above all to "humanity" and its capacity to act and think on a grand scale. This "dimensional" relationship with human works does not feel right.

When I speak of the "humanistic foundation of progress" I am referring to that ethical and cultural center that is capable of forming islands of sense within the present artificial universe, devoid of destiny and meaning.

At a dramatic time in which all the ideological and political certainties on which we used to rely in our youth are crumbling, at the beginning of an age in which there no longer appears to be any feasible, comprehensive alternative to the socioeconomic system in which we live, it seems to me that there are only two possibilities. The first, which is rapidly gaining a grip on the Western world, consists in yielding to those creative and violent processes that are born out of impotent perception of the injustices and contradictions of society. These processes transform into nothing but cold and blind destructiveness the uneasiness of a generation that cannot see any practical alternative lying ahead of it but self-destruction, or simply the destruction (although not in any liberating sense) of the physical world that surrounds it.

The other, more radical, alternative lies instead in the search for a "strong foundation" on which to reconstruct, starting from the bottom, a possible cultural strategy of the project; in other words a positive significance that goes beyond the mere multiplication of pointless signs and sounds, within this macro-system of pointless signs and sounds that is the metropolis.

For me this "strong foundation" consists in believing that the ultimate aim of the project is neither architecture nor design as such, but lies instead in the possibility of these becoming tools that are "capable of making the world habitable again."

And human beings inhabit the places and objects with which they are able to create a richer and more complex rapport than a simple functional and technical relationship; a rapport that consists of poetic, affective, symbolic, and psychological interchanges.

The task of design is precisely this: realizing this new rapport, a qualitatively more complex interface between humanity and the surrounding world. Humanity and the world of objects have always had a complex and often ambiguous and mysterious relationship, made up of emotional and technical interchanges. In many ways it resembles the one that has always linked human beings to the domestic animals that live, like benign spirits, in their homes.

Humans ascribe to objects an identity of their own, a "soul" that gives them a life beyond their mere technical function. The designer has to be capable of putting this "soul" into the objects, into the structures that he creates; otherwise he should pick a different job. To do this he can use all the possible methodologies available to him, mixing them up or inventing new ones: what counts is not respect for the rules of work, but the quality of the results obtained.

In recent years many people have proposed "the protection and conservation of the environment as the true purpose of a new way of designing." To these people I would like to say that they are confusing the instruments of the project with its aim, and that the question put in these terms is the wrong one.

I am not interested in the salvation of nature except as a corollary of the physical and spiritual salvation of modern man; saving nature as vegetable kingdom, rather than as the system of symbols, dreams, and mysteries that humans have attributed to it, does not interest me. Nature in conflict with man, nature as the preservation of privileges, is often the result of this attitude. Nature as the bearer of mystery, of unease, of great unsolved enigmas: this is the nature that interests me. Mirror of an unsettled, enigmatic, uncertain humanity. But I am also very interested in the other nature, the artificial world of chemistry, electronics, and information that surrounds us. An extensive and intru-

"Portrait with Closed Eyes" by Andrea Branzi (Milan, 1975).

sive nature, in which man is immersed like a fish in the sea; a metropolitan nature, made up of hard and soft structures, free of confines and uprooted from history.

This artificial universe too has to be made livable, friendly, and domestic again.

Design – and I with it – has followed two apparently opposite roads to attain this result: on the one hand it has "domesticated" the wild technologies of mechanics, industry, and chemistry so as to be able to introduce them, without trauma and as new resources, into the human environment. On the other it has used the strategy of "cruelty," placing humanity directly in contact, without buffers, with these atheistic and agnostic realities, bringing into the home these fierce and pitiless technologies totally lacking in humanity and warmth, making human beings "interiorize the machine" in order to change their sacred defenses and make them better suited to the New World that surrounds them. A cruel, progressive therapy, aimed at slowly shifting the threshold of humanity's survival.

So the quest for a possible "ecology of the artificial world" has become that strong point of reference of which I was speaking. A strong point that does not just mean the search for technologies compatible with the protection of the environment, but signifies above all turning the high level of complexity and the enormous discontinuity of the physical world that surrounds humanity into a positive advantage. It is a physical world completely different from the one imagined by the "moderns," made up wholly of standardized objects and mass production: a world instead in which opposite and contradictory logics coexist in a chaotic and turbulent form, without one ever prevailing over the other: industrial production and craftsmanship, languages for the masses and private codes, definitive products and disposable ones, advanced technologies and archetypal tongues.

Thus designing no longer means embracing just one of these logics at the expense of all the others, but maintaining an equilibrium, a positive ecological balance, amidst this great multiplicity of opposing realities, so similar to the one that exists in the truly natural world.

This is why, over the last twenty years, my work, like that of many other protagonists of Italian New Design, has embraced both industrial and craft projects, art and reason, technology and prehistory, together with objects, architecture, and the metropolis.

We have shifted the concept of orthodoxy and rigor, going to look for it deeper down, in the unfathomable and secret relationship that links the works of humanity to its destiny in the world. We are seeking a broader kind of rationality, one that also takes in the irrational and the dream, which make up so large a part of the world.

Andrea Branzi, 1992

Above: group photograph at the Villa Strozzi. From the left: Paolo Deganello, Andrea Branzi, Massimo Morozzi, Gilberto Corretti (1967).
Right: Permanent Amusement Park in Prato, Andrea Branzi's graduate thesis at the Faculty of Architecture in Florence. Tutor Professor Domenico Cardini (1966).

SUPERARCHITETTURA

Poster/manifesto and prototypes presented by Archizoom and Superstudio at the first exhibition of "Superarchitecture" at Galleria Jolly 2 in Pistoia, 1966.

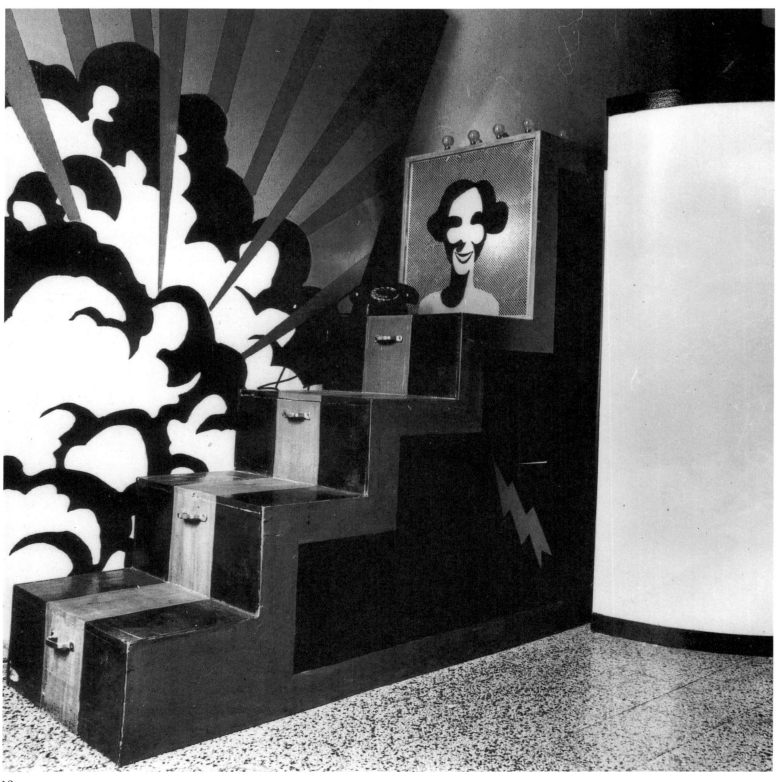

"Superarchitecture is the architecture of super-production, of super-consumption, of super-inducement to super-consumption, of the supermarket, Superman, and Super gasoline."

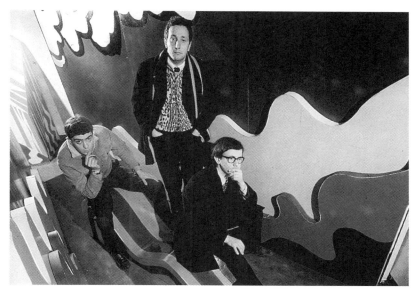

From left: Massimo Morozzi, Andrea Branzi and Adolfo Natalini at Galleria Jolly 2.

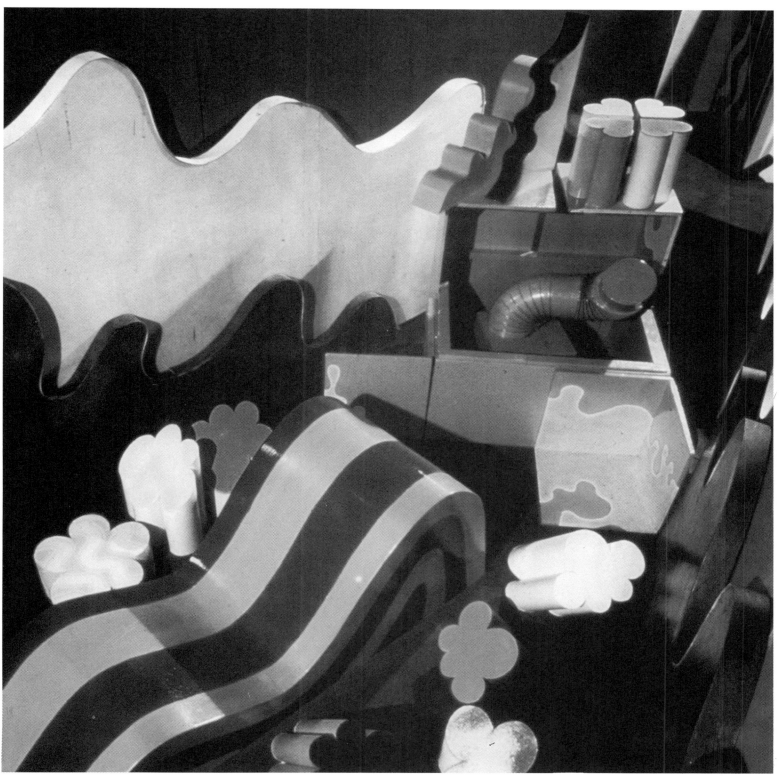

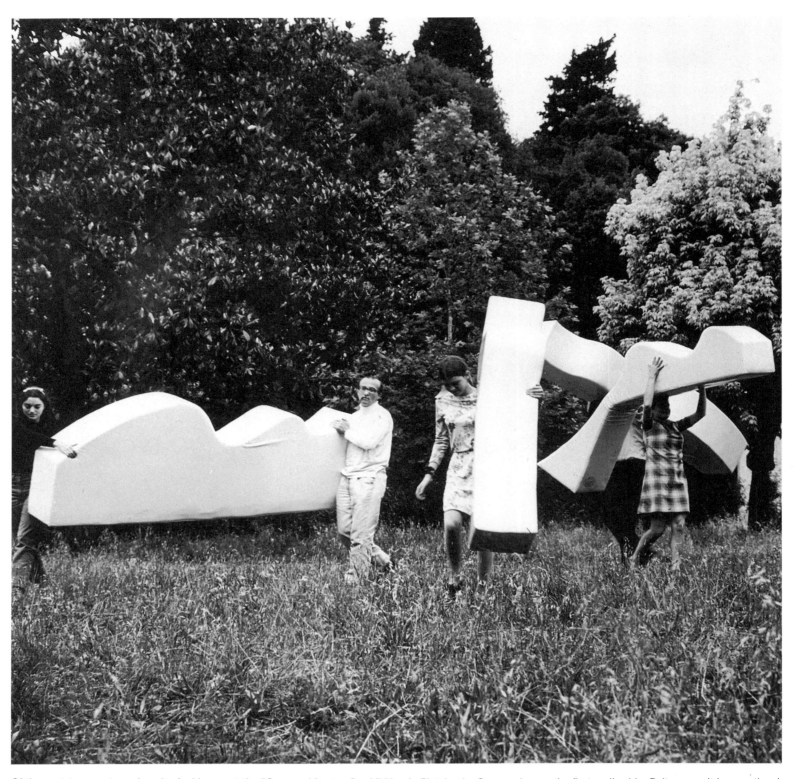

Of the prototypes put on show by Archizoom at the "Superarchitecture" exhibition in Pistoia, the Superonda was the first realized by Poltronova. It is a sectional couch made of polyurethane, photographed here in the park of the Villa Strozzi, the first premises of the Archizoom Associati studio, and in the home of Massimo and Cristina Morozzi (right).

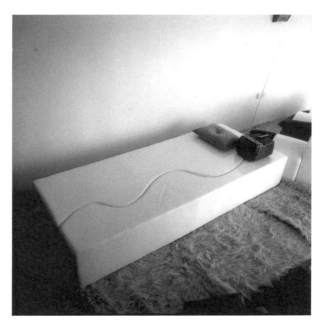

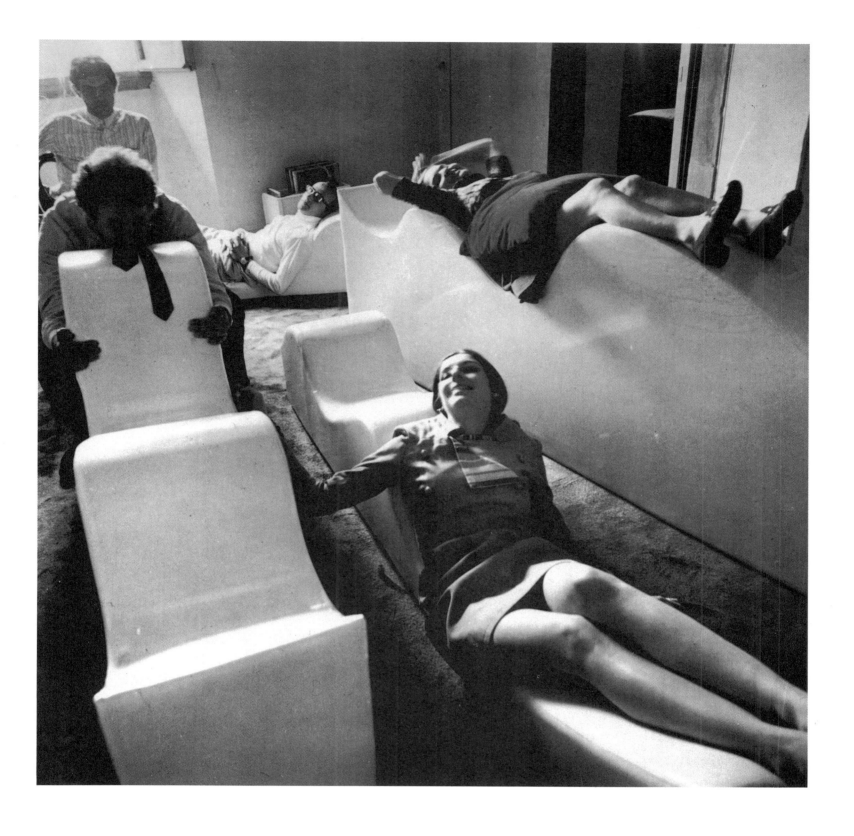

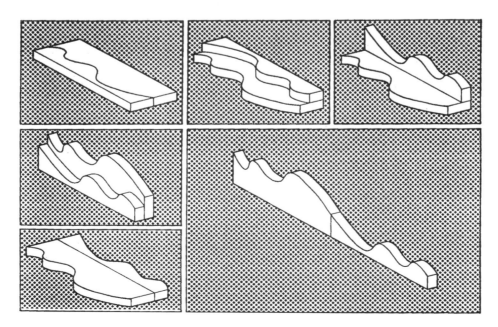

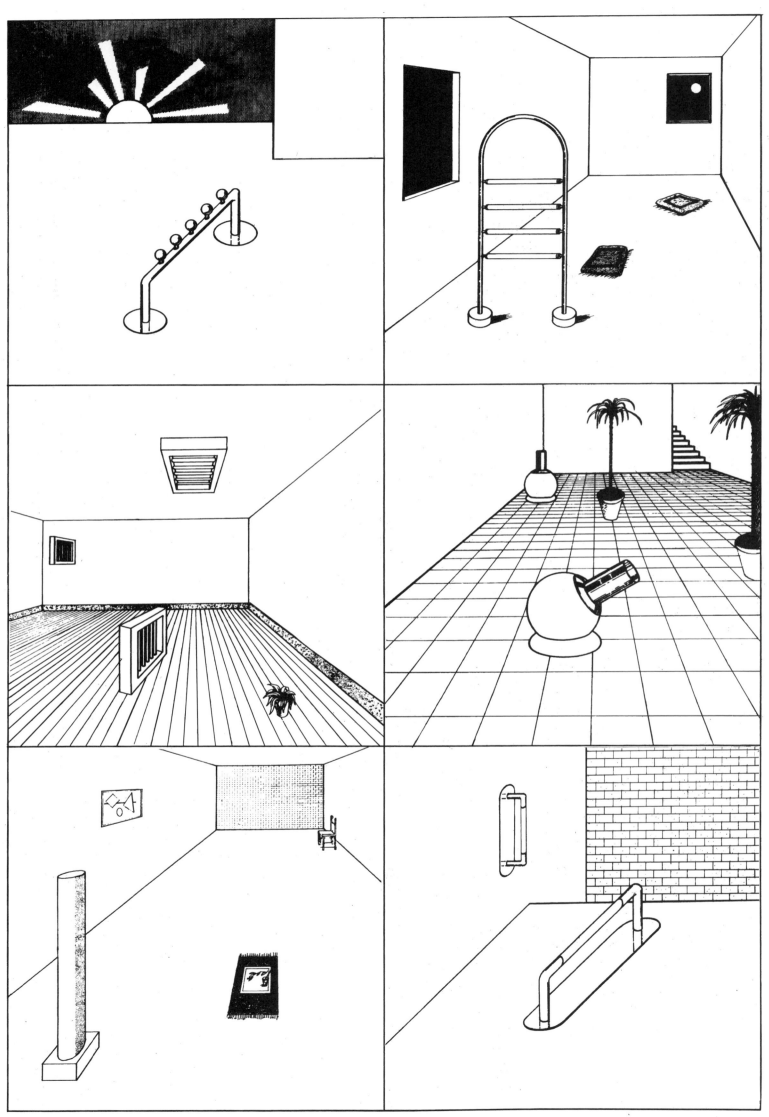

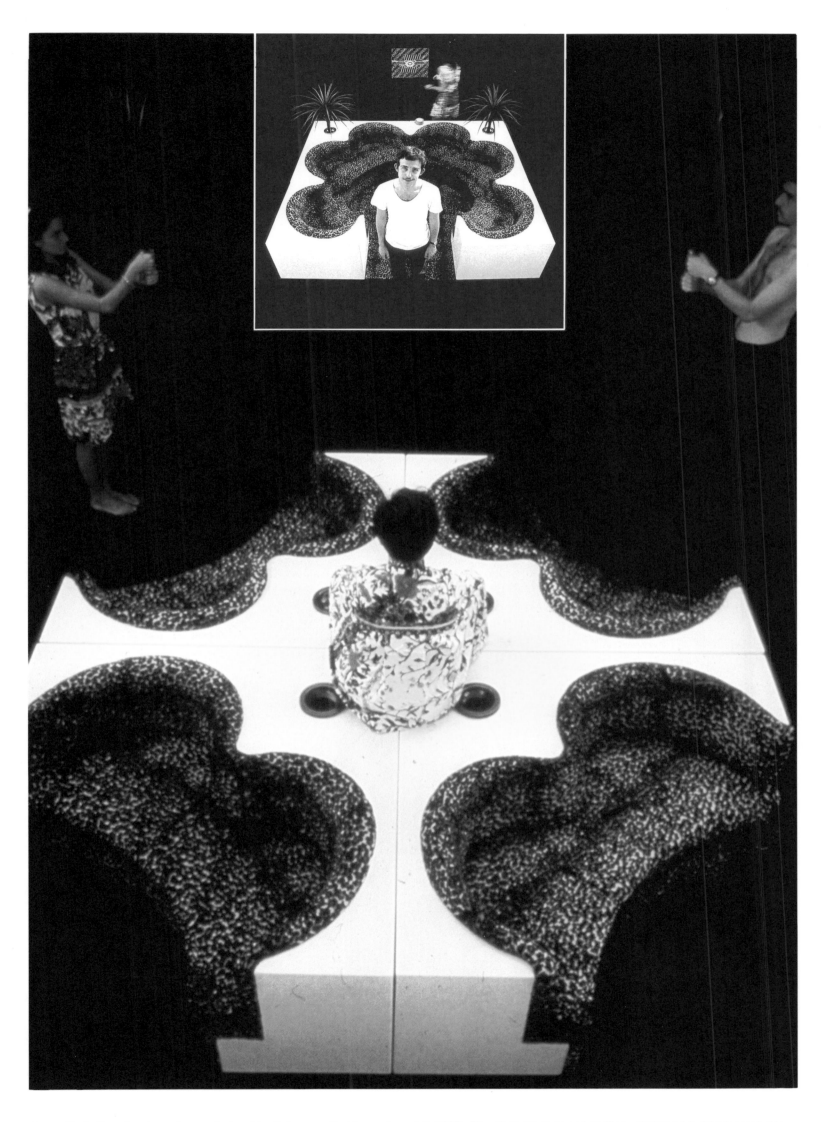

Above: "Safari" sectional couch, manufactured by Poltronova (Archizoom Associati, 1967). Fiberglass structure and stuffing upholstered in fake leopard skin.
Left: project for the "Yamajiwa" International Competition of Lamps, Tokyo (Archizoom Associati, 1968), second prize.

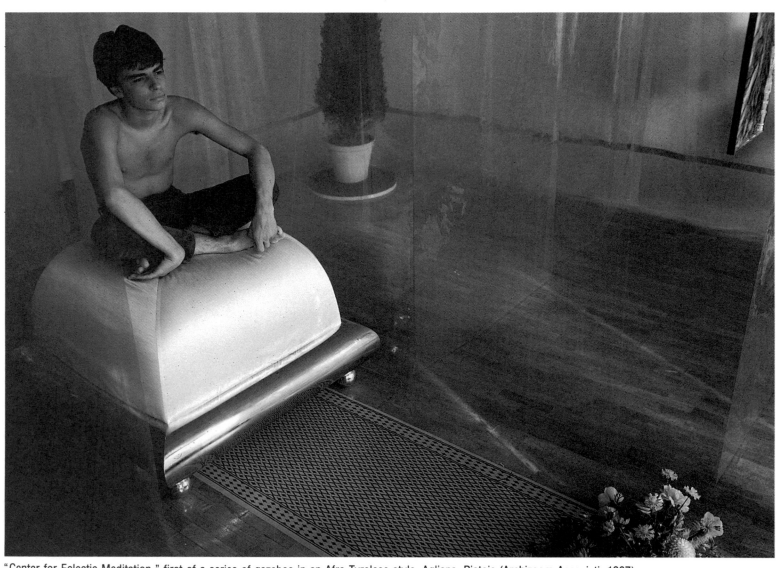

"Center for Eclectic Meditation," first of a series of gazebos in an Afro-Tyrolese style, Agliana, Pistoia (Archizoom Associati, 1967).

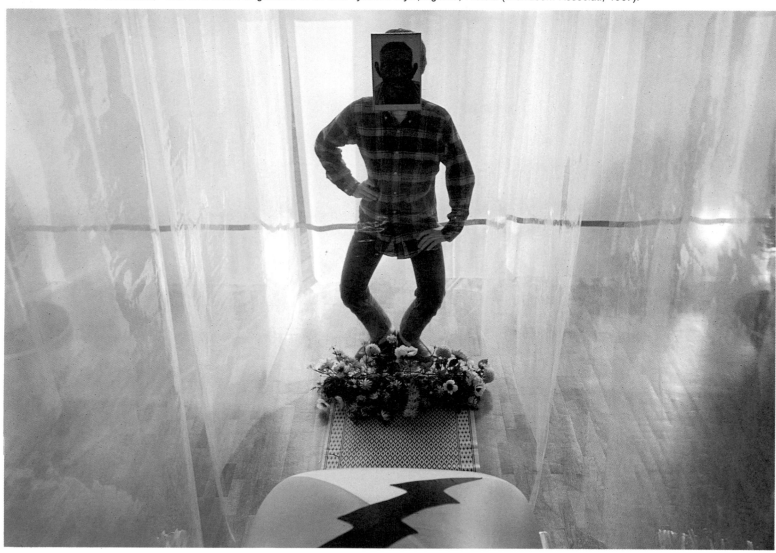

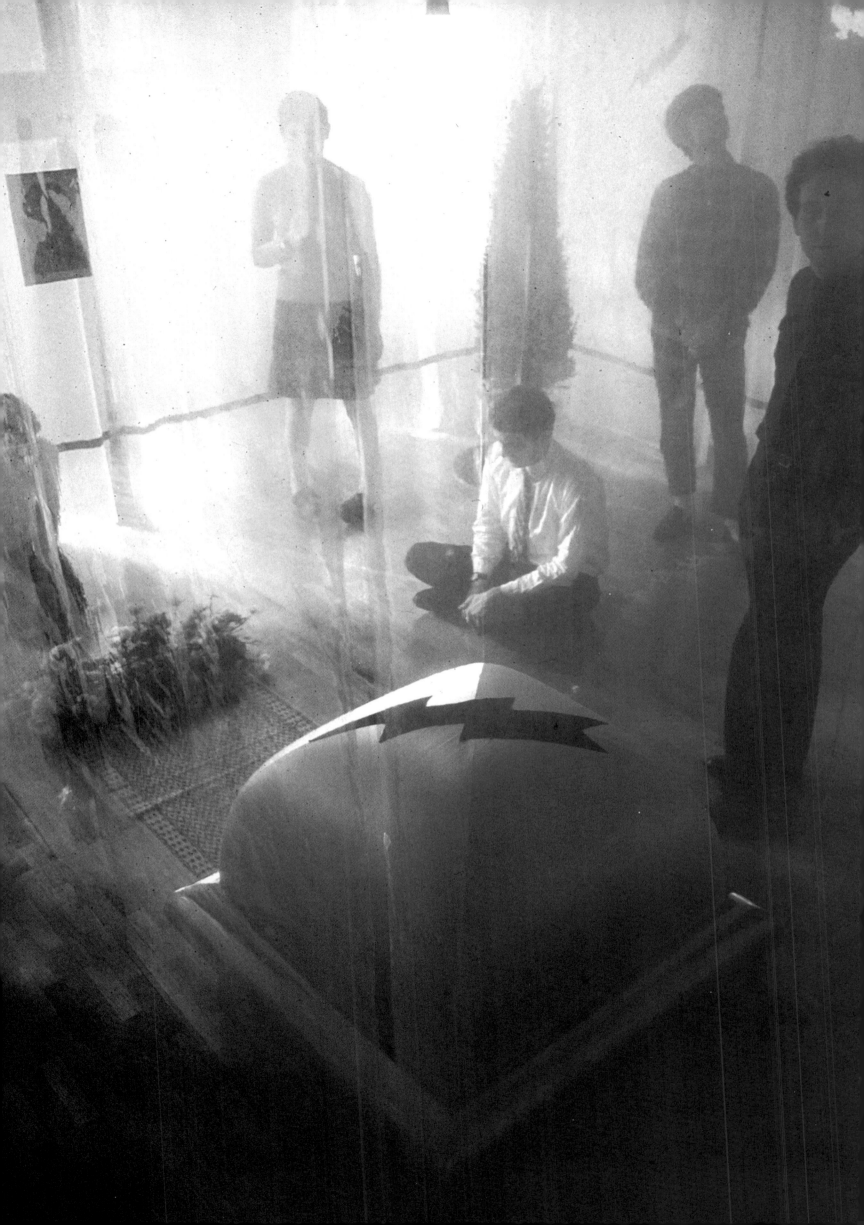

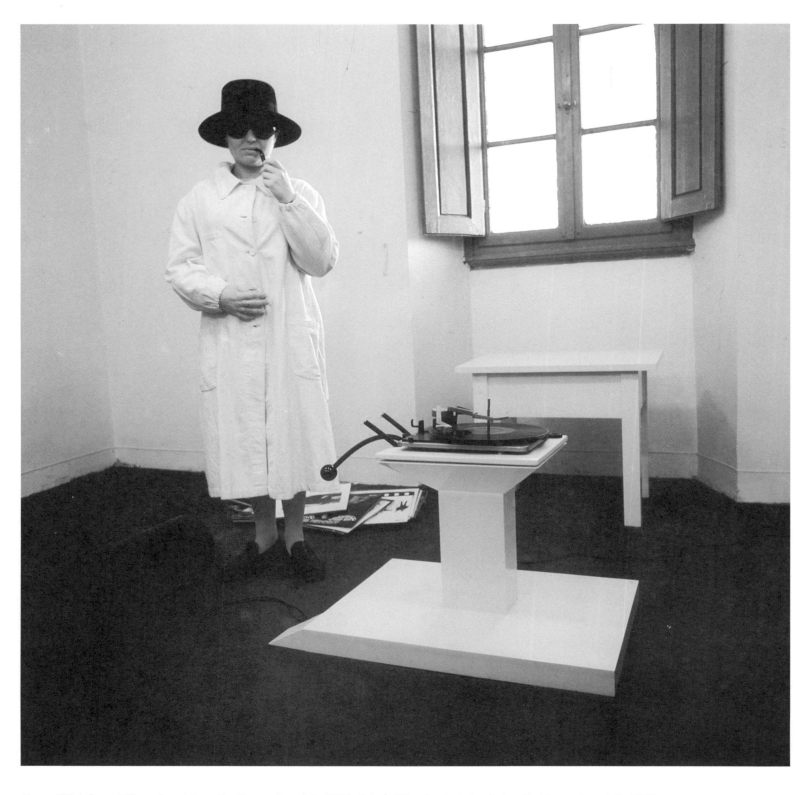

Above: "Pink Record Player," prototype (Archizoom Associati, 1968). Below: "Moschea" electronic toy (Archizoom Associati, 1968).
Right: record player with egg cup (Archizoom Associati, 1970). Prototypes realized by Dario and Lucia Bartolini.

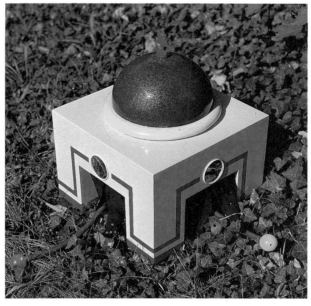

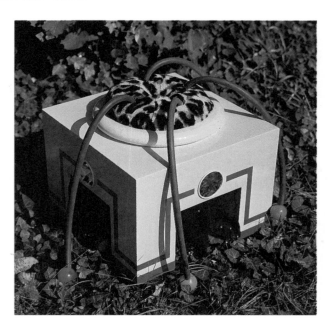

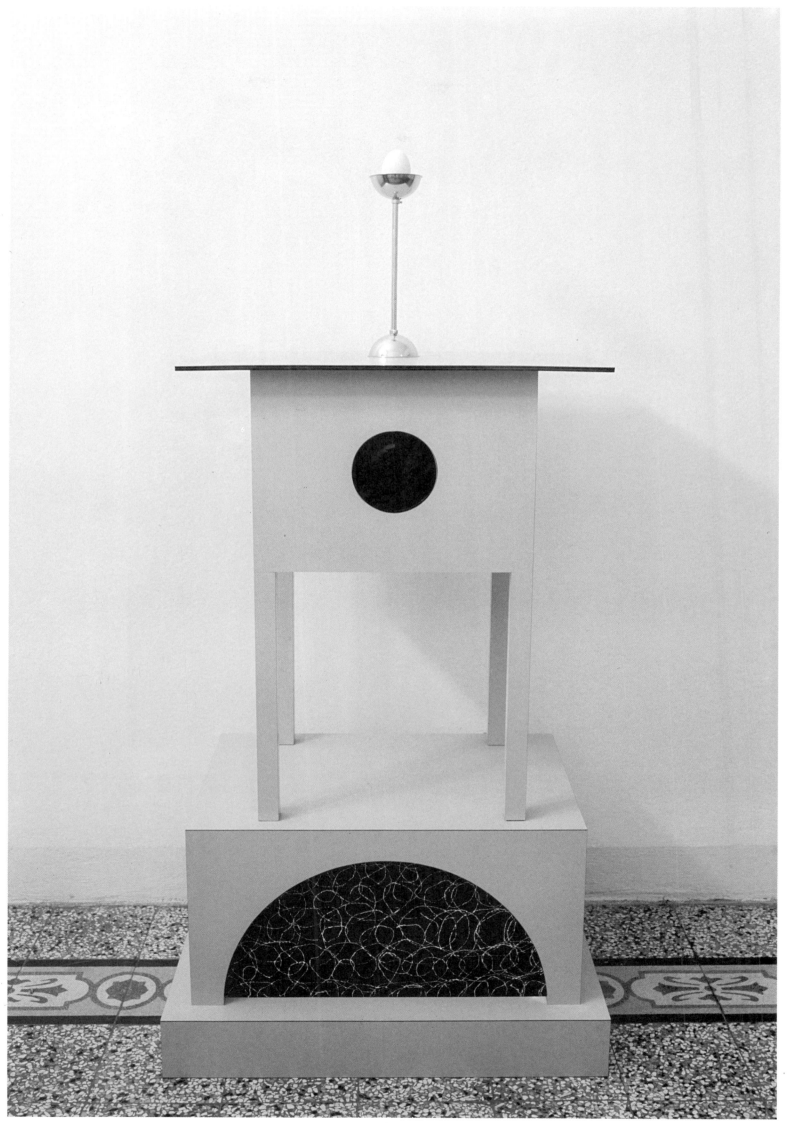

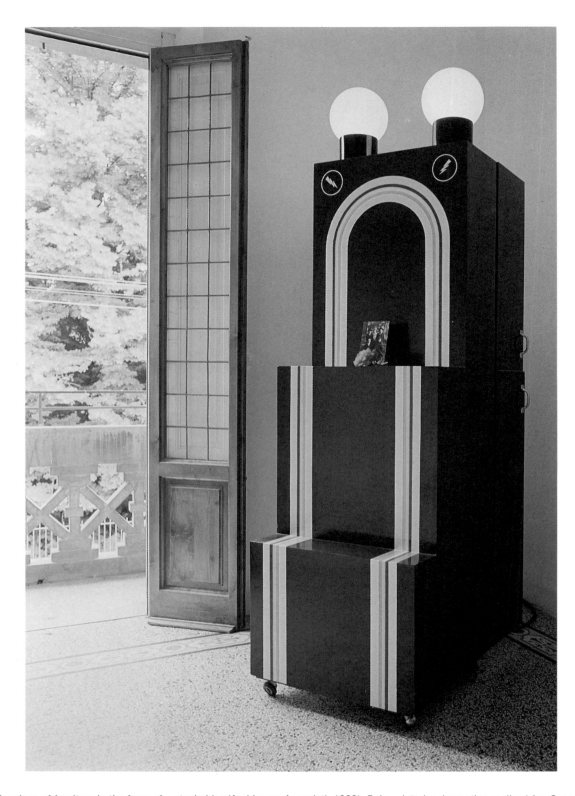

Above: prototype of a piece of furniture in the form of a stepladder (Archizoom Associati, 1968). Below: interior decoration realized for *Casa Vogue* in the home of Gilberto Corretti (Archizoom Associati, 1968). Right: entrance of the Libreria Editrice Fiorentina in Florence (Archizoom Associati, 1968).

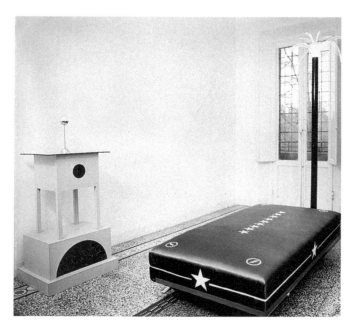

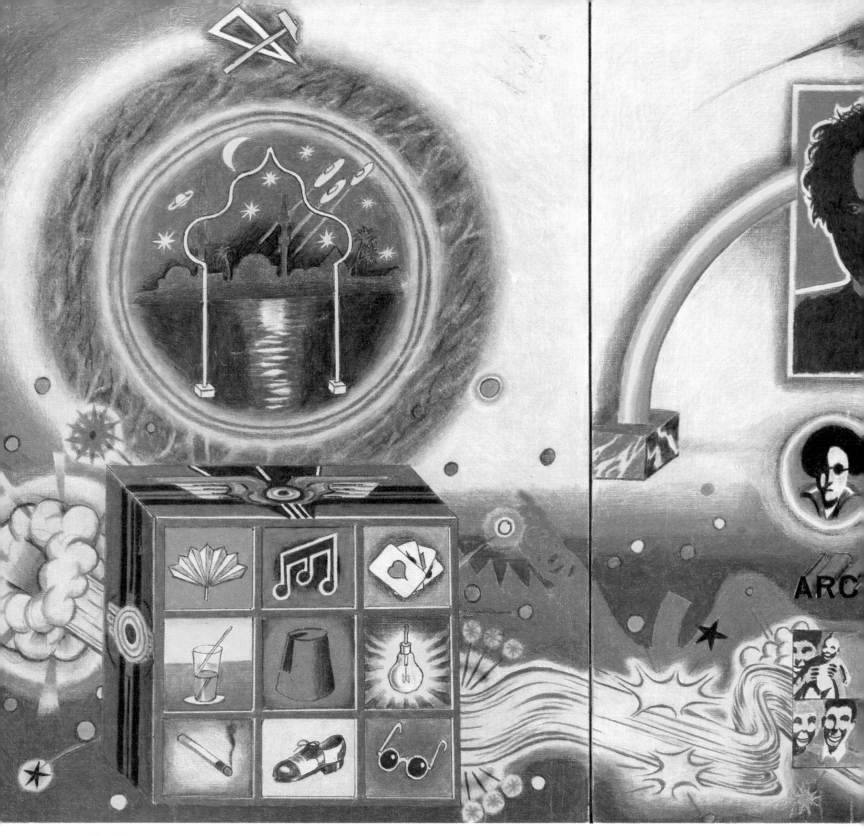

Above: Self Portrait, pastel drawing made at Interlaken, Switzerland, in 1968.

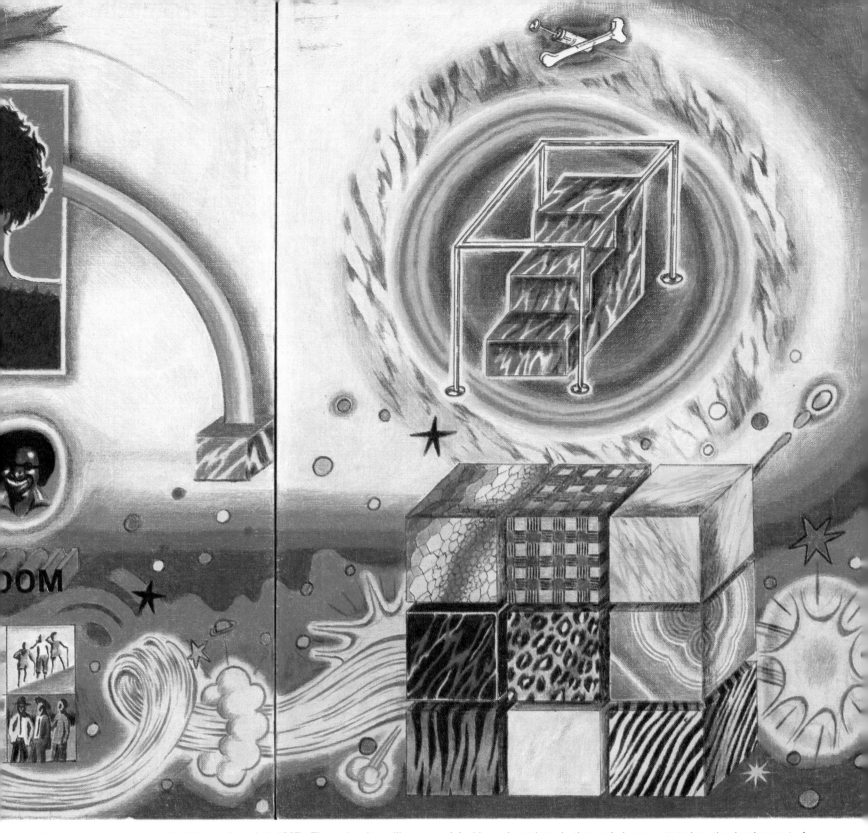

Below: studies for carpets (Archizoom Associati, 1967). These drawings, like many of Archizoom's projects in that period, concentrated on the development of eclectic and syncretistic components, including Islamic and Afro-Tyrolese elements.

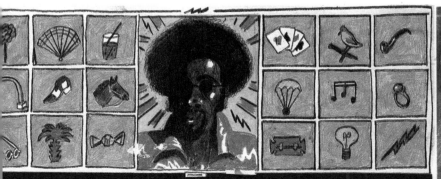

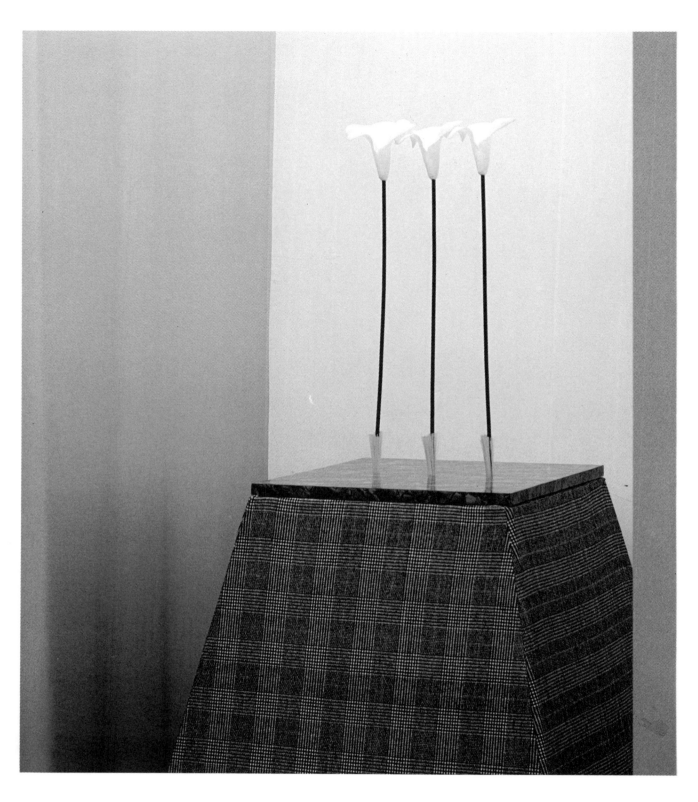

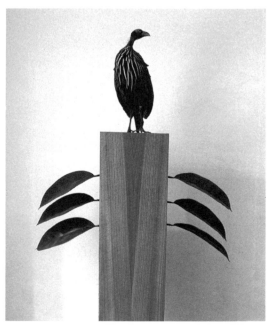

Exhibition of gazebos with stuffed animals and plastic flowers at the "Mana Art Market" in Rome (Archizoom Associati, 1968).

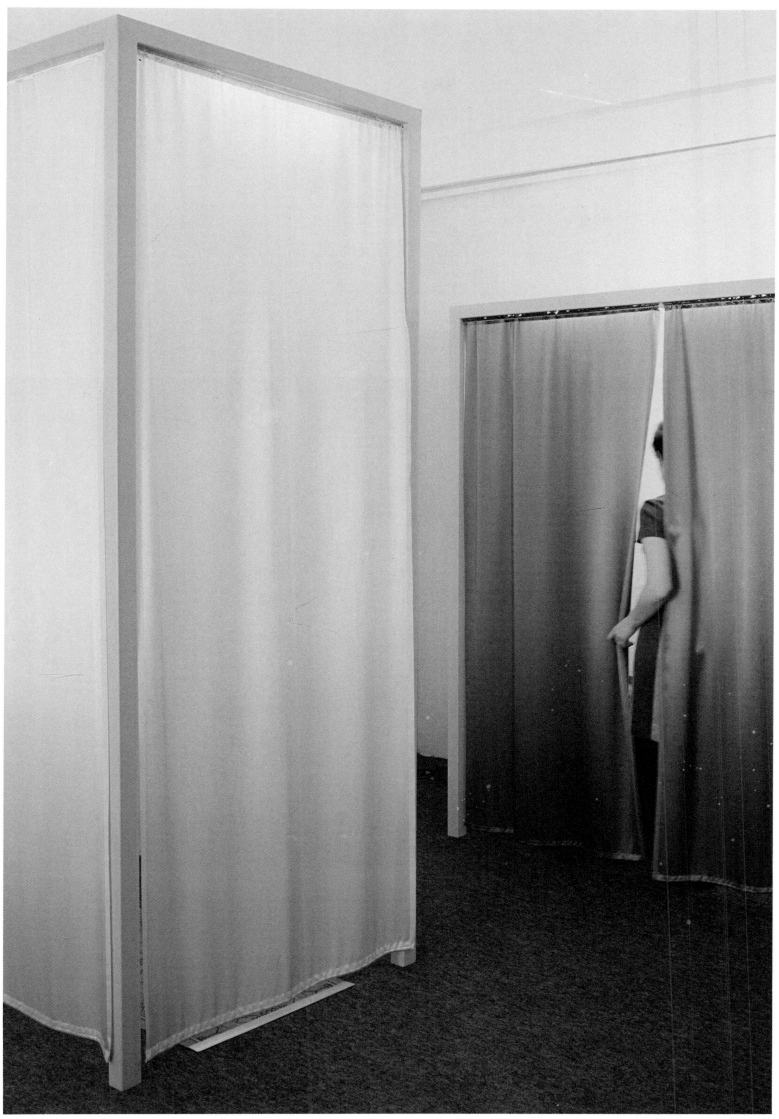

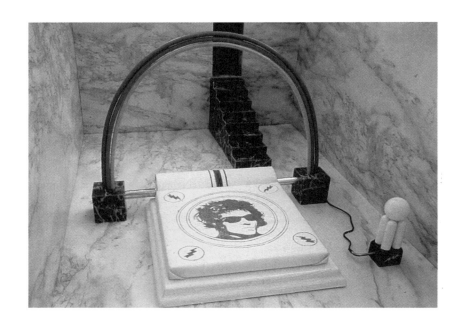

Models of dream-bed dedicated to "New Empire styles." Above: "Delirium of Roses" (Archizoom Associati, 1967).
Below: "Presentiment of Roses" (Archizoom Associati, 1967).

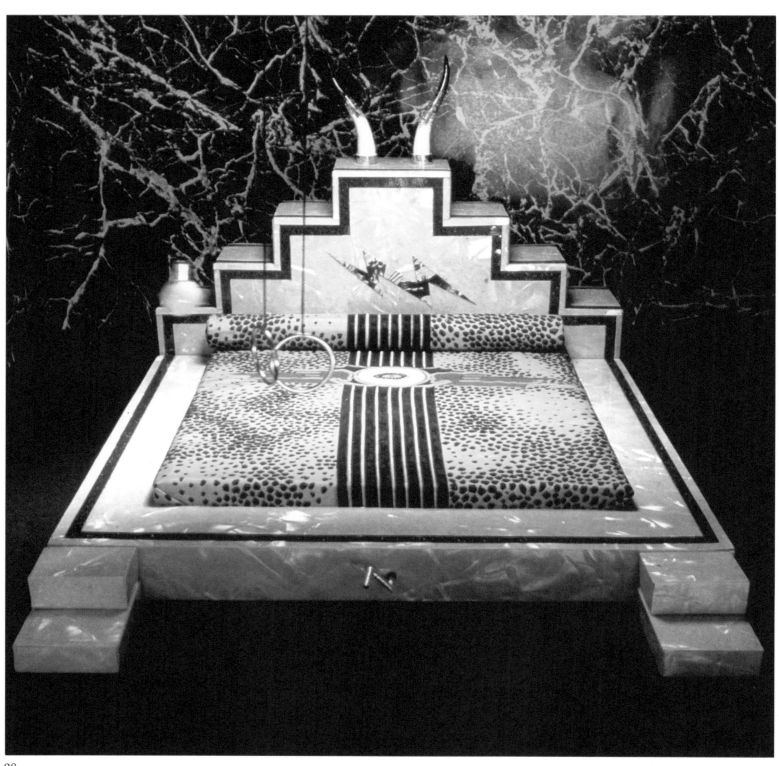

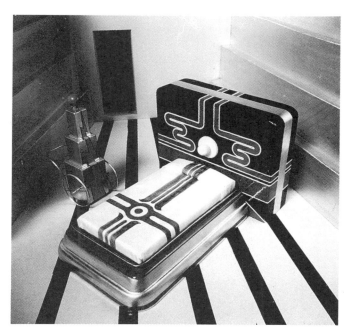

Above: "Rose of Araby" (Archizoom Associati, 1967). Below: "Shipwreck of Roses" (Archizoom Associati, 1967).

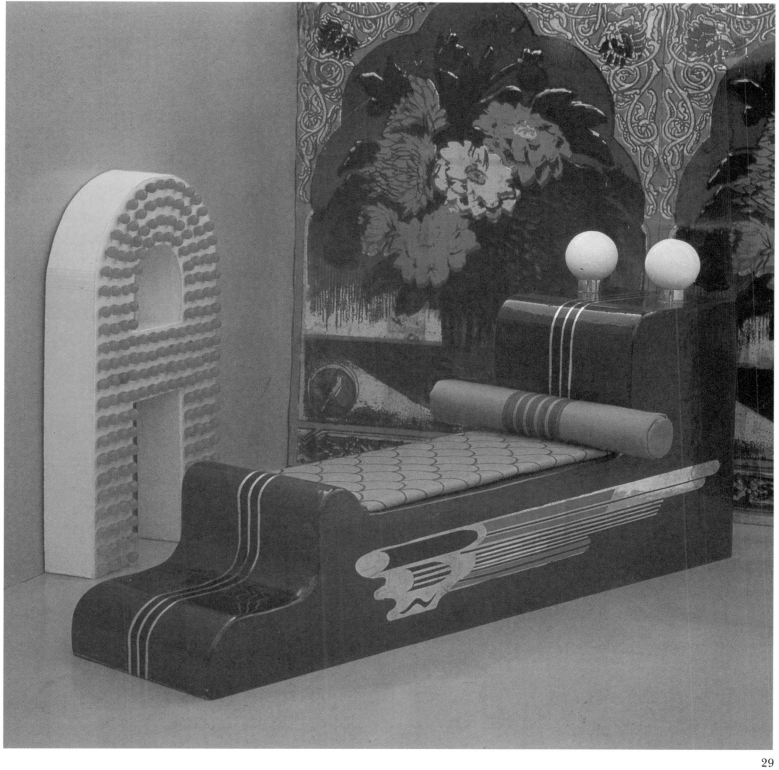

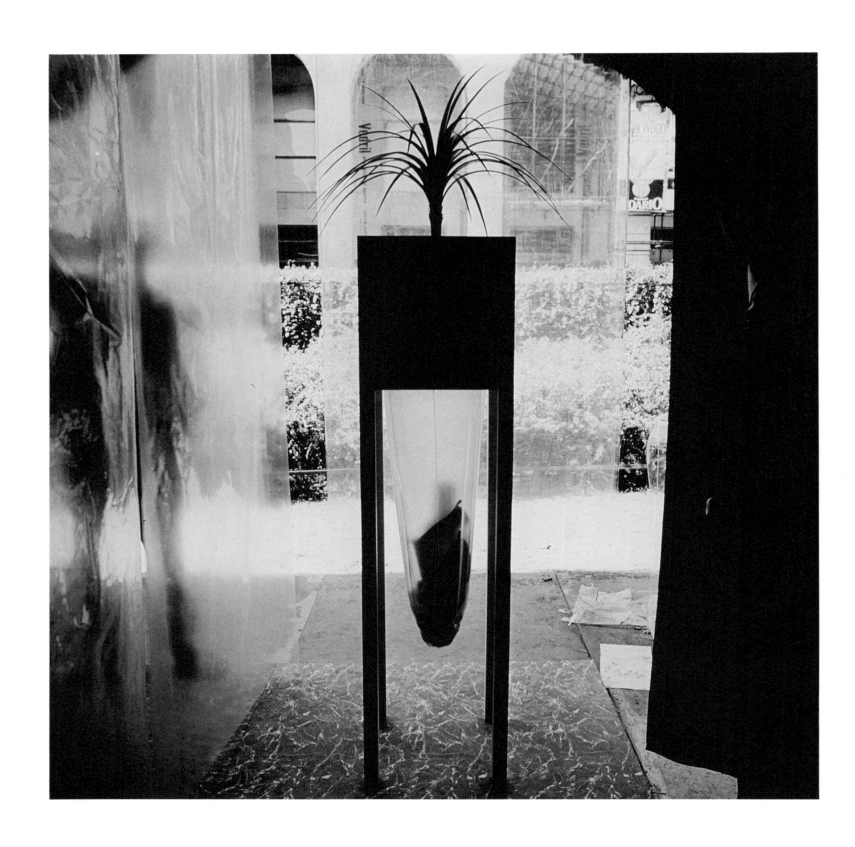

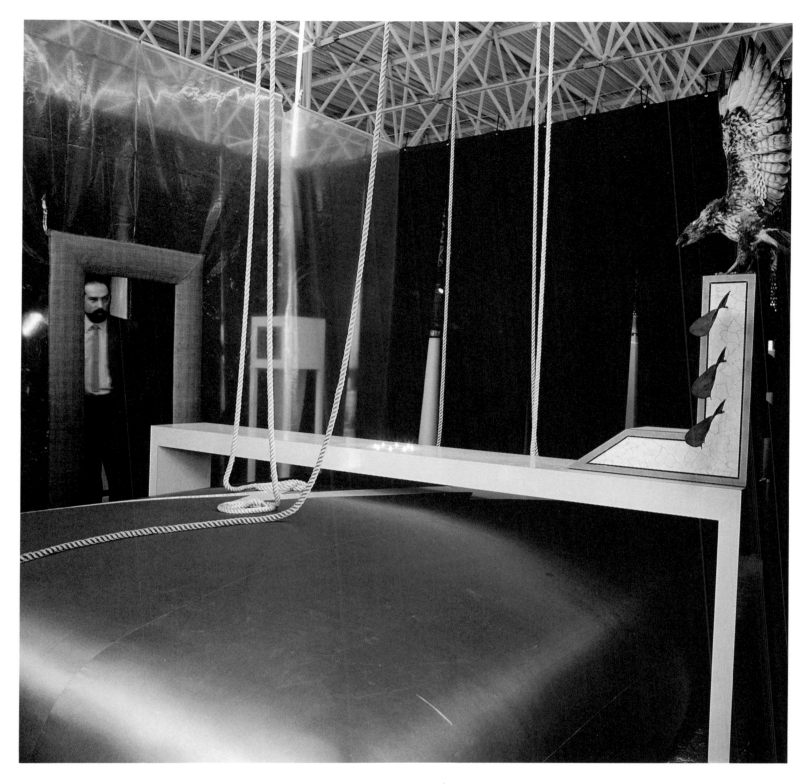

"Center for Eclectic Conspiracy" gazebo, dedicated to Malcolm X, at the 14th Milan Triennale. Environment with black drapes and large Turkish-style bed (Archizoom Associati, 1969).

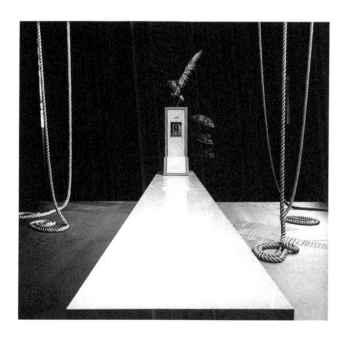

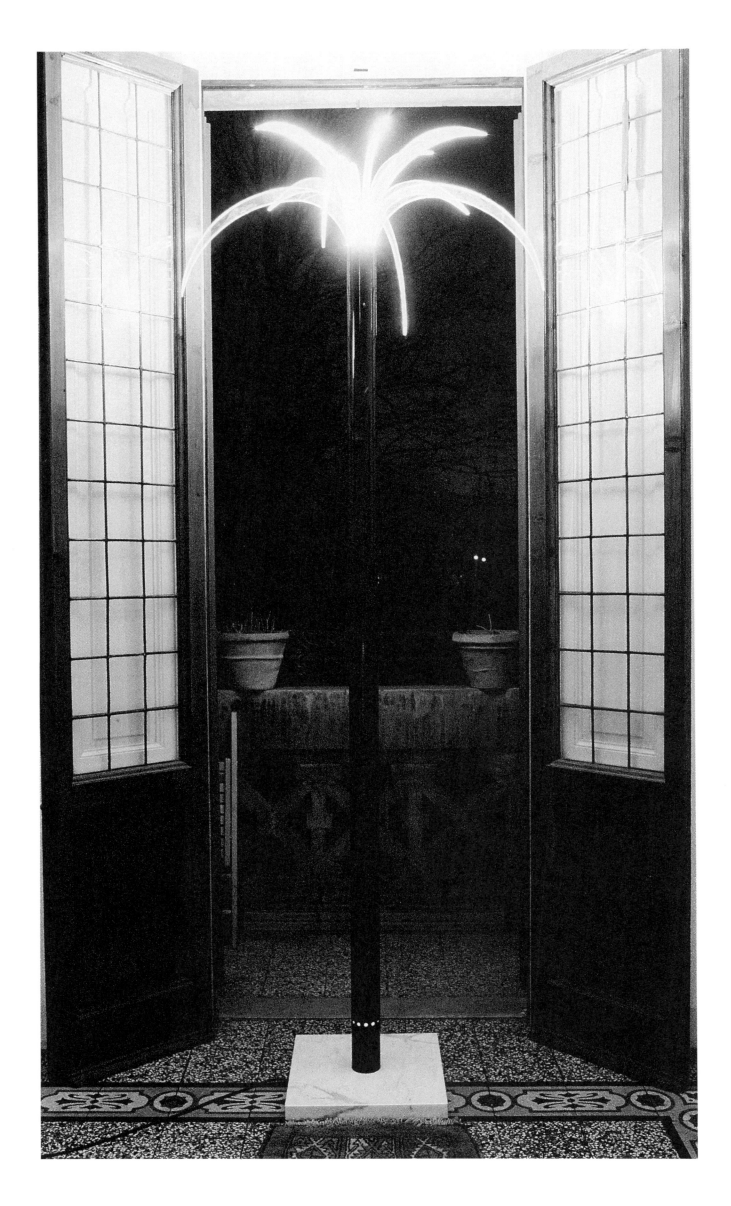

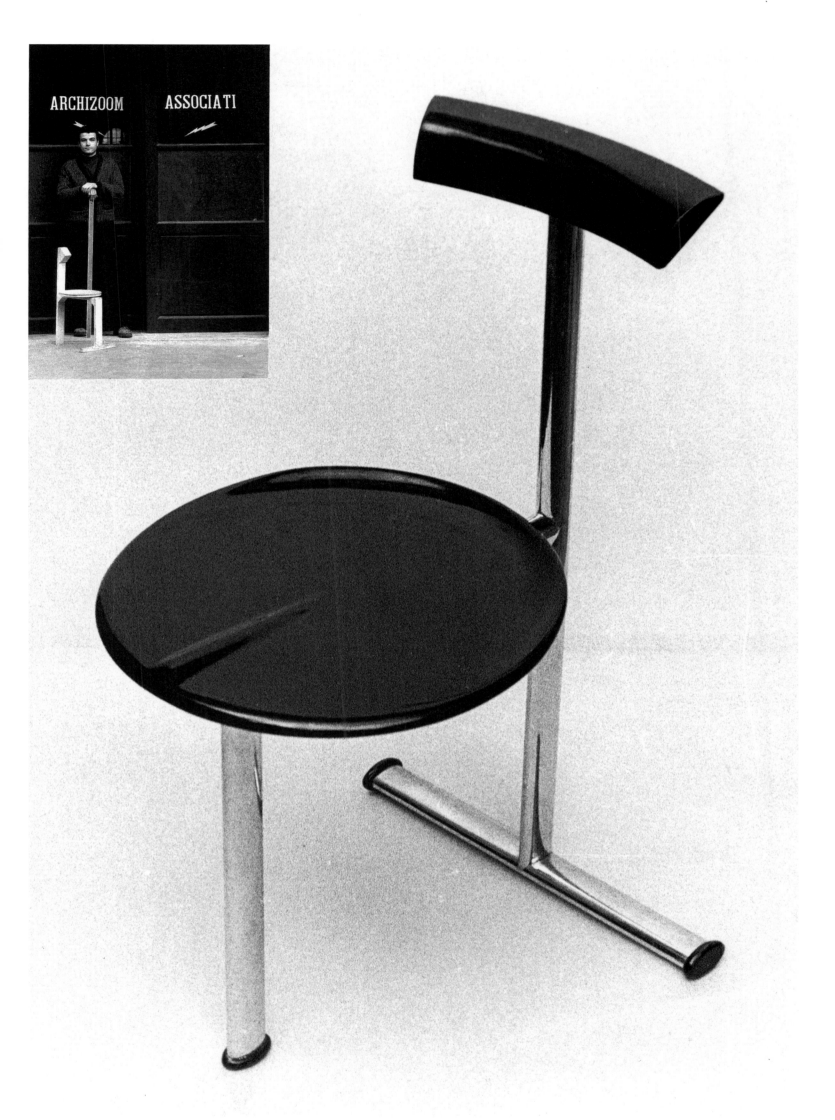

Left: "Sanremo" palm-lamp, manufactured by Design Center. Prototype made by Dario and Lucia Bartolini with a light-sensitive "electronic cricket/trigger" (Archizoom Associati, 1972). Above: prototype of the "N.E.P." three-legged chair (Archizoom Associati, 1968). Inset: the wooden prototype in front of the studio on the via di Ricorboli.

"Poltrona a braccio", prototype made by Centro Ricerche C & B (Archizoom Associati, 1972).

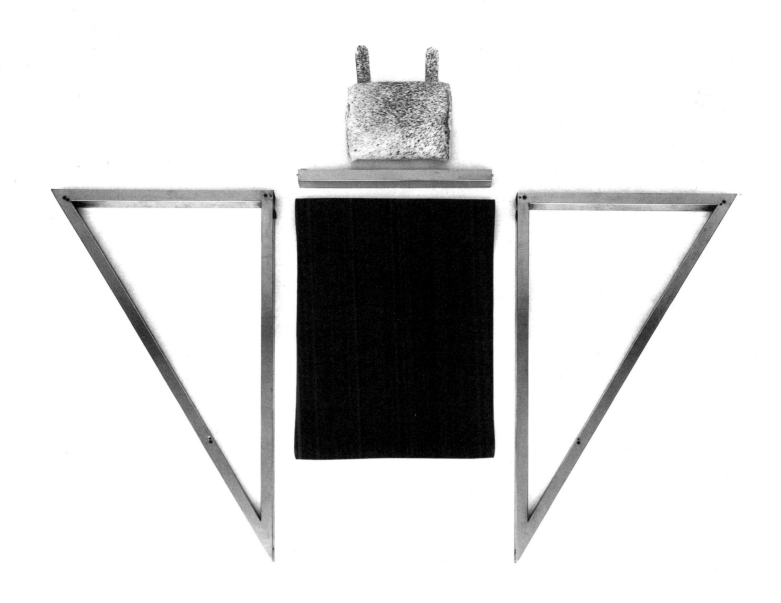

"Mies" elastic chair, manufactured by Poltronova (Archizoom Associati, 1969), made of a triangular metal framework and a sheet of Pará (natural rubber).

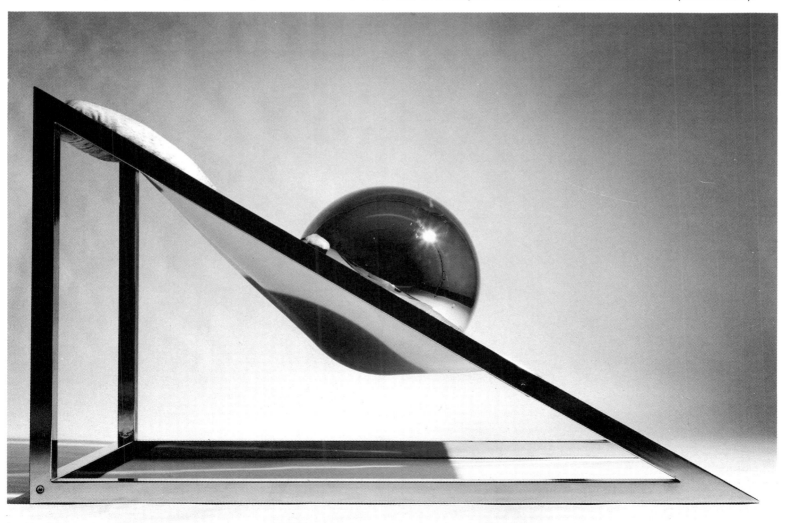

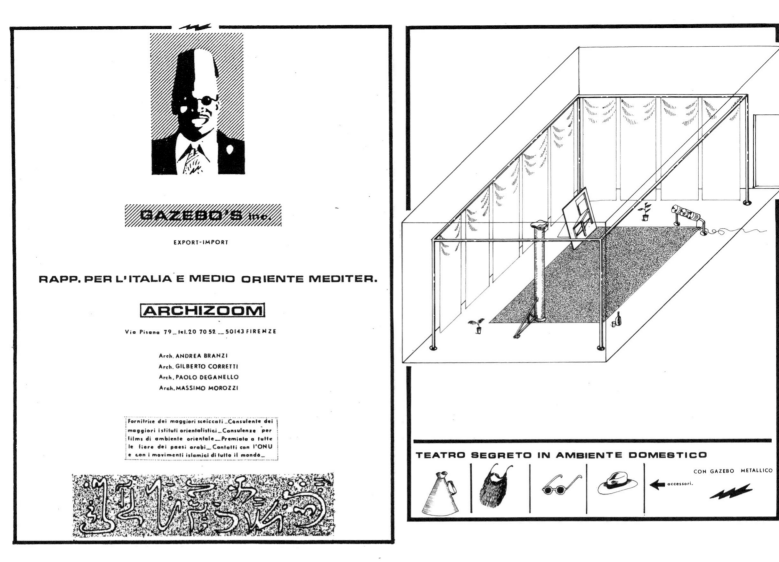

Mail-order catalogue of gazebos, published in the first issue of Pianeta Fresco under the title: "Archizoom Associati, Gazebos Inc. Export-Import" – for the creation of Oriental settings in one's own home.

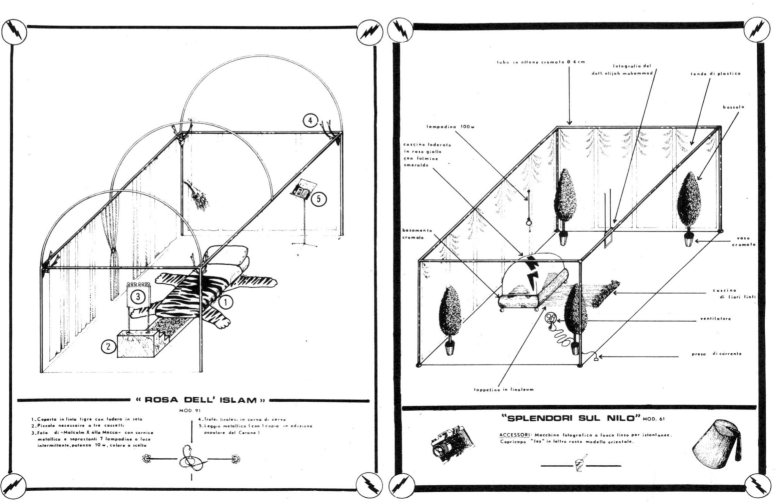

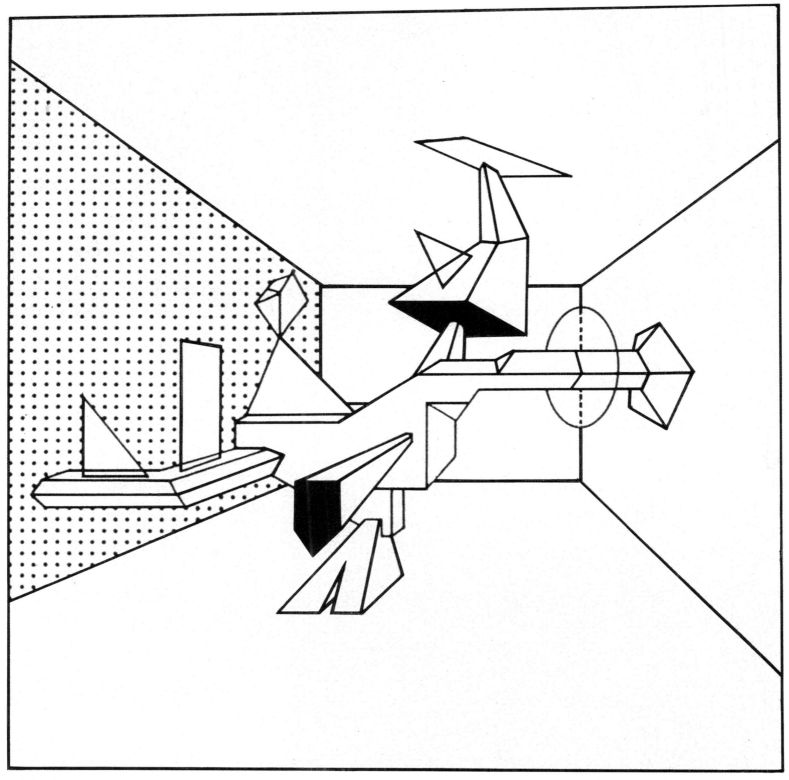

Drawings of "Wardrobes," published in *IN* by Archizoom Associati in 1968, on the theme of aggressive and extravagant domestic structures.

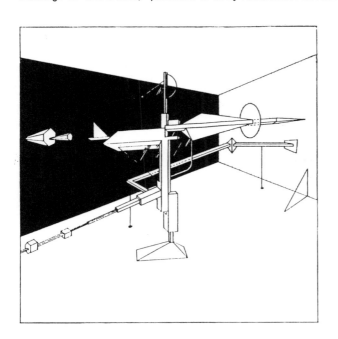

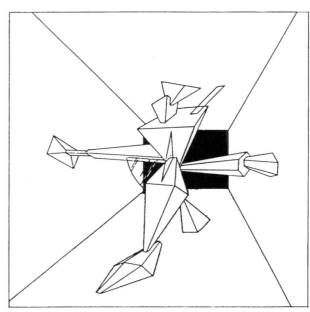

Perhaps the problem is another one, how to have a very, very hot street and a very, very cool ice cream shop: so one puts the cream, the wafer, the wedge of pineapple, the cherry, the straw, the spoon, and the flag on top of the cup, and the Coca Cola on top of everything, so that someone helps himself to the ice cream in such a way that when he goes it stays served. The problem for us, on the other hand, is how to serve up an ice cream in such a way that he loses the desire to eat it for the rest of his life. Or an ice cream that, once it has been bought, grows bigger than him and humiliates him. Or that becomes a piece of the world surrounding him and frightens him.... In short an ice cream with no alternatives: either you eat it or it eats you. Or rather: it starts to eat you as soon as you have finished it. And then we think: apple-bombs, poisonous

RADICAL ARCHITECTURE

sweets, false information, in short Trojan blankets, beds, or horses that are brought into the house and destroy everything in it. We want to let in everything that stays outside the door: carefully constructed banality, deliberate vulgarity, urban fittings, dogs that bite. To scientific progress, fruit of the intelligence that explains everything and of the elegance that saves everything (disconnecting the fuses and preparing the future with a smile), we prefer a brilliant horizon of paper streaked by the rainbow. Like fake pacifists, we take off our beards and mustaches in the evening, contemplating the most violent betrayal. We would also like to say: we are not where they seek us, do not put too much trust in how we greet you.

And then there is this scent of dead roses in the air which we don't like much....

(From "The Archizoom," *Domus* 455, October 1967)

The end-purpose of modern architecture is the "elimination" of architecture itself. As a "rational structure" tending to resolve the greatest number of functional problems at an optimum technological level, modern architecture tends to work out definitive solutions and typologies, to regard, that is, the solution of problems as a progression towards the elimination of all unsolved problems through their gradual solution.

It tends to present itself as a planning process which finds solutions, not of a cultural but of a scientific nature, to housing problems.

The "inevitable" quality of many architectural solutions and of widerspread didactic methodology suggests an attempt to lead a large part of modern architecture beyond history and therefore beyond culture, and to drive it towards a threshold of unshakeable security where it will be safe from historical judgment and from future evolutions in idiom and form. In this sense the process of stripping away all esthetic, superstructural, material, and formal decorative elements becomes a plan for the elimination of ar-

chitecture as a cultural structure: it no longer represents the status symbol of a social class and, more generally, it no longer "represents" anything at all, unless it be the mere availability of the structure for indiscriminate and culturally neutral use.

At the same time, and in a diametrically opposite sense, architecture is offered as a strictly and exclusively private matter, as a direct extension of the body and of its expressive possibilities, as creative space related to one's psycho-physical individuality, and no more as planned space but as an infinitely variable communicative experience.

In this sense, architecture is defined as an experience that cannot be codified (and therefore cannot be planned), unless it be through some kind of experimental procedure which is in fact extraneous to any kind of cultural or disciplinary methodology. Within the limits of this contradiction, historical architecture is presented as a "cultural" structure that seeks to guarantee the highest number of freedoms for the house owner in the urban context (which is his real future) and in private (where he reveals his real nature).

The conflict, then, is between the individual and architecture, between pure phenomenon and universal order, between meaninglessness and artistic message. But it is conflict and not dialogue, because it is in terms of a clash that this relationship is couched today, since all the acts of self-liberation that the individual carries out are destined to put him beyond the moral, esthetic, and cultural inhibitions of the current Establishment.

The movement for the liberation of man from these "behavioral codes" helps him to regain culture as creative energy and as the spontaneous definition of his own identity.

Any awareness of this right immediately clashes with the whole organization of contemporary society, which is based on productive labor and on the division of the same. This determines, on the one hand, the intellectual profession, whereby

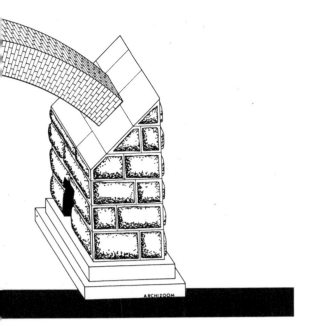

a highly restricted part of society "produces culture," and on the other, the great mass of people who are expected only to consume it in the form of products, structures, and models of behavior, which simulate the use of creative faculties that, in point of fact, have atrophied.

The fundamental problem of architecture and of culture, then, is that of "freedom." Le Corbusier proposed a "free" plan, a "free" facade, grounds "free" from the building, thanks to his pilotis, the "free" use of roofing, etc.; thereby putting the problem of "freedom" at the very center of architectonic quality. However, Le Corbusier still formulates this problem in "architectonic" (i.e. compositional) terms, thereby confirming the figurative and mediatory social role played by the historical tradition in architecture. This mediation is carried out in terms of allegory, but it breaks down when the relationships between specific and general reality cease to be the effect of reciprocal "hypotheses" and establish with each other a confrontation which is directly and exclusively political.

Social and cultural progress itself, then, to which architecture contributes, slowly removes its own premises or cultural structure – that is, its ideology.

By its very nature, then, architecture lies at the center of a crossroads into which the basic contradictions of all planning activities flow, and, driven by science, these activities strive to achieve "definitive solutions," while at the same time (driven by social growth) guaranteeing the "absolute relativity" of every private process as a defense of man against the universal orders that condition and limit him.

On the one hand – that is – there is a tendency to go beyond the upper limits of meaning and to place one self above history; on the other hand, there is the tendency to cross the lower threshold of meaning and to place oneself within the infinitesimal folds of history itself. All in all, architecture today tends to solve its existential problem by eliminating itself.

(From *Casabella* 399, 1975)

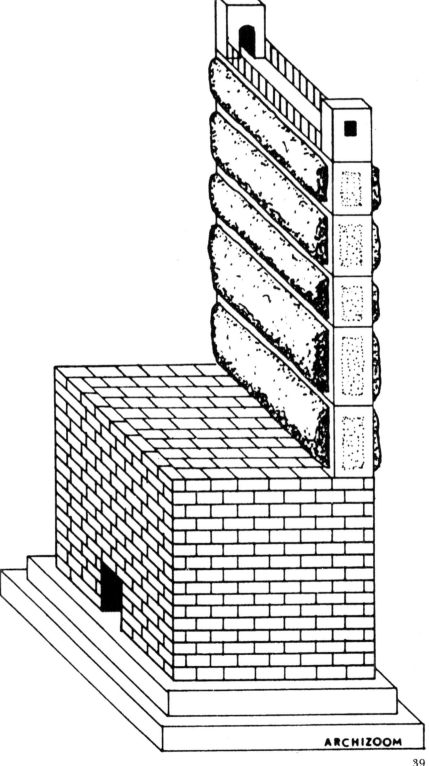

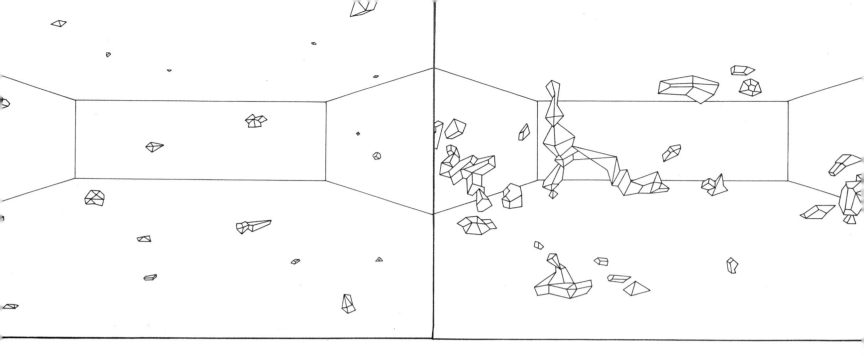

Above: "Structures in Liquefaction," published in *IN* by Archizoom Associati in 1969.

The civilization of today is an imperial one, the civilization of great international trusts, of big financial or real estate agencies, of oil companies, of major deposits. It is a civilization that is fundamentally not unstable, but broad and cosmopolitan, stretching from America to the Arab countries. Composite, eclectic, and syncretistic, but lucid and luminous, free from doubts and problems. Its architecture is that of a great empire....

It never tackles the problem of new organisms, but deals with existing ones by a method borrowed from industrial design, which is required to design something that already exists. It has no "conception of space," but new problems of representation. It does not give a damn about architectural problems, just as we do not give a damn about the problems of those who make our clothes. It is not the civilization of technology and science, but of trade and commerce: we should not let ourselves be deceived by the whirl of consumption and the speed with the "large number" is absorbed, for behind them stands a marble chicken that does not eat and does not move....

From a certain moment onward architectural culture began to talk about the "conception of space," and in this way succeeded in giving material form to a datum that does not exist, or that if it does exist is only an element in the utilization of the far more

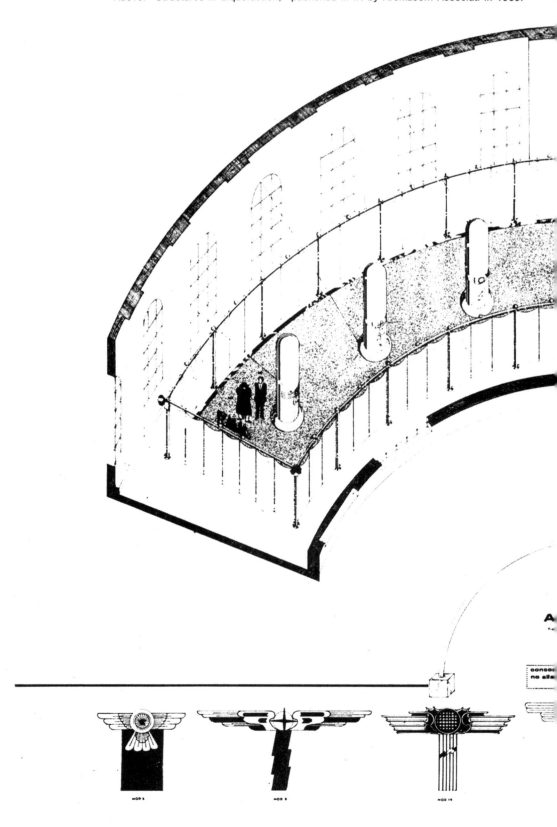

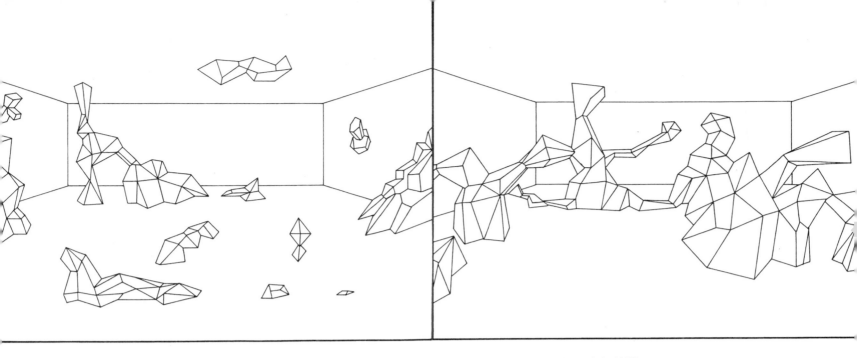

Below: "Large Gazebo in a Curve," competition for the Italian pavilion at the 14th Milan Triennale (Archizoom Associati, 1968).

complex architectural phenomenon whose laws of composition are not utilizable in spatial terms....

The pavilion we have proposed has a fundamental motive in the representation of a situation that now exists: from the four loudspeakers at the sides a voice can be heard continuously reading one of the many critical texts that can be found today on the problem of the "large number" (the text announcing the competition itself, for instance). The pavilion contains seven chrome-plated obelisks, immobile and shiny, on which are set seven colored friezes representing winged coats of arms. These obelisks are neither sculptures nor machines; rather they are automobiles, that is objects of design that have attained the highest level as imperial and triumphal symbols.

Why do we think that this can be the Italian response to the problem of the "large number?" In our view it represents, to some extent, a typically Italian condition: in part because there is a deep-rooted architectural tradition in this country, a fairly classical one, of representing a system and not judging it, a refusal to exploit culture, but a belief in its capacity for restitution at a higher level of cognition. And in part because Italy retains, precisely as a result of its half-industrialized and half-rural state, the ability to perceive new problems and control them in an ironic fashion....

Competition for the Italian pavilion at the Universal Exhibition in Osaka. The exhibition hall is underground. On the rolling lawn stand a series of large parallel walls of plate glass for the display of typical Italian products, and, in section 9, plaster statues by Fausto Melotti (Archizoom Associati, 1969).

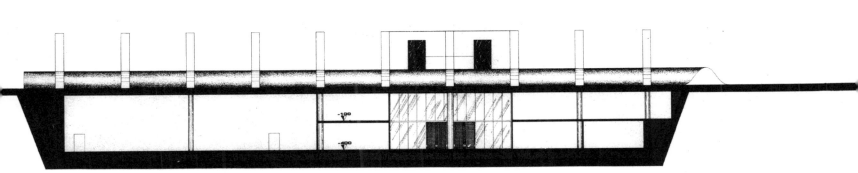

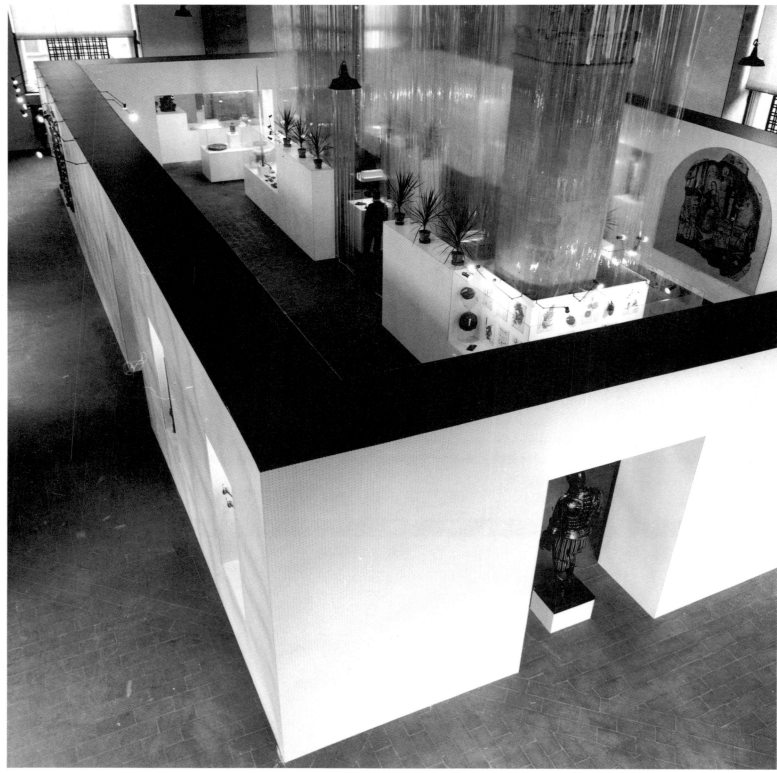

Installation in Orsanmichele, Florence, for the exhibition "Art and Science in Tuscany in the Donations of Private Collectors to the Public Collections of the 20th Century," with large plastic drapes and partitions of phaesite (Archizoom Associati, 1969).

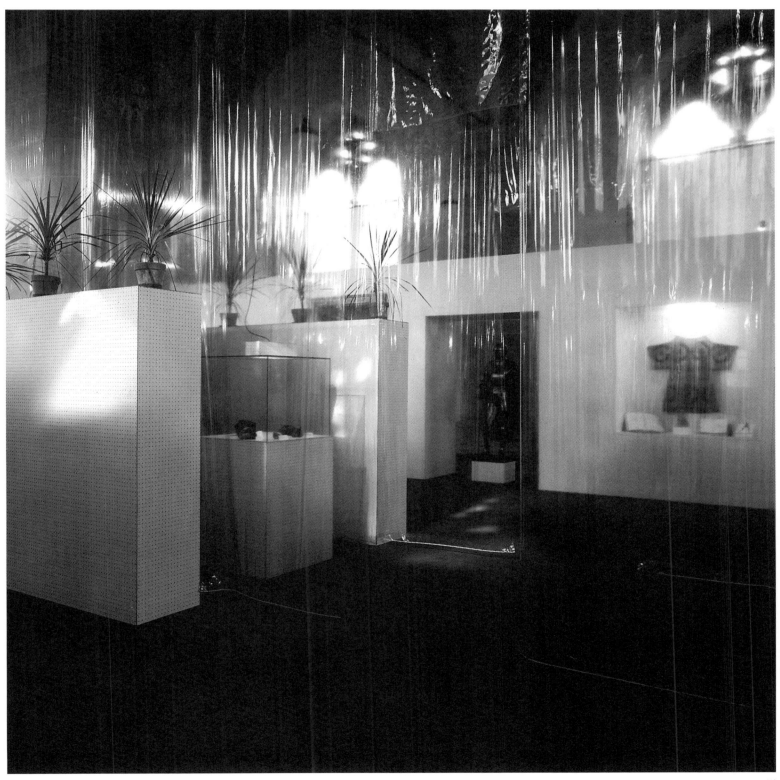

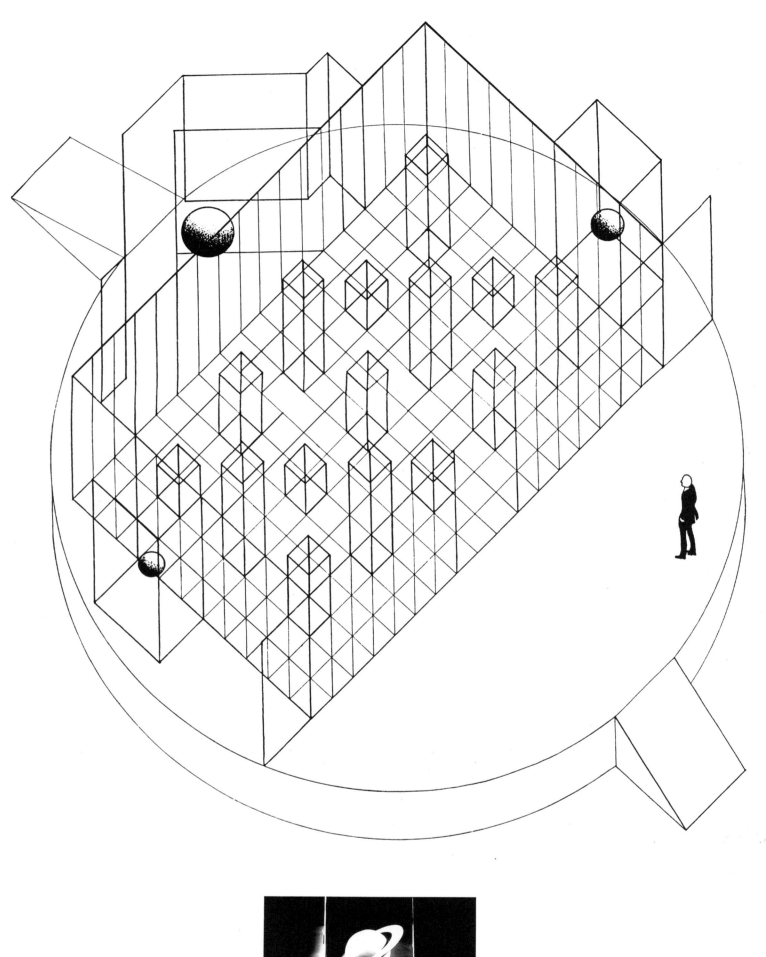

RAI (Radiotelevisione Italiana) Pavilion at the Electronics Show staged at EUR in Rome; the hall contains black prisms with television sets inside them. The setting was lined with mirrors, some of which concealed planets and moons whose reflections created the effect of an imaginary space (Archizoom Associati, 1969).

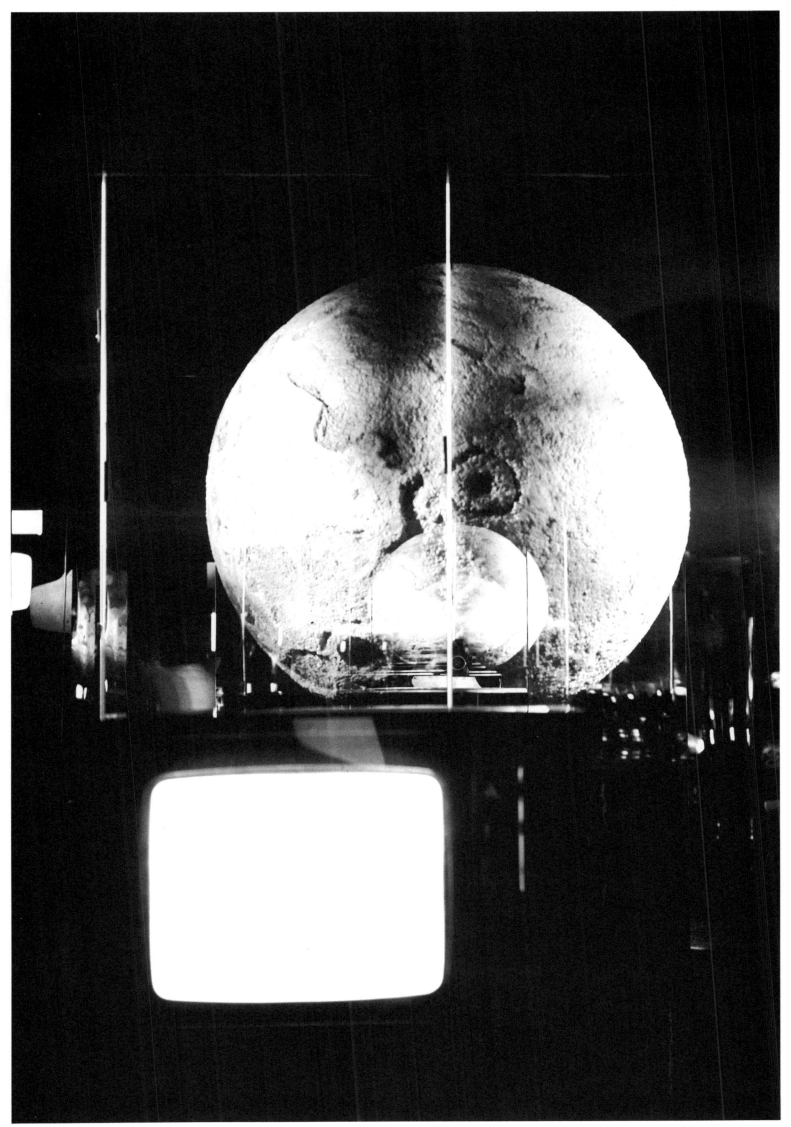

Project for the competition for the layout of the Crafts Exhibition at the Fortezza da Basso in Florence. A large homogeneous structure was inserted within the monumental walls of the fortress, completely filling its space (Archizoom Associati, 1968).

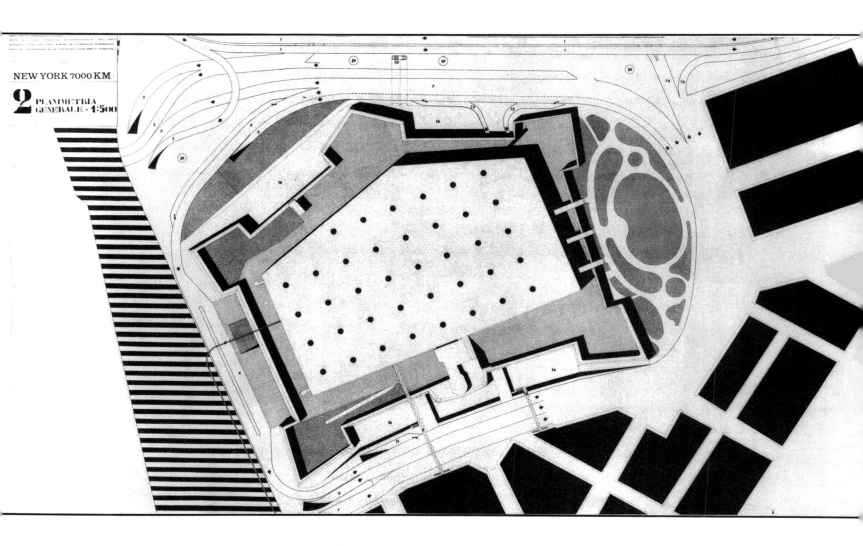

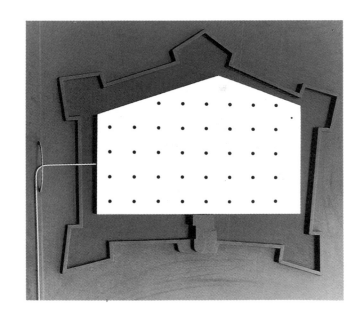

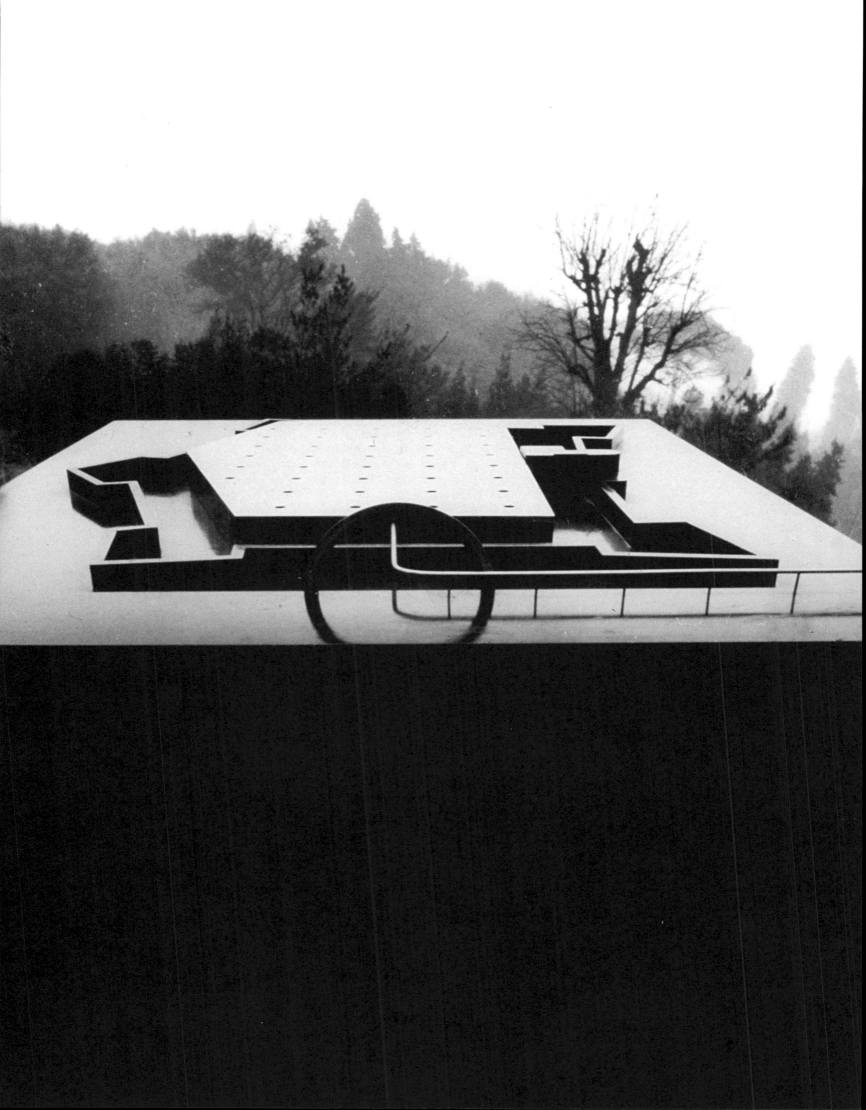

Nowadays there can be no hesitation in admitting that the urban phenomenon is the weakest point in the whole industrial system. The metropolis, once the traditional "birthplace of progress," is today, in fact, the most backward and confused sector of Capital in its actual state: and this is true to such an extent, that one is led to wonder if the modern city is nothing more than a problem which has not been solved, or if, in reality, it is not a historical phenomenon which has been objectively superseded. That is, we must determine whether Capital still confronts the task of managing its own organization and image on an urban level, as it did a hundred years ago, or whether the changes which have taken and are taking place have not altered its actual sphere of action, thus transforming the concept of the city. The problem, then, is no

THE FLUID METROPOLIS

longer that of creating a metropolis which is more humane and better organized, but rather that of understanding the objective laws which control the shaping of the urban-architectural phenomenon, demystifying the complex ideology which surrounds the discussion and conditions the form it takes. According to the naturalistic myth of free competition, it was the city, as a center for trade and commerce, that guaranteed ideal market conditions, making for a natural equilibrium between opposite interests, in the general background of the harmony reached between technology and nature. But now the use of electronic media takes the place of the direct urban praxis: artificial inducements to consumption allow a much deeper infiltration into the social structure than did the city's weak channels of information. The metropolis ceases to be a "place," to become a "condition:" in fact, it is just this condition which is made to circulate uniformly, through Consumer Products, in the social setting. The future dimension of the metropolis coincides with that of the market itself. The intensively concentrated metropolis corresponds to the now superseded phase of spontaneous accumulation of Capital. In a programmized society, the management of interests no longer needs to be organized on the spot where trade is to take place. The complete penetrability and accessibility of the territory does away with the terminus city and permits the organization of a progressive network of organisms of control over the area.

In the bourgeois ideology ecological balance and social justice become part of the same battle: the appearance of the city gives a formal verification of this equilibrium. In Town Planning, therefore, an attempt is made to achieve a not impossible harmony between the Public interest and the Private interest: these two categories, however, are always taken as antithetical, contrasting, and irreconcilable phenomena. The problem therefore becomes that of finding a two-dimensional net, to guarantee the fitting together of such components as are irreconcilable.

The traffic can be taken as the most general link of communication between the two, as it becomes the objective and figurative schema of the functioning of urban life. In fact roads do not merely serve the compact fabric of what is private, but they also dissect it and make it communicate, making place for the emergence of architectonic language. The skyline becomes a diagram of the natural accumulation which has taken place of Capital itself. So the bourgeois metropolis remains mainly a visual place, and its experience remains tied to that type of communication.

The carrying out of a social organization of labour by means of Planning eliminates the empty space in which Capital expanded during its growth period. In fact, no reality exists any longer outside the system itself: the whole visual relationship with reality loses importance as there ceases to be any distance between the subject and the phenomenon. The city no longer "represents" the system, but becomes the system itself, programed and isotropic, and within it the various functions are contained homogeneously, without contradictions. Production and Consumption possess one and the same ideology, which is that of Programming. Both hypothesize a social and physical reality completely continuous and undifferentiated. No other realities exist. The factory and the supermarket become the specimen models of the future city: optimal urban structures, potentially limitless, where human functions are arranged spontaneously in a free field, made uniform by a system of micro-acclimatization and optimal circulation of information. The "natural and spontaneous" balance of light and air is superseded: the house becomes a well-equipped parking lot. Inside it there exist no hierarchies nor spacial figurations of a conditioning nature.

Typology, as a functional figuration of society, undecided between the certain datum of a survey of a social structure and the almost certain datum of an assumption of the aspirations of that society, rests so entangled in the allegorical representation of such a conflict that it beco-

mes an extra functional cultural coefficient. In an attempt to supply the user with the highest degree of liberty within the most rigid possible "figuration," architecture comes to recognize its real destiny in the urban phenomenon, and its real nature in the private. Thus, in contradictory fashion, on each single occasion it will prefigure a general lay-out of things and at the same time set itself up to defend the partiality of the individual experience with respect to collective experiences. Thus it mediates between the contradicting forces of public and private: now, however this conflict is no longer left on the speculative level of existential consciousness. Economic Planning, by organizing the whole of society productively, eliminates the conflict, considers the contradiction fictitious and takes any strictly individual datum as experimental. Up till now, the mass of the general public has been excluded from the architectonic phenomenon: being temporary guests of the integrative "existenz-minimum" of a much more real day's work, people have used home only to eat and sleep in. Inside the house everything had been thought out by an architecture whose aim was to console: nothing was left but to hang a few pictures on the walls. The house was the first, most important step in the total adoption of the bourgeois way of life. But now people, being strengthened by the new and ever increasing capacity to decide for themselves which they have won at work, must take housing into their own hands, freeing it from all preconstituted cultural and social models, breaking the subtle intellectual links and hysterical linguistic knots which characterize architecture as the figuration of space. Freed from the armor of its own character, architecture must become an open structure, accessible to intellectual mass production as the only force symbolizing the collective landscape. Therefore, the problem becomes that of freeing mankind from architecture insomuch as it is a formal structure.

Nowadays the only possible utopia is quantitative. Social conflict is no longer going through the phase of the confrontation of alternative models, but is in that of dialectical negotiation between a balanced development of the system and the growing cost of the labor force. The clash no longer takes place in the field of ideology but in quantitative terms: it is via this parameter that the summing together is made possible of different phenomena which apparently have no link with one another. As general terms of reference disappear, behaviour becomes a structure free from moral allegories. Freedom, as an end, becomes an instrument of struggle.

(From *Domus* 496, March 1971)

Wind Town, photomontage (Archizoom Associati, 1969).

Theoretical photomontages investigating new architectural and urban signs by Archizoom Associati (1969).

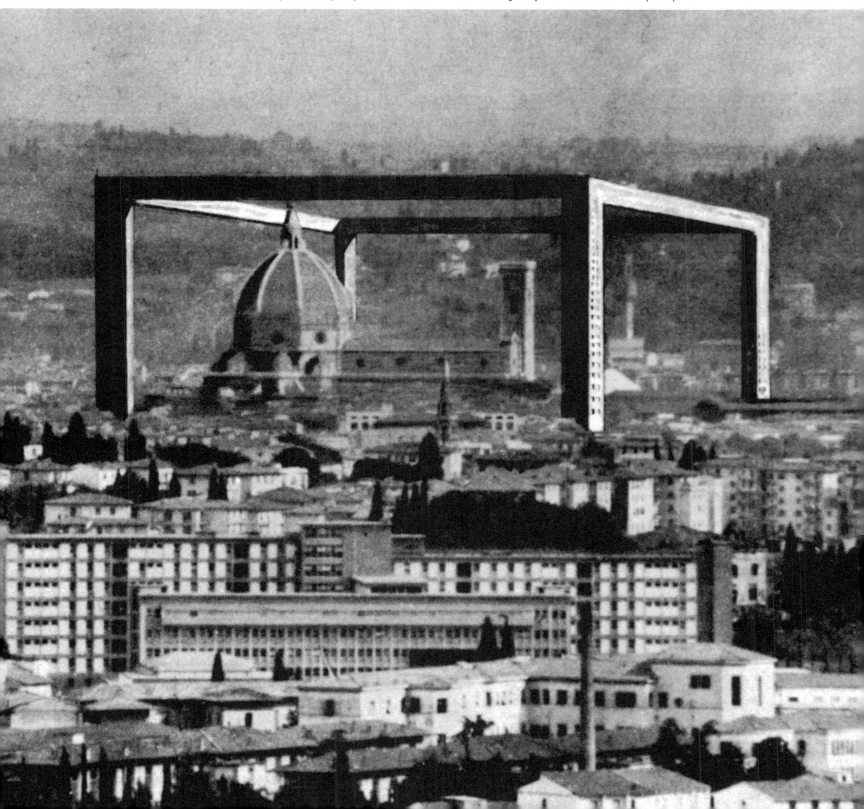

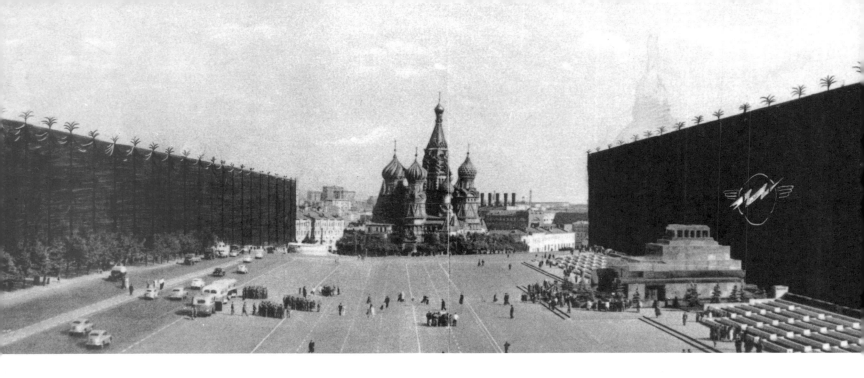

Top left: textile decoration in Red Square, Moscow. Bottom left: parallel districts in Berlin. Top right: housing unit in Red Square. Bottom right: roof garden.

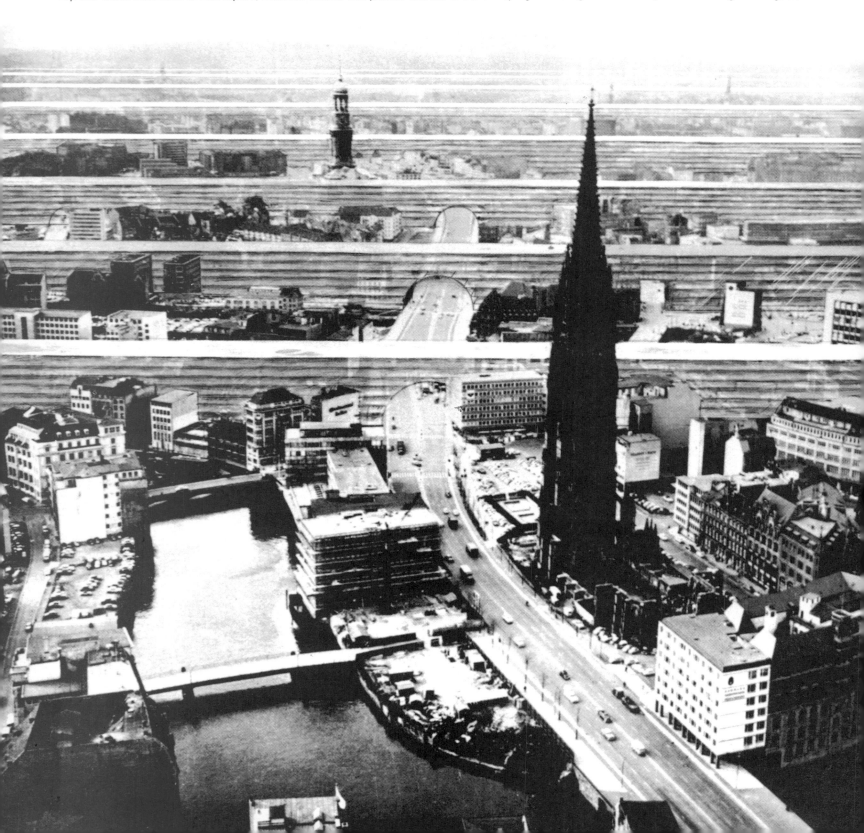

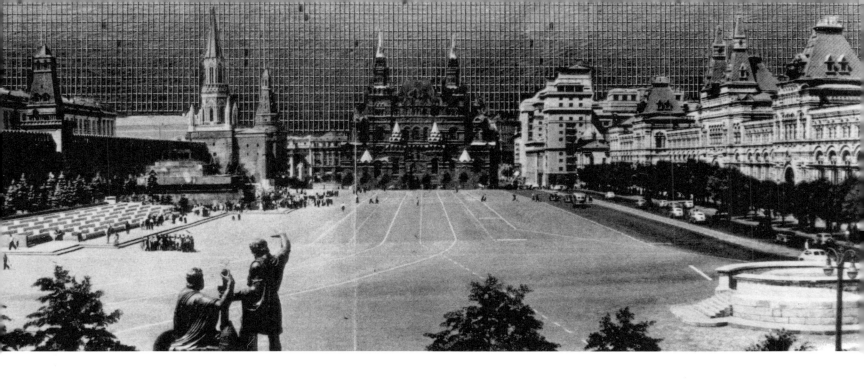

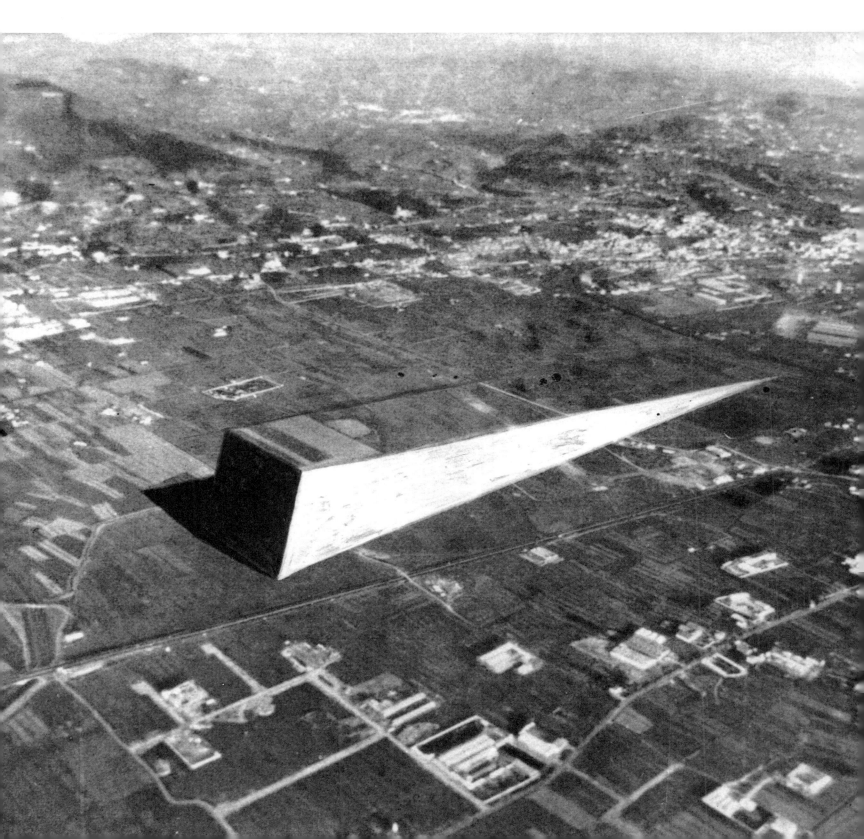

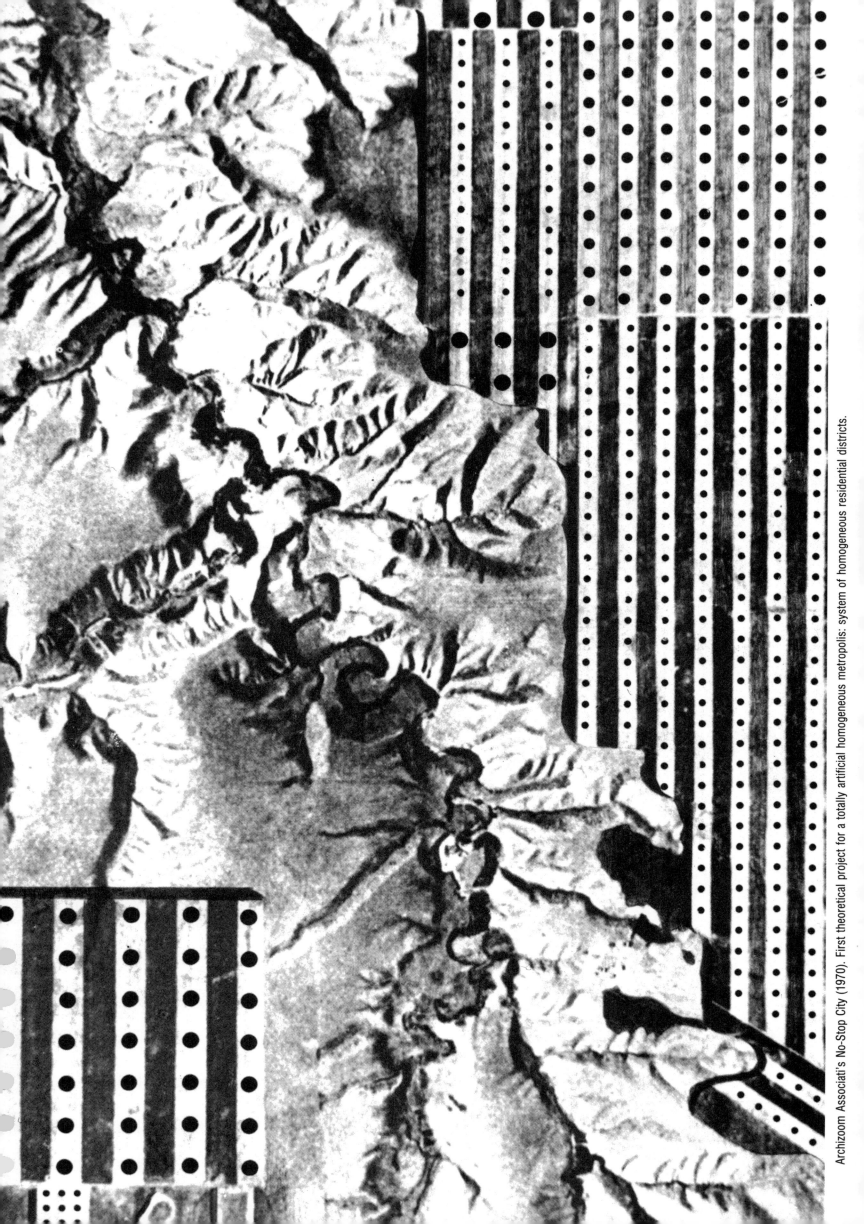

Archizoom Associati's No-Stop City (1970). First theoretical project for a totally artificial homogeneous metropolis: system of homogeneous residential districts.

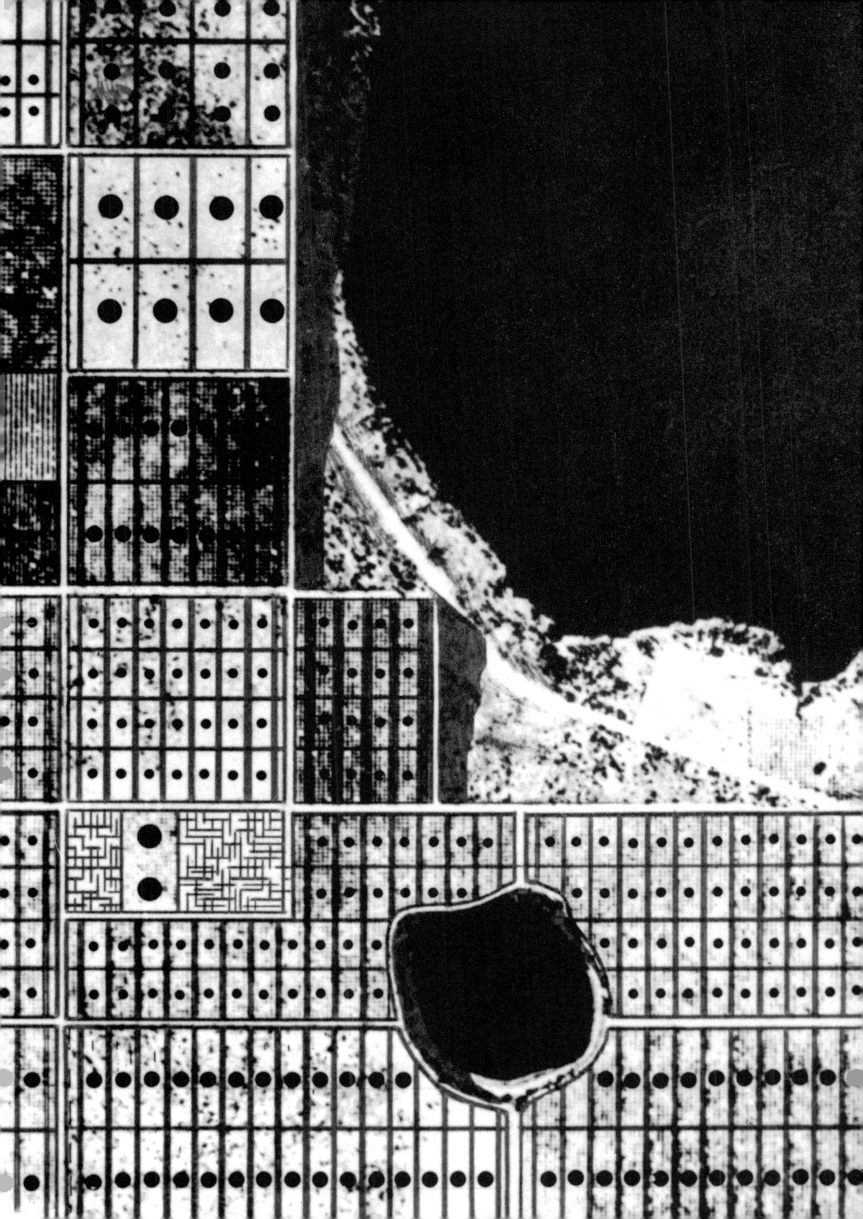

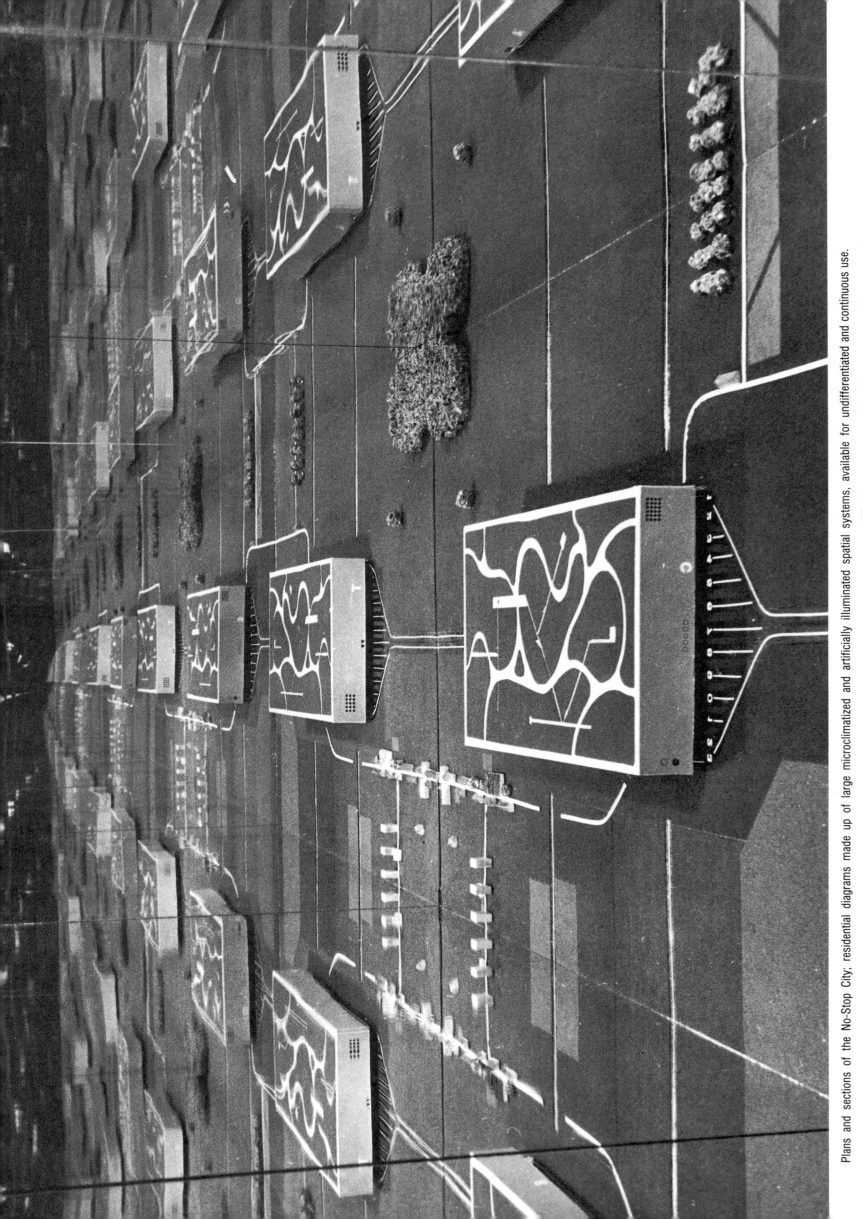

Plans and sections of the No-Stop City; residential diagrams made up of large microclimatized and artificially illuminated spatial systems, available for undifferentiated and continuous use.

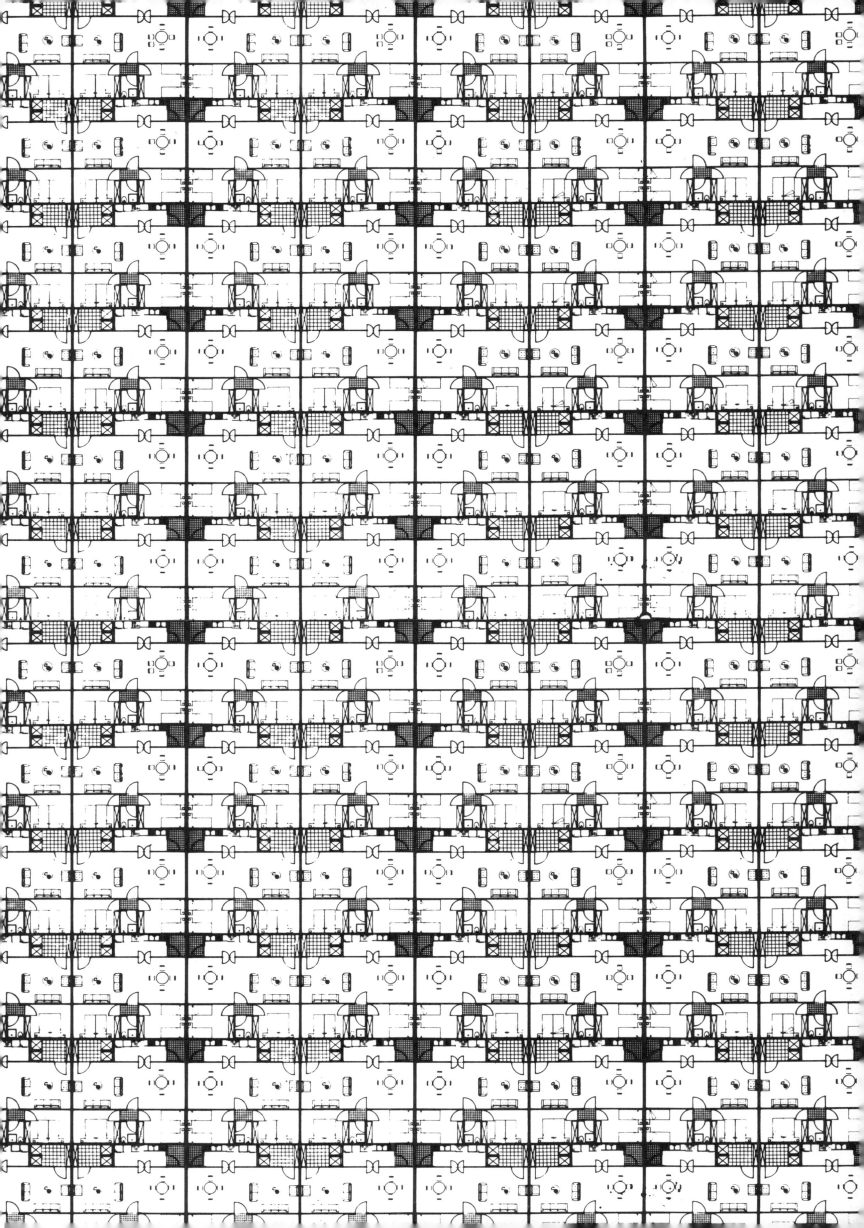

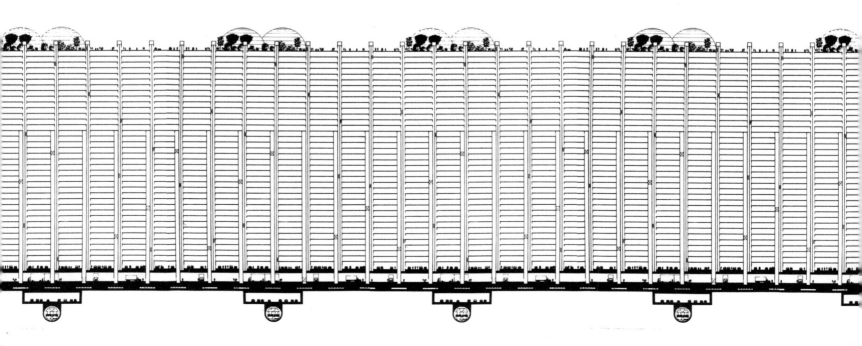

No-stop City: continuous section, showing the vertical and horizontal system of distribution (Archizoom Associati, 1970).

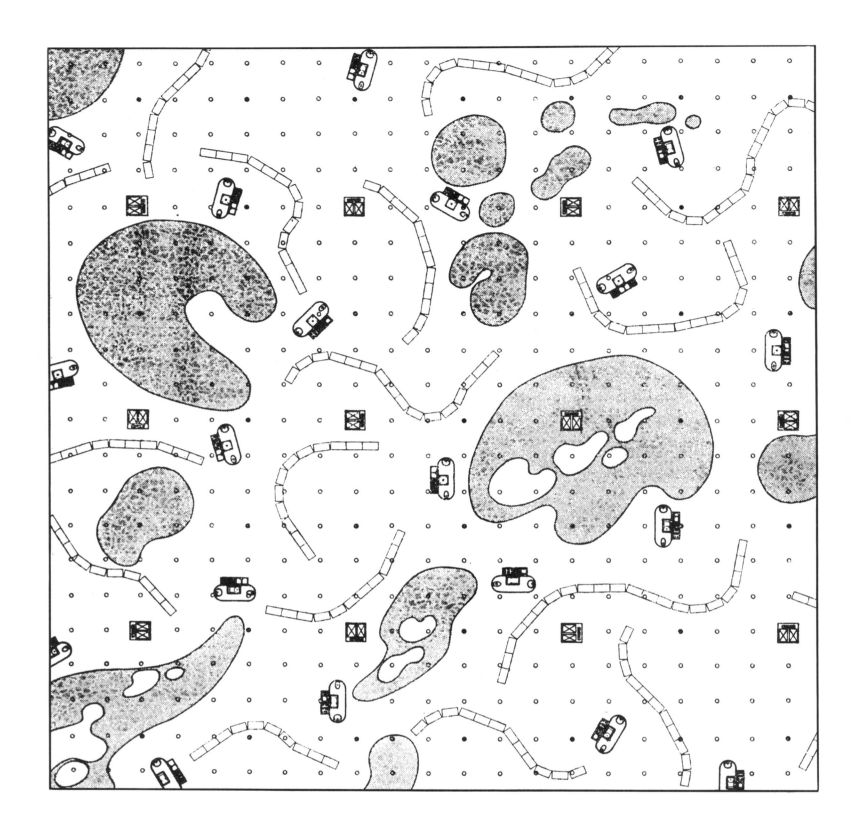

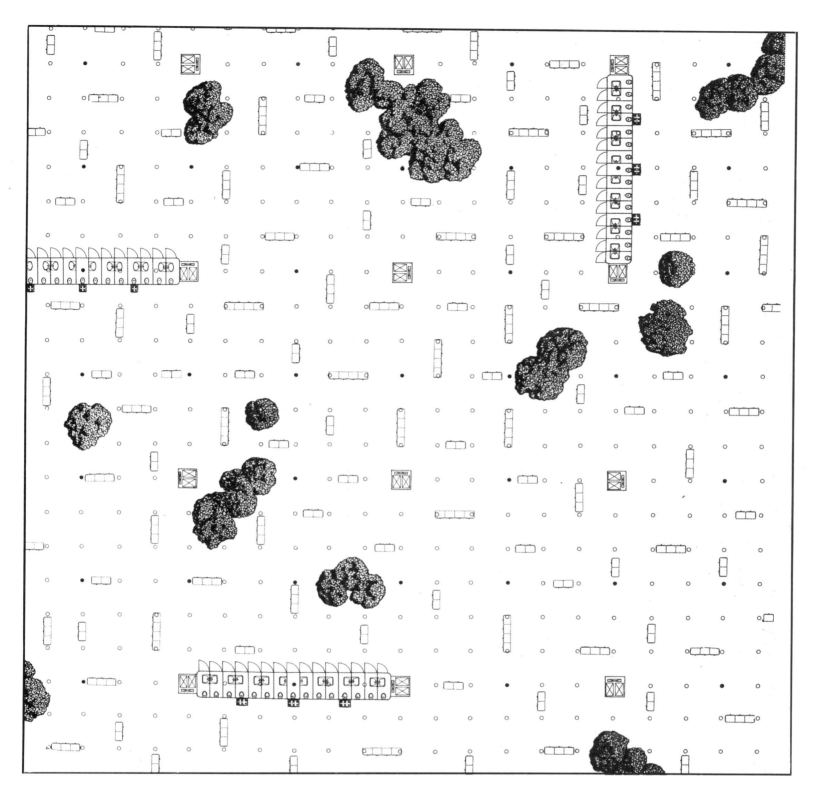

No-Stop City: residential districts (Archizoom Associati, 1970).

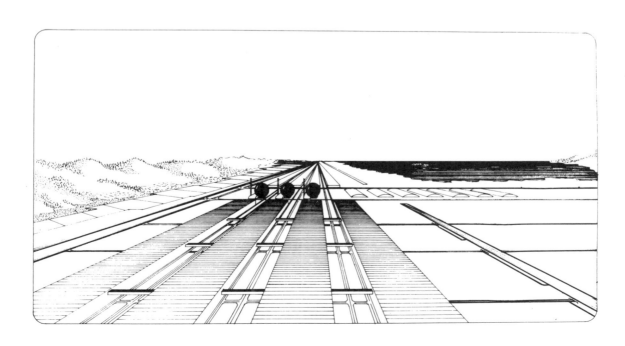

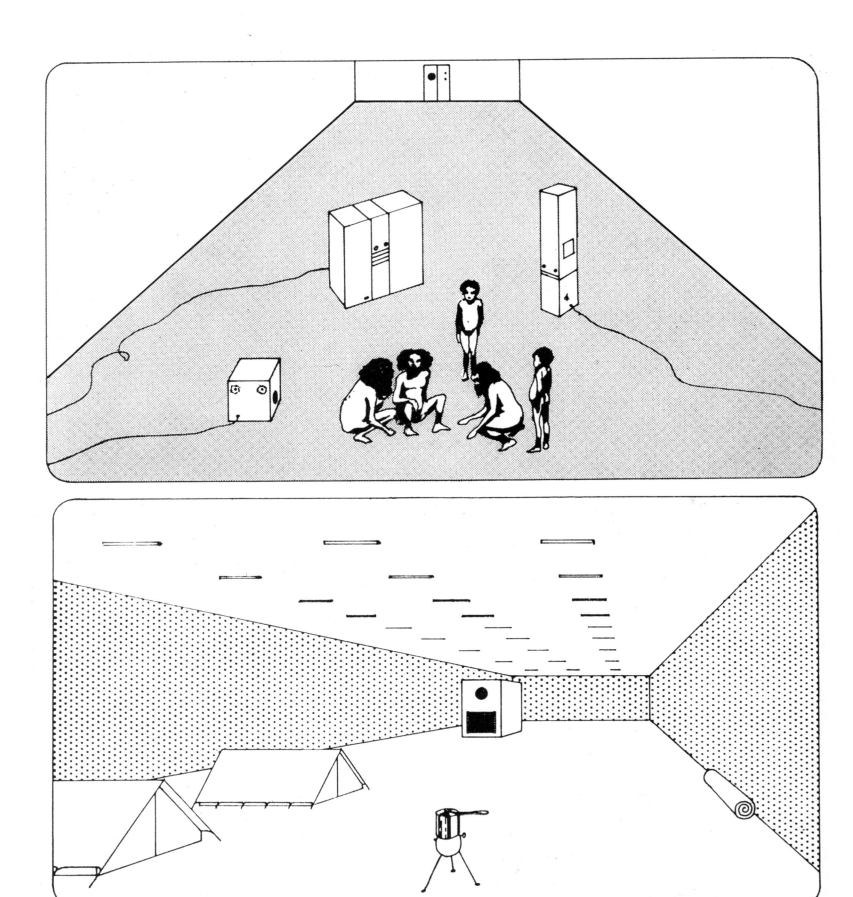

"Residential Parking" lot; dwellings as free and equipped spaces, in which to reconstruct a spontaneous use for the house (Archizoom Associati, 1970).

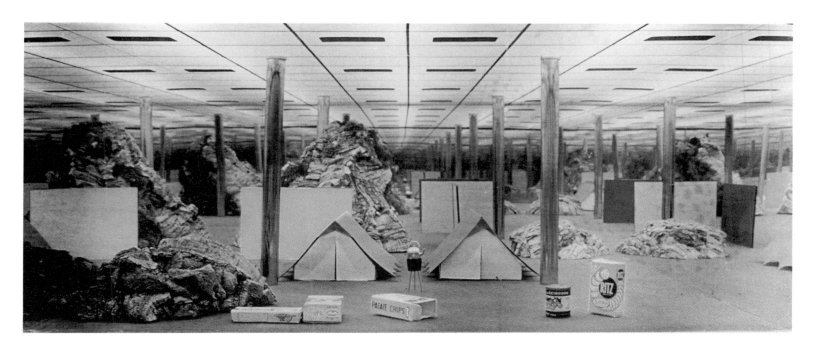

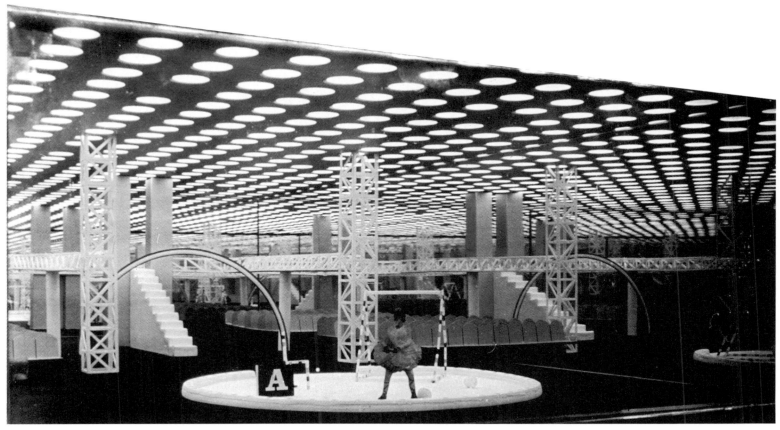

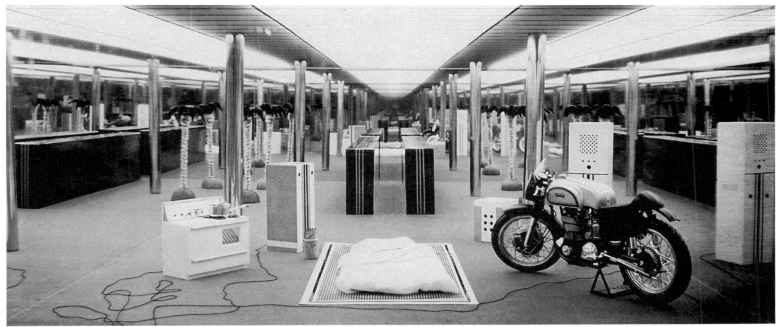

No-Stop City: internal landscapes, made up of large, continuous spaces. Artificial landscapes in which to live freely as if in a microclimatized wood (Archizoom Associati, 1970).

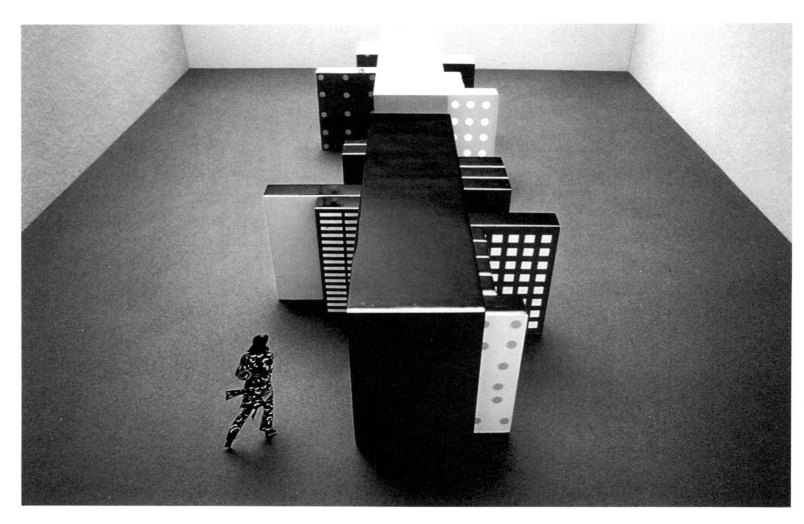

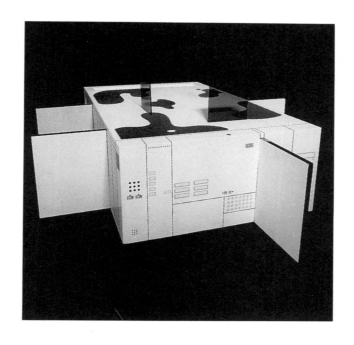

Habitable closets for the exhibition (never staged) "The Neutral Surface," sponsored by Abet Print (Archizoom Associati, 1972). These are theoretical projects for highly artificial domestic spaces, in which the different functions are contained in large automatic dispensers, set in empty spaces.

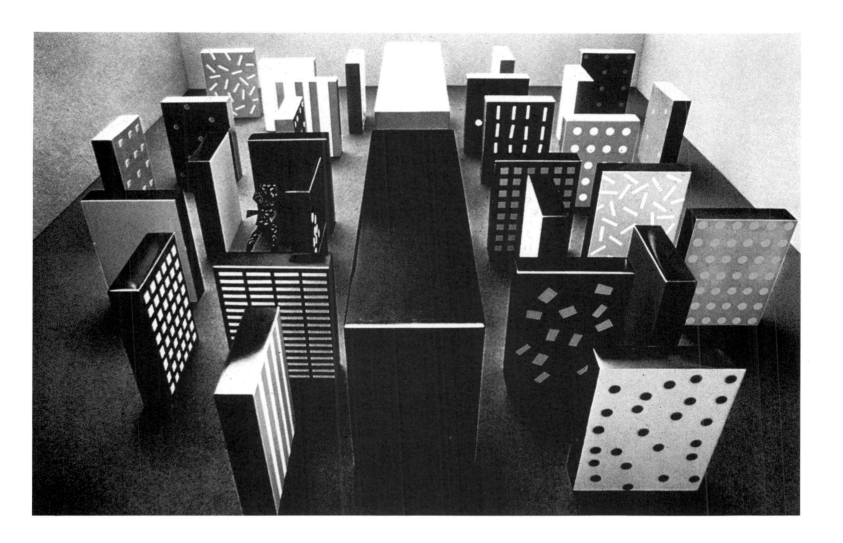

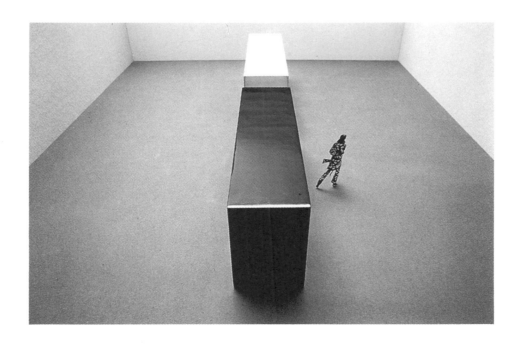

Following the channel cleared by the pop acceptance of phenomena from mass culture, and ready to explore new frontiers of design opened up by the so-called death of architecture, Archizoom Associati initiated projects in "dress design." Tackling the design of clothing meant moving outside the limits of the discipline and beginning to concern ourselves with mass communications and new forms of consumption. By that time, fashion had ceased to be a model of dress proposed by a few opinion makers and supinely accepted by the masses; it had become a free circulation of symbols and citations that seemed to arise spontaneously from an increasingly broad spectrum of society. The uniqueness of fashion and its rigid seasonal patterns had been replaced by the simultaneous presence of more than one

DRESS DESIGN

fashion. Potentially, there were as many fashions as there were people who wished to create their own self-image. The myth of being in fashion seemed to collapse: everyone could be; the place of the old *maison de haute couture* was taken by the "diffuse design" of a new manner of dressing.

We saw the new definition of the metropolis as arising out of the consumer market and not the traditionally accepted areas of town-planning. Dress design signified a branch of urban design where it was possible to experiment with the new dimension of a collective culture as a specific requirement of the project. Our entry into the world of fashion was partly the result of an attempt to find a new intermediary between the necessities of production and the stimulation of consumption, or between industrial design and peculiarities of taste. It was not a question of looking for clues or predictions of taste, and still less of translating current fashion into design, but rather one of adapting to a different cultural pattern that affected the organization of production as well as design. We were not interested in definitions of fashion based on surplus (economy, sociology, politics, history) or on scarcity (psychology, marketing, caprice); we also avoided interpreting the phenomenon in a merely eulogistic way, as a linguistic sector that in some mysterious, mediumistic fashion anticipates the marks of history and culture; or alternatively as a sector that records the same events with a delay of ten years. Instead we looked on fashion as material culture, a creative field with its own independent foundation and endowed with its own strong artistic intuition; at the same time we saw it as a theoretical model for a new kind of production, given the name post-industrial by theoreticians in that the all-embracing logic of mass production, which represses changes in taste as an unpredictable and irrational variable, was giving way to a search for flexibility. It was no longer society that must resemble the factory in every way, but the factory that

had to try to adapt to society.

From this axiom, which we call fashion but which signifies a different pattern of development and role for industry, design can derive a different strategy of research, aimed not so much at an optimal solution for the problems of production, but at a symbolic attachment between man and his household articles.

This was not an experiment without precedent: exchanges between the two cultures have formed part of the history of the Modern Movement. In his 1911 essay "Architektur," Adolf Loos wrote: "Many will have been perplexed... as to the parallel that I draw between architecture and tailoring." The radical change that he introduced into the very concept of design, as Benedetto Gravagnuolo has pointed out in his book on Loos, was based on considerations that did not belong to the realm of building, but to that of inhabiting.

In general, architects who have shown an interest in the design of articles of clothing have used methods already proven in the field of classical design: they have designed "objects" that have a rigid shape of their own; by wearing them, the individual subjugates his own "shape" to that of the clothing, i.e. to a geometrical and rational form. Our experiment took a different path: we were not operating as stylists looking for a new line or the clothing of the future, or any kind of "different" dress; instead we were investigating a different way of using clothing.

The system of dress that we exhibited at Moda-Mare-Capri in 1973 was an open structure made up of two basic articles of clothing: a scanty costume, elastic and coloured, that could substitute for underwear while remaining a complete article of clothing in itself, the minimum basis of urban dress, and a coloured and very loose overall to be worn over the costume cum underwear or over other clothes.

The problem of planning industrial production in a market as "spontaneous" as that of fashion was a new and fascinating one. Production, with its myths of infinite

 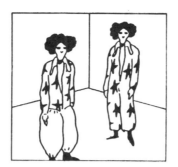

runs and uniformity of the consumer market, had to deal with a highly advanced culture of consumption, where each consumer tended to be different from the others and to re-invent the product through an original mechanism of combination and assembly. Design was obliged to concentrate not on the production of fashionable clothing, but on basic clothes out of which fashion could be created, in an artisan process controlled by the consumer himself. The goal, then, was a product that would stimulate but not exhaust the creativity of its user.

A good example of a modern industrial process of this kind is furnished by the functional and cultural use to which blue jeans have been put over the last thirty years. Born as a functional article designed for large-scale industrial production and devoid of any really expressive features, but practical and robust, blue jeans became the "neutral base" out of which developed the most advanced fashions of the post-war years. Existentialists, Teddy boys, Rockers, Beatniks and Hippies, and the youth movements of the sixties in general, each used blue jeans in a different way, that is to say in the context of different and often contrasting modes of behavior and cultural patterns.

The clothing industry, forced to follow in the wake of these giddy changes of style, was obliged to reproduce by machine what had been thought up according to an exclusively decorative logic. Not possessing a design culture of its own, i.e. not basing its product on the best utilization of machines and materials, the clothing industry behaved like a gigantic tailor's workshop, reproducing a hand-crafted product on an industrial scale. In the film *How Gogol's Overcoat Is Made*, exhibited at the 15th Milan Triennale (1973), the production situation in the clothing industry was analyzed, showing among other things how at the end of the assembly line of a major manufacturer there was a mock client who tried on the clothes.

Hence the whole cycle of the tailor's workshop was reproduced in a large factory, still concluding in a client who actually put the product on. Anthropomorphism, waste, regression to the artisan level: this is what happens when the logic of production and the logic of consumption come into conflict.

(From *The Hot House*, Milan, London and Boston, 1984)

Dress design "Nearest Habitat System." Consisting of colored body stocking and overalls, it can also be worn on top of or underneath traditional clothing (Lucia Bartolini for Archizoom Associati, 1971).

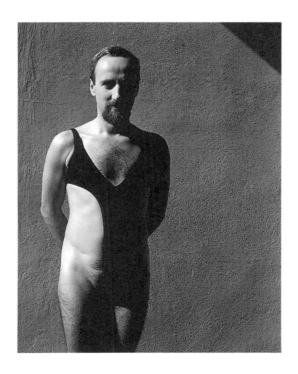

From the film Dressing is Easy, produced by Abet Print (made by Politecne Cinematografica) and presented at the 15th Milan Triennale. Do-it-yourself system of clothing made by using only square cuts of fabric, with no wastage, and sewn with only straight seams (Lucia Bartolini for Archizoom Associati, 1972).

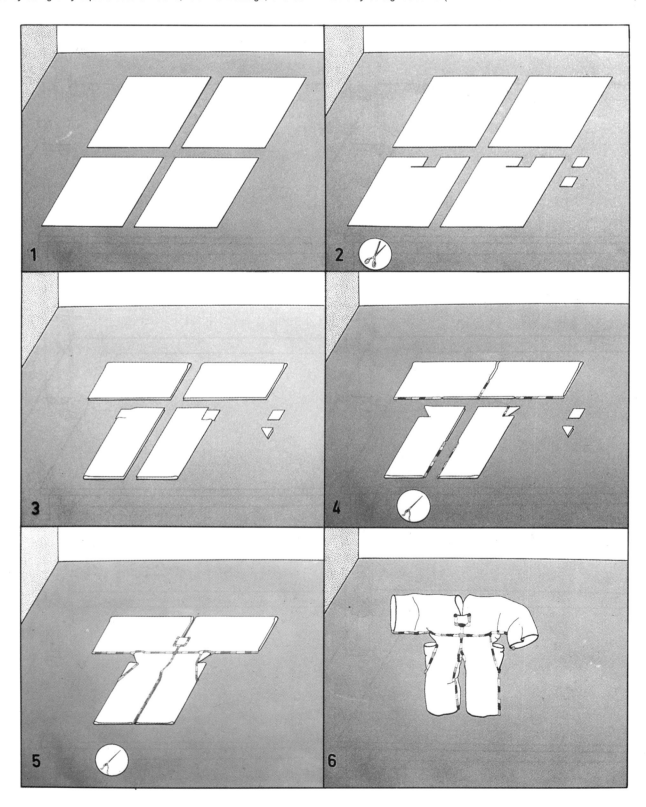

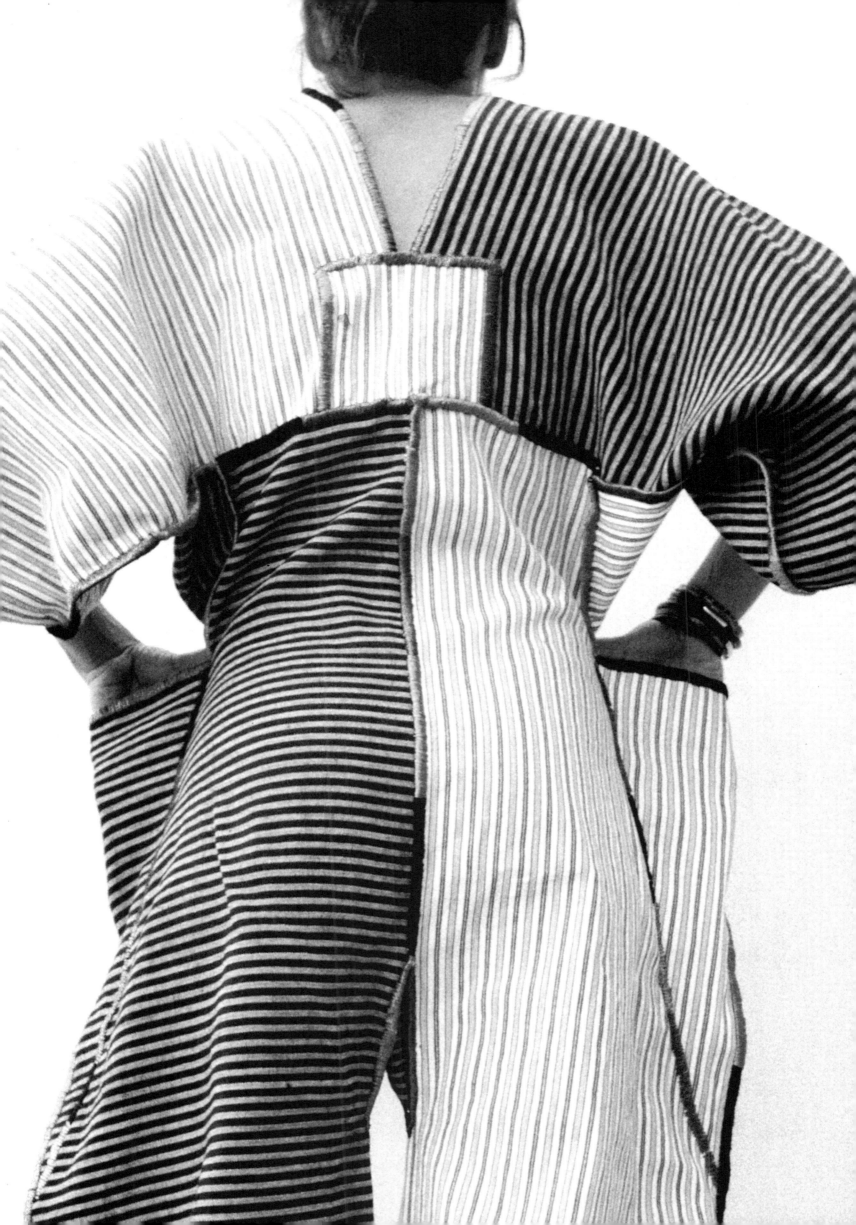

Above: "Nearest Habitat System" photographed in Studio Archizoom. Right: Donna Jordan photographed by Oliviero Toscani for *UOMO VOGUE*.

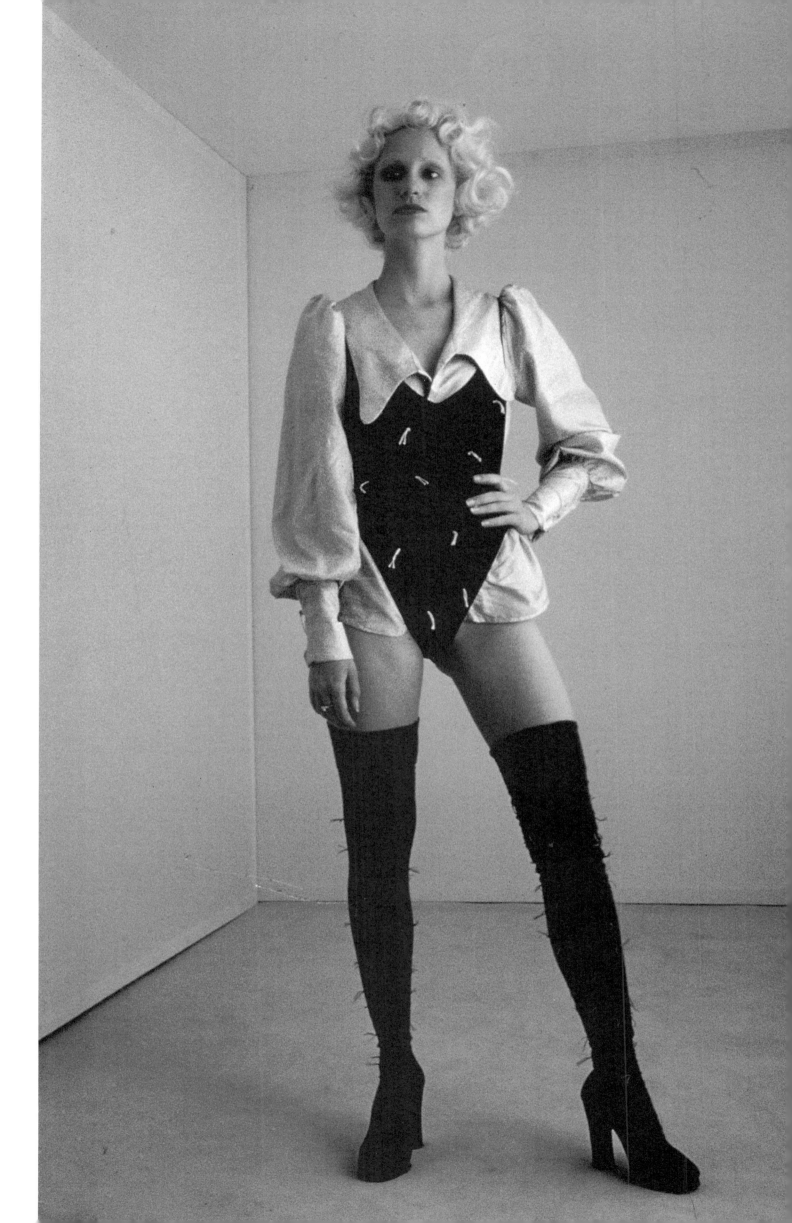

I shall not make an objective analysis of the programs and strategy of the present avant-garde, but verify it on the premise of a thesis. Any historical material serves only to illustrate a present hypothesis. For we inherit nothing from the past.

The premise I shall demonstrate is this: the precise role of today's avant-garde is the "technical destruction of culture." By culture are meant all the values and meanings, moral, religious and aesthetic, of the society in which we find ourselves. By destruction is meant the removal without substitution of new values or meanings.

Historically, every time such an attempt has been made, bourgeois culture has brilliantly regained its ground; the destruction of culture has become still another culture, the

MASS CREATIVITY

destruction of language still another language. Yet the dimensional conditions of this operation have changed today. And in favor of the negative sign. Above all, the "social destruction" of culture has increased.

There is, in fact, a destruction worked by Capital which reaches the point of structuring a process of total substitution of "values" by means of "other values."

There is another kind of social destruction of culture which occurs not through the opposition of alternative patterns (not in a dialectic manner, that is), but in a mechanical way. This destruction is generated by the economic growth of the proletariat. The working class, in fact, does not produce an alternative culture, but uses the patterns produced by the bourgeois class as strategic steps in its own economic escalation. It uses these patterns and at the same time destroys them, precisely because in order to reach them, it destroys the economic equilibrium on which they are based.

The destruction of all cultural and moral structures is an operation of release which has as its goal the removal of the diaphragms which prevent a direct knowledge of reality. In this sense, the operation of the avant-garde is "indirectly" political, modifying the revolutionary availability of the individual and the group.

The (scientific?) direction of the avant-garde is to reduce reality to simply "quantitative parameters." To destroy culture as an organizable sector of the production of values does not mean we visualize man as all cold logic (which would be proposing a pattern), but that on the contrary we refuse any formal verification of his actions. In order to do this we must modify the "social use" of culture itself.

The total recovery of all of one's own creative faculties, considered a natural right and not a message in code – that is the "new" social use of culture.

Culture as producer of patterns of behavior is a moment of the productive organization of society.

"To reject culture is to reject work." This rejection is no longer the secret dream of some derelict or the prophetic doctrine of scattered groups: it will be the biggest collective discovery of this century.

Any culture is "repressive" because the social distinction on which it stands, the functional separation between producers and consumers of culture, is repressive.

If all men are equal, and they are, the distinction between user and artist is false, favored by the present division of labor.

All children are artists; only one adult out of a thousand is.

Capital is, in fact, answering the rejection of labor with the "automation" of its productive cycles.

Freeing itself of human labor (and strikes), it is programing a society transformed into pure "Consumer Force." And Capital considers consumption a creative activity because it produces values and patterns. The freedom which results is, however, a patterned one of which the development mechanism and dimensional perimeter are already known.

Dead Work, then, does not introduce an era beyond history in which all the bets have been placed; quite the contrary, "how society will operate" this automation remains the problem to be solved.

The individual artist's message for society, strong with a sense of his "differentness" will cede its place to the "Intellectual Production of the Masses."

We must arrive at this historical appointment with all the structures and technologies that render culture a product of specialists, unusable for the masses, already undermined and destroyed.

Today, creating music, poetry, painting, sculpture, dance, engaging in any other physical activity requires a technical knowledge of the particular subject matter. The avant-garde destroys these techniques, prefacing any operation it undertakes with this single program: "Art is easy."

The avant-garde of architecture aims to reduce all processes of design to zero, re-

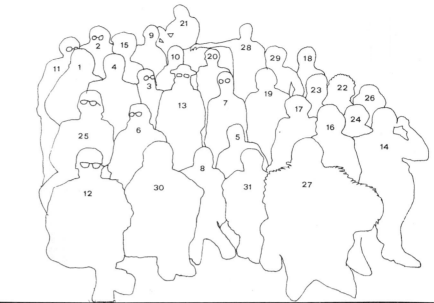

fusing the role of disciplinary sector engaged in prefiguring with environmental structures a future already selected by others.

The avant-garde of architecture refuses to hypothesize on the "form of the city of the future." It establishes a scientific rapport with the city, in the sense that it eliminates any concept of quality, typical of architecture, from urban debate, reducing the phenomenon to simply "quantitative parameters."

The greatest inventions of Modern Architecture have been "quantitative inventions:" the Skyscraper and the Housing Unit. Both have destroyed the equilibrium of the bourgeois city.

The Skyscraper effects a brutal accumulation upon a traditional city plan; the relation between plan and rise is completely destroyed.

The Housing Unit, instead, is different: it takes a city with all its traditional components and collocates them on a vertical plane. The results are shocking. The difference between the single building and the city disappears.

There are no longer different architectonic forms corresponding to the different functions of the city: stores, theaters, schools, etc. no longer have a "shape" of their own. They have become homogeneous parts of a single plane of services that cannot be distinguished from those of the dwellings. The city and nature no longer fit in together on a single bidimensional plane of experience. Nature no longer designs the city and the city no longer outlines nature. The "pilotis" allow the two phenomena to flow separately. The city no longer lies upon the land, nor does it identify its history with it, but rather it is placed freely upon it like a great manufacture possessing a clearly artificial logic all its own.

(From "La Gioconda Sbarbata," *Casabella* 363, 1972)

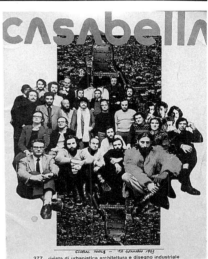

The group who met in the editorial offices of Casabella on 12 January 1973 in order to found GLOBAL TOOLS (photo: Carlo Bachi, design: Adolfo Natalini)

1. Andrea Branzi - 2. Gilberto Corretti - 3. Paolo Deganello - 4. Massimo Morozzi - 5. Dario Bartolini, Lucia Bartolini - 6. Remo Buti - 7. Alessandro Mendini - 8. Carlo Guenzi - 9. Enrico Bona - 10. Franco Raggi - 11. Luciano Boschini - 12. Riccardo Dalisi - 13. Ugo La Pietra - 14. Giorgio Birelli - 15. Carlo Caldini - 16. Fabrizio Fiumi - 17. Paolo Galli, Gaetano Pesce - 19. Gianni Pettena - 20. Adalberto Dal Lago - 21. Ettore Sottsass - 22. Piero Frassinelli - 23. Alessandro Magris - 24. Roberto Magris - 25. Adolfo Natalini - 26. Cristiano Toraldo di Francia - 27. Carlo Bachi - 28. Lapo Binazzi (Patrizia Cammeo, Riccardo Forese) - 29. Titti Maschietto - 30. Alberto Breschi (Giuliano Fiorenzuoli) - 31. Roberto Pecchioli (Nanni Carciaghe, Gigi Gavini).

Left: "Global Tools" cooperative, 1973. General seminar staged by Global Tools at Sambuca in Chianti. Above: image from the Whole Earth/Hearth Catalogue, 1967.

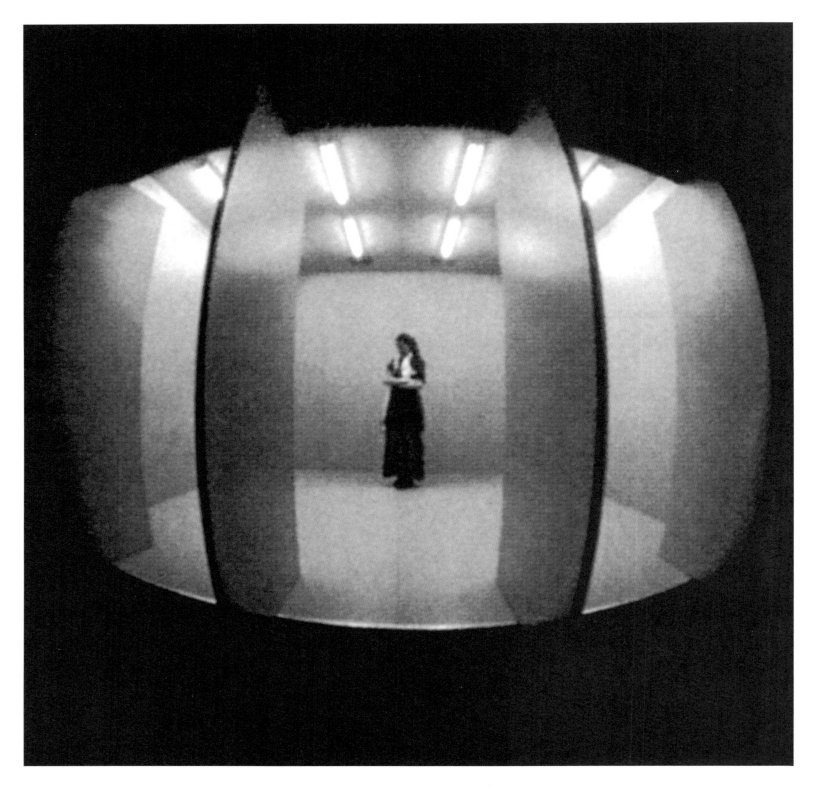

"Empty Gray Room," at the exhibition "Italy, the New Domestic Landscape," organized by Emilio Ambasz at the Museum of Modern Art in New York (Archizoom Associati, 1972).

The voice of the little girl (sound track by Giuseppe Chiari) recounts:

"In this gray setting, we have not placed a single object. Just a quiet voice that speaks, and that describes a setting.
"We have decided not to create a single image, our own, preferring to create as many as there are people who,
listening to this account, will imagine, in a way that is beyond our control, this setting inside themselves.
"Not just one utopia, then, but as many as there are listeners.
"Not a single culture, but one culture each.
"Living somewhere is easy."
(Press release by Archizoom Associati for the exhibition "Italy, the New Domestic Landscape.")

...look, I am really convinced that it will be something truly out of the ordinary. Very large, very clear, and very regular, without any holes, you see.

There will be good lighting, very bright, that will illuminate all those objects scattered untidily over the floor. And the great thing is, it will all be very simple, with no mysteries or eccentricities of expression, you see....

Beautiful! Really very beautiful, very beautiful and very big! Truly extraordinary.

It will be nice and cool in there and very quiet....

My God, how can I describe the splendor of the colors to you!?

Look, it is even difficult to define many of the objects, partly because they will be used in such a new way; and then there will be glass, wood, linoleum, water, plants, vases, and a lot of those used boxes, of wood or plastic, all empty....

The really extraordinary thing is that many of these things will be made by hand, especially the biggest ones.... Others, instead, will be molded of course.

The bathrooms/household articles will be truly perfect, and a very beautiful color, neutral I would say.... The rest is clear, and there will be a large swing with seats for two people.... You see;

there will be so many fine things, and yet it will seem empty; so big and so beautiful... one will feel great in there... all day without doing a thing, without having to work or anything like that...

you understand, very good...

look, I am really convinced that it will be something truly out of the ordinary. Very large, very clear, and very regular, without any holes, you see... (all over again).

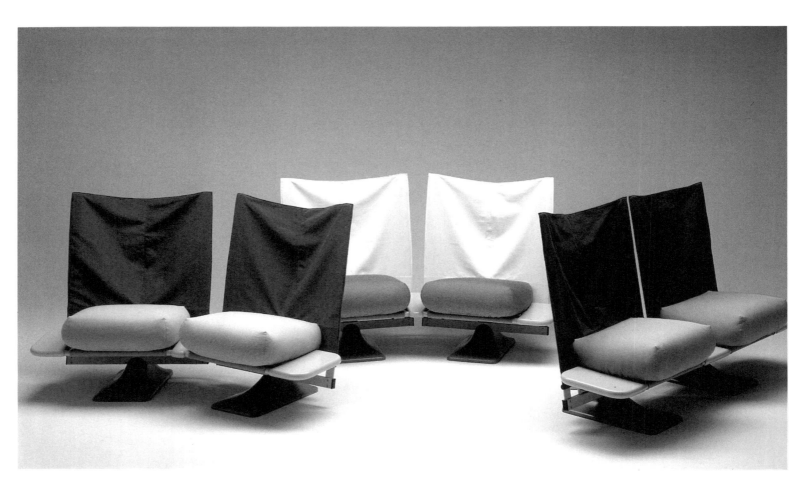

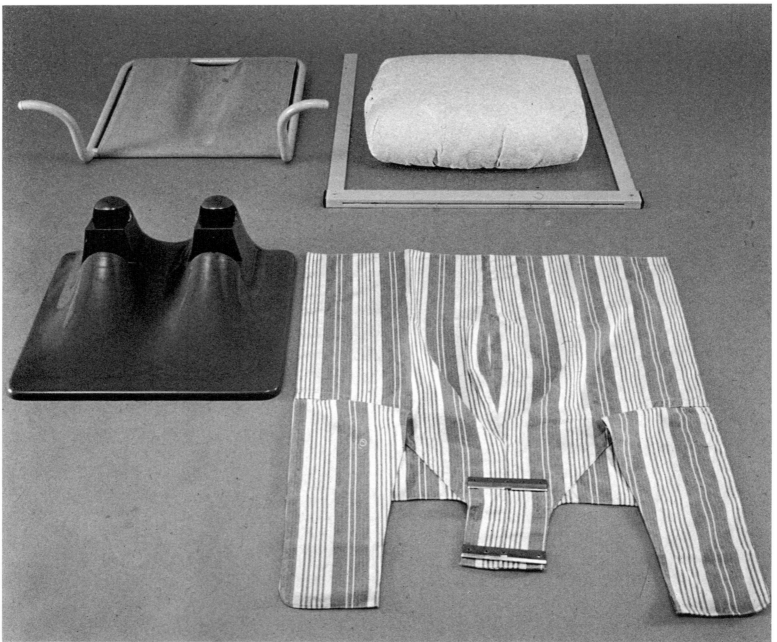

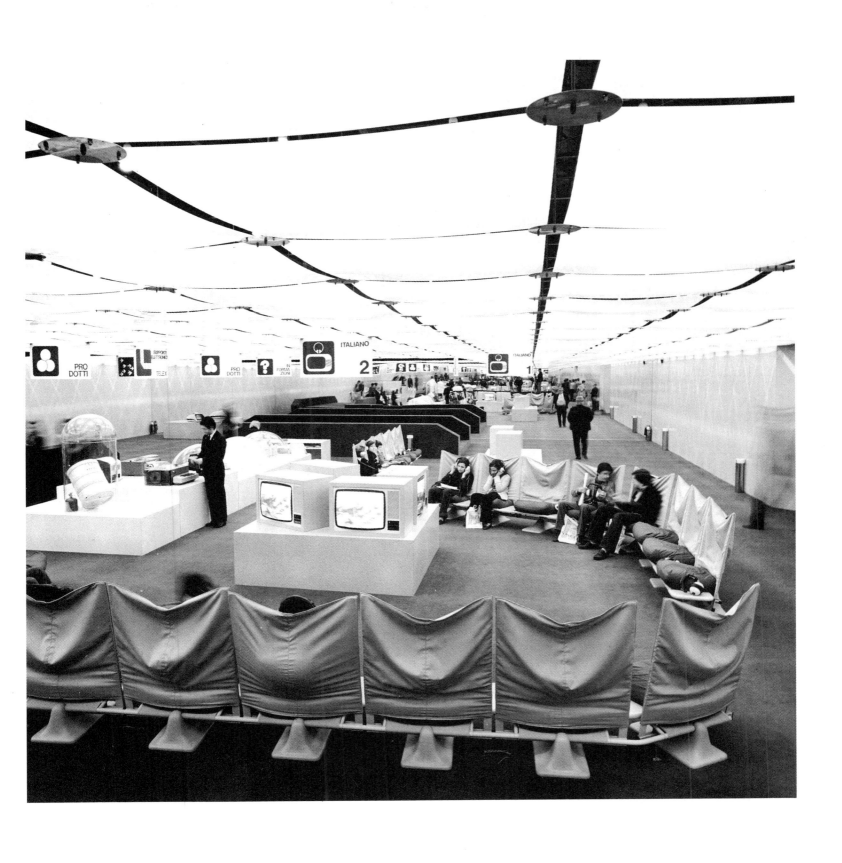

Left: "AEO" chair, manufactured by Cassina (Paolo Deganello for Archizoom Associati, 1975).
Above: Montedison pavilion. The AEO is a chair of experimental construction, in which each part is made of a different material.

The research undertaken by the whole of the Modern Movement was aimed at a "methodology of design," that is at the identification of an optimal model of organization for the new problems that the industrial world, and humanity and its cities, were dumping on the architect's table.

There was a general certainty that the cultural parameters of an object or an environment still consisted of "hard" structures, in other words of formal and structural qualities.

The relationship that was established between user and environment was still of a "visual" nature: there was no suggestion of the existence of deeper structures, which might have an influence on the quality of use of both product and space.

These deep structures are made up of such parameters as light, climate control, dominant colors, acoustic conditions,

PRIMARY DESIGN

and information systems. Structures that we shall define as "soft." Primary design works on these structures by developing new instruments of control.

The textile is involved in this new dimension of design as one of the products best suited to the enhancement of these new factors. As a support for background colors, as a means of decorative communication, and as one of the basic elements of acoustic regulation.

The development of the chemical industry, of plastics and paints, has meant that the majority of the objects that surround us and that we use possess a color that has been designed for them, in other words an artificial one.

Today, in fact, color serves as a general mediation between us and the world of objects; the first thing that we perceive of an object, even before its shape, is its color. The environment in which we live, whether house or city, is made up of a set of chromatic structures, whose perception actually constitutes a specific sphere of use of the environment itself.

The quality of the color and its level of definition, its coordination, and its expressive value are, today, instruments that make it possible to exert an influence on the quality of life itself.

Every nation and, in general, every ethnic or religious group, possesses a chromatic culture of its own: this culture consists in the attribution of symbolic meanings or functional significance to particular families of colors, and therefore in the persistence of particular colors over time.

Nowadays such cultures, which could be described as minorities, are subjected to powerful pressures from industrial development, urbanization, and modern systems of communication.

There is in fact an "international color policy" that is working toward the codification and rational reduction of the endless range of variants in order to come up with universal codes of communication.

The fact is that the development of modern publishing, graphics, systems of signs, and mass production makes it necessary to be able to convey a color with absolute precision, to repeat it over the course of time, and to identify it within the limits of particular tolerances.

For this purpose codes have been created, that is to say systems for the identification of colors comprising the most complete possible classifications of tints, tones, and saturations. The most widely used of such manuals are the Munsell code (2000 colors) and the Pantone code (500 colors). Many industries extract their own range of colors from these systems of identification and use them as private codes of reference for production and institutional communication.

There are also channels that supply information on market trends in color. These services are provided by groups of experts or specialized institutes, and their function is to furnish indications of use in design or marketing, drawing attention to the advent of new colors as they are introduced onto the market by cultural or scientific developments, noting the disappearance of other colors, or making known the identity of standard ones.

These forecasting services generally cover a period of one or two years.

The principal ones are the Centro Design Montefibre in Italy, with editions for interior decoration and for fashion, Mafia in France, Hoechst in Germany, Derlin in Britain, and House and Garden in the United States.

Textile products for furnishing (carpets, broadlooms, upholstery, drapes, etc.) are some of the main supports for background color.

Their great importance lies on the one hand in the chromatic definition of individual pieces of furniture, and on the other in the quality of the background color. These two levels of intervention correspond to two different functions of color and make it possible to return, within the limits of a correct ergonomics of color, to individual types of approach to the emotional significance of the product.

Decoration, as a figurative and linguistic

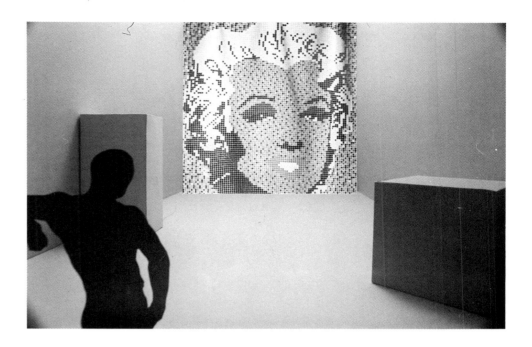

phenomenon, has always been regarded by official culture as a by-product of painting.

Indeed the term "decorative" has become synonymous with the vulgarization of figurative phenomena, transformed by processes of repetition to the point where they lose any cultural value.

I believe that to a great extent this negative attitude should and could be revised today.

In the first place it has to be recognized that decoration, and especially textile decoration, has followed a line of research that is historically independent of official painting, and that it has a conceptual originality that is absolutely its own.

Unlike in painting, in fact, the decorative pattern is not intended to be a sign that acquires meaning and succeeds in communicating only in relation to its completely unique character.

Unlike the picture, the decorative sign is not created within a definite boundary, but forms the plan for a potentially infinite structure that extends in a homogeneous way over an unlimited plane (the textile).

This dimension of the plan means that the decorative sign possesses semantic characteristics of its own: in contrast to the painting, every part of the decorative surface contains the sum total of information in the whole.

Decoration is a system of cultural communication within the limits of the environment and the product. Its structure is a repetitive, two-dimensional, and symbolic one; the distributive structure of this information, the choice of pattern, the sequences of joins, the graphic structure and its greater or lesser degree of legibility, and the succession of background colors mean that the process of designing a system of decoration requires a high degree of professional specialization.

The unknown decorator has always had a rational instrument for the organization of figurative communication. This specialized line of research, within the sphere of furnishing textiles as well as that of fash-ion, has often led him or her to anticipate by many years the discoveries made by painting.

For example the possibility of communicating by means of "non-figurative" signs, the organization of individual signs into overall structures of composition, the concept of absolute conventionality of color, and the selection of the "significant symbols" of a culture are all discoveries that official painting has only caught up with in the last few decades, but which have already served as a working instrument for countless generations of decorators.

(From *TA* 12, spring 1974)

Top: "Physiolight" curtain system with controlled light (CDM: Andrea Branzi, Clino Trini Castelli, Massimo Morozzi, 1976). Below: Clino Trini Castelli: "Gretel's soft diagram" (1977).

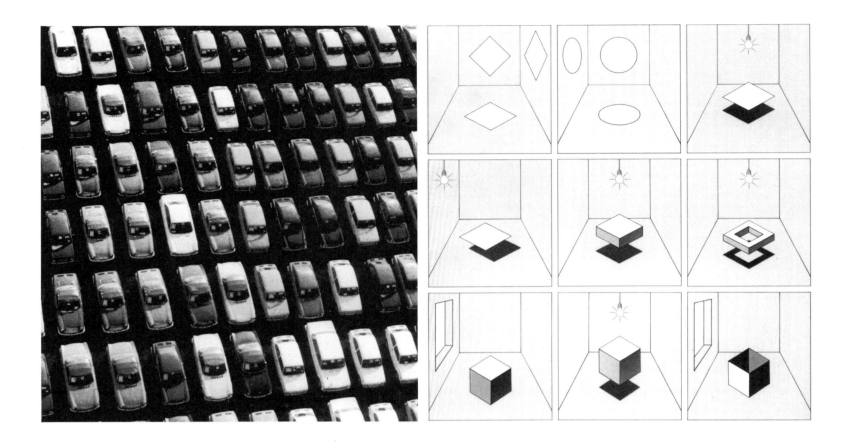

Decorattivo nos 1 and 2 (Consulenti Design Milano: Andrea Branzi, Clino Trini Castelli, Massimo Morozzi; collaborators: Adela Coat Turin, Sauro Mainardi, Fabrizio Sabini, 1977). Decorattivo was a series of manuals describing trends in environmental decoration, realized by C.D.M. for the Centro Design Montefibre between 1975 and 1977. The decorative themes dealt with included Amorphous Designs, Neckwear, Stripes and Checks. These manuals contained analyses of, and documents on the linguistic structures of textile decoration, and compared them with current visual culture.
Decorattivo aroused, in the mid-seventies, a new interest in decorative culture, ignored or resisted by Modernism. An interest in decoration as a system of symbolic cultural information, capable of affecting the expressive and functional qualities of a product.

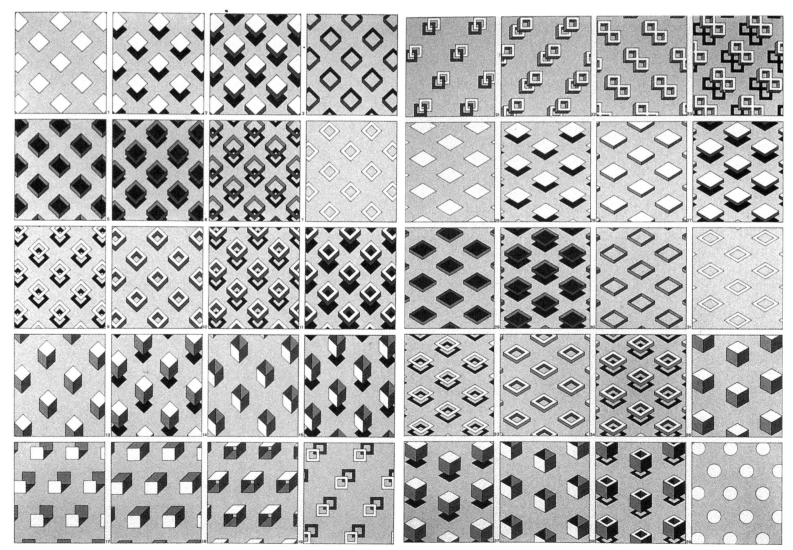

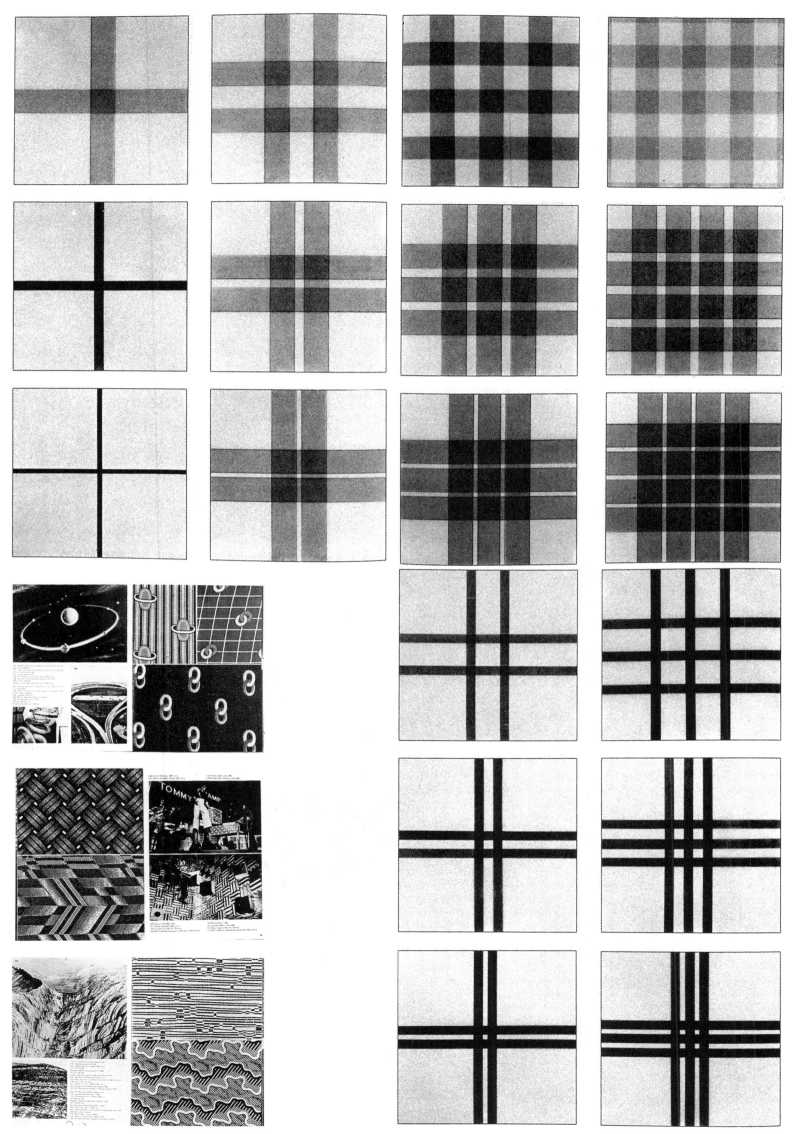

Colordinamo (Consulenti Design Milano: Andrea Branzi, Clinio Trini Castelli, Massimo Morozzi; collaborator Alessandro Degregori: 1975-77).
The Centro Design Montefibre was the first center of design for an industry producing raw materials (chemical fibers). It was not concerned with finished products, but provided services to the textile industry, by means of manuals on trends, basic research, and development of semi-manufactured products.

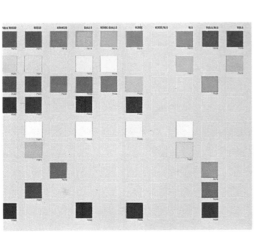

The Colordinamo manuals were devoted to trends in background color; monographs were published on the "*Colors of Energy*" (1975), "*Pre-Synthetical Colors*" (1976), and "*Background Colors*" (1977).
The recognition of the great importance of color design in the industrial world was part of the broader theme of primary design, concerned with the design of soft structures in the environment: microclimate, color, sound, odors, decoration, and surface finishes.

Above: Fiorucci store in New York (Andrea Branzi and Ettore Sottsass Jr., collaborators Franco Marabelli and Ulla Salovaara, 1976). Below: Ettore Sottsass Jr., Elio Fiorucci and Andrea Branzi in New York (1976). Right: sectional system of hats for *Domus Moda* no. 1 (from the exhibition "Hats and Shoes by Twelve Designers," conceived by Alessandro Mendini and Patrizia Scarsella, staged by *Domus* and Borsalino, 1981).

Piaggio color system (Andrea Branzi, for Consulenti Design Milano, 1979).

P.8/3 P.6/3 P.2/2 P.4/7 P.4/1

Modification of the new Alfa Romeo "Giulietta" for Fiorucci. Realized by Zagato (Andrea Branzi and Ettore Sottsass Jr., 1978).

"Reli-tech" three-dimensional laminate, one of the earliest examples of material design. The Reli-tech was a high-strength plastic laminate, with a multicolored

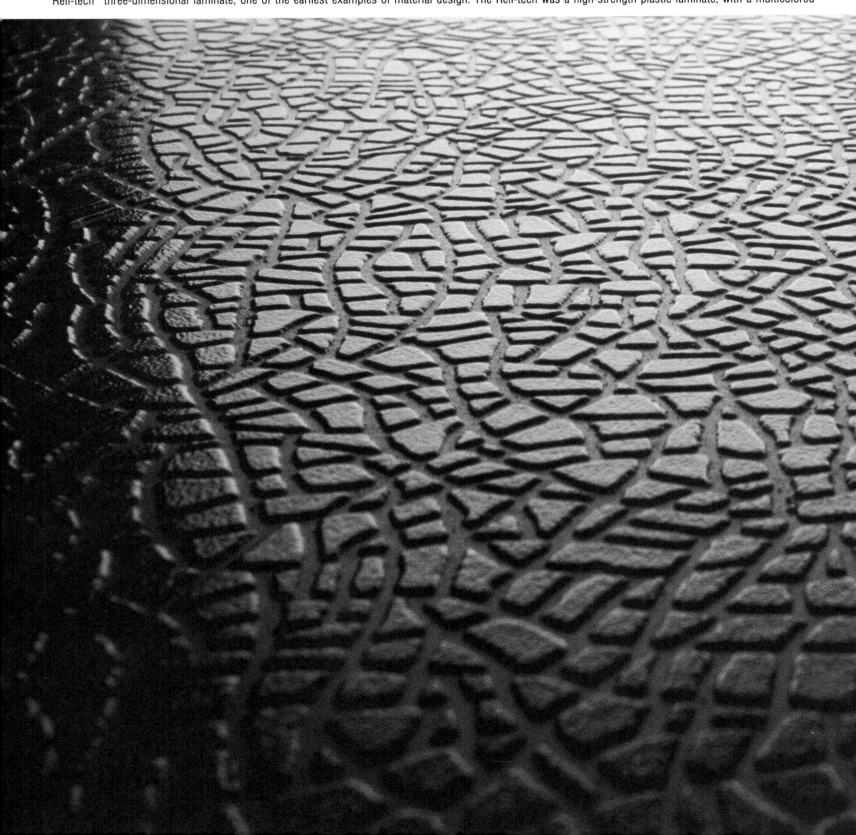

three-dimensional structure produced by a single process of rolling by press. Manufactured by Abet Laminati (1978). (A. Branzi for Consulenti Design Milan).

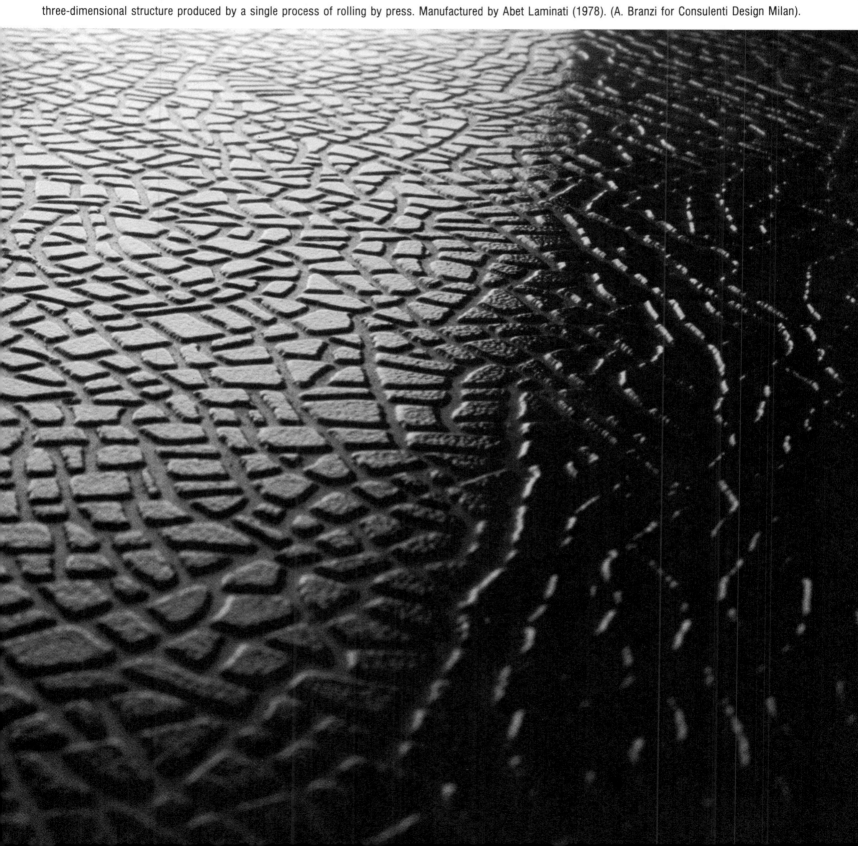

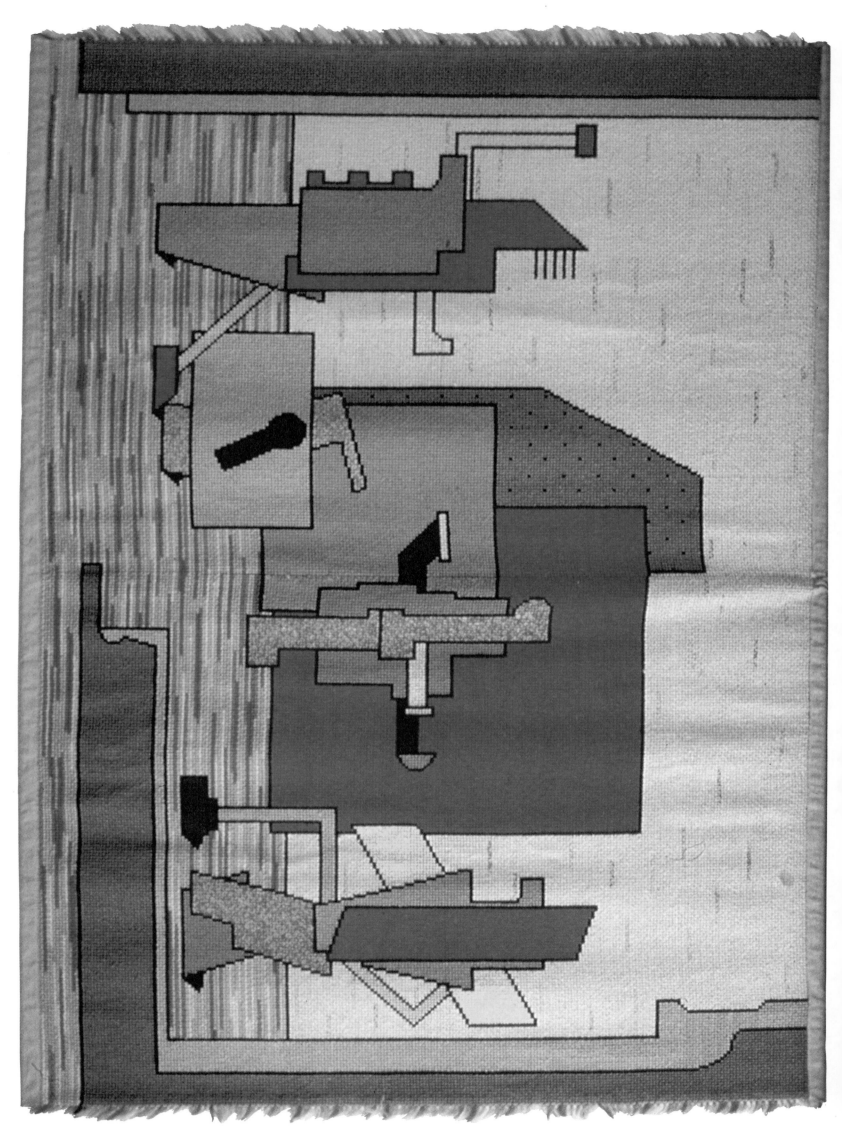

92

Left: Geometric Ballet, tapestry handmade by Andrea Branzi (1976). Steinegger collection. Above: prototype of a modular mirror realized by Cristalarte (1976). Below: Day and Night patchwork, prototype, realized by Lombarda Cuscini (1980).

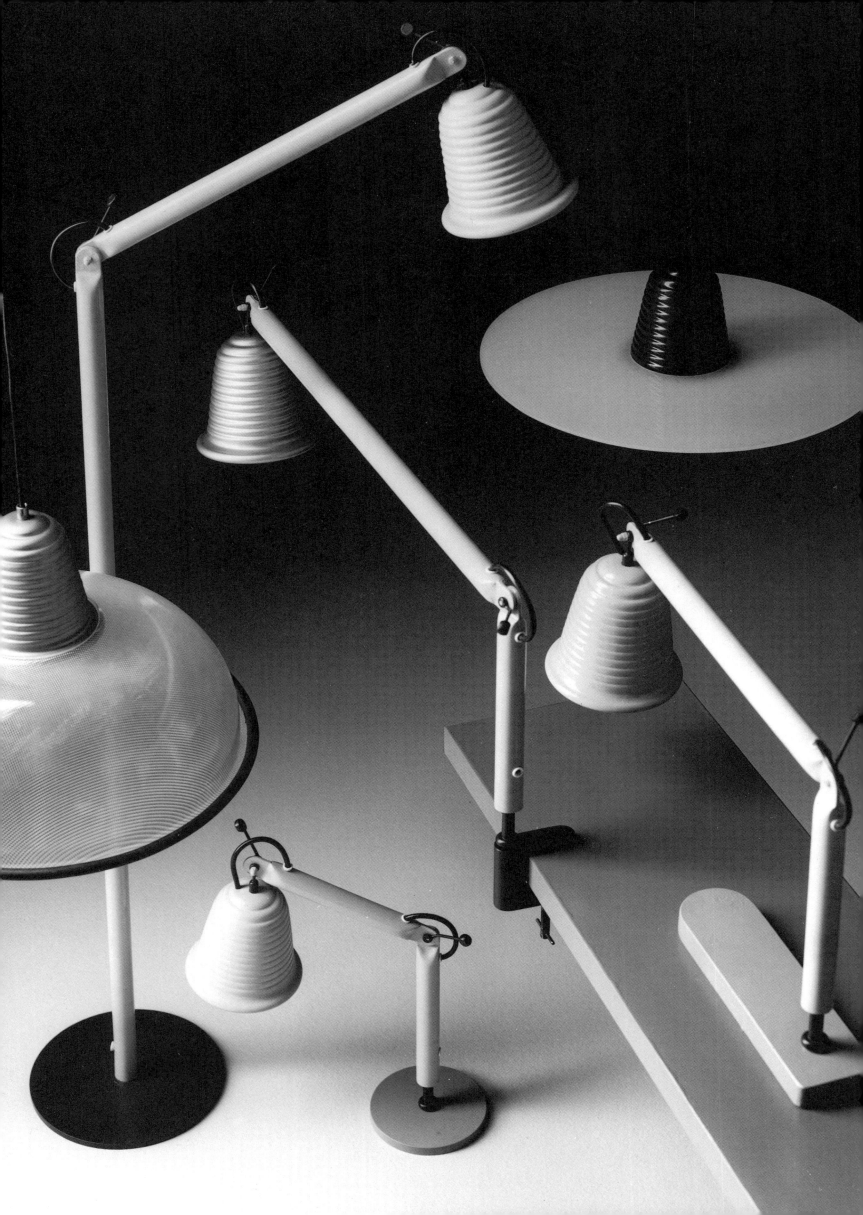

Left: "Vallechiara" system of sectional lamps for Croff Centro Casa, manufactured by Latina Illuminazione (1978).
Above: studies for a plastic armchair (1979). Below: blue teapot, prototype (1975). Collection of the Musée des Arts Décoratifs in Montreal.

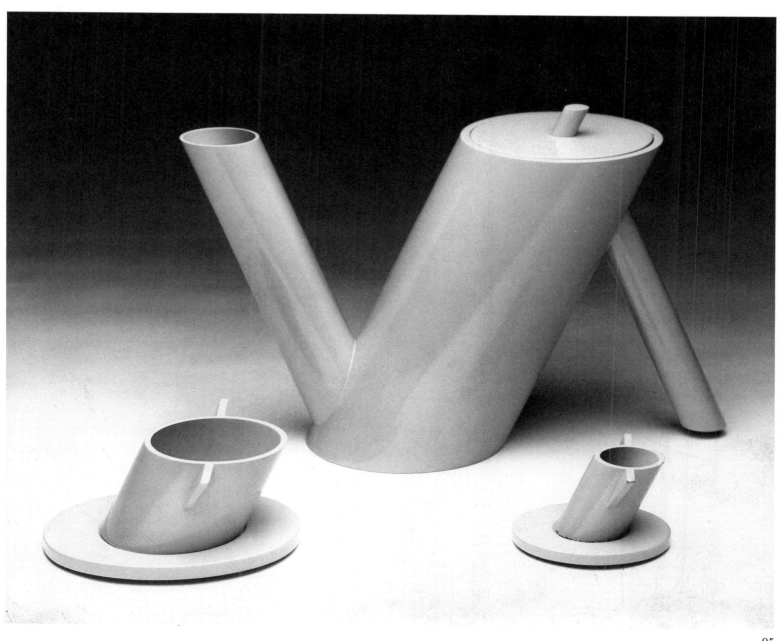

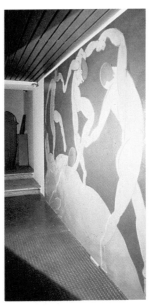

Above: Henri Matisse, *Dancers*, 1910.
Handmade reproduction on a scale of 1:1
(1980). Right: tile decoration (1976).

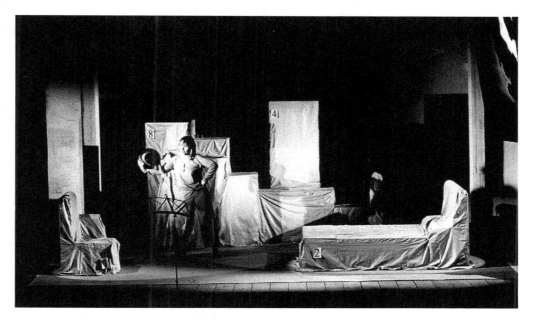

Above: scenery for *Molly cara*, a monologue taken from James Joyce's *Ulysses*, performed by Piera degli Esposti and directed by Ida Bassignano (1978).
Below: Andrea Branzi, Alessandro Mendini: architectural decoration, Giulianova (1978).

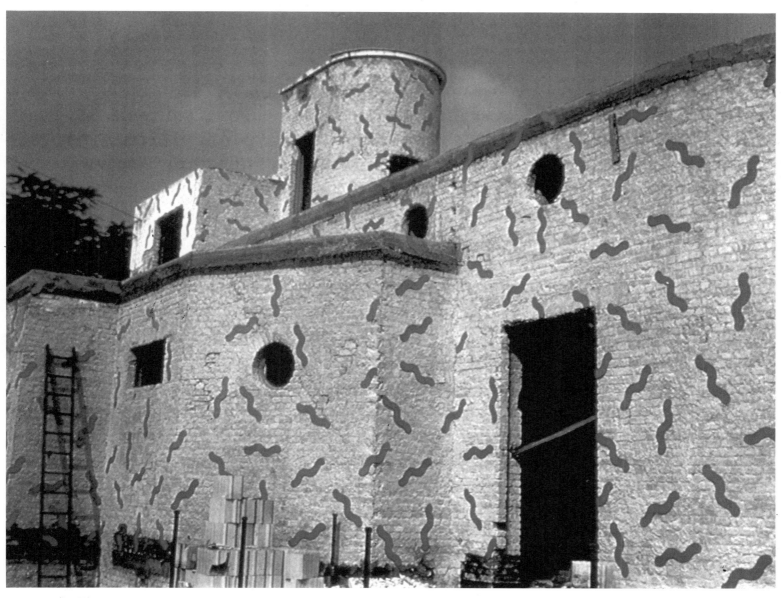

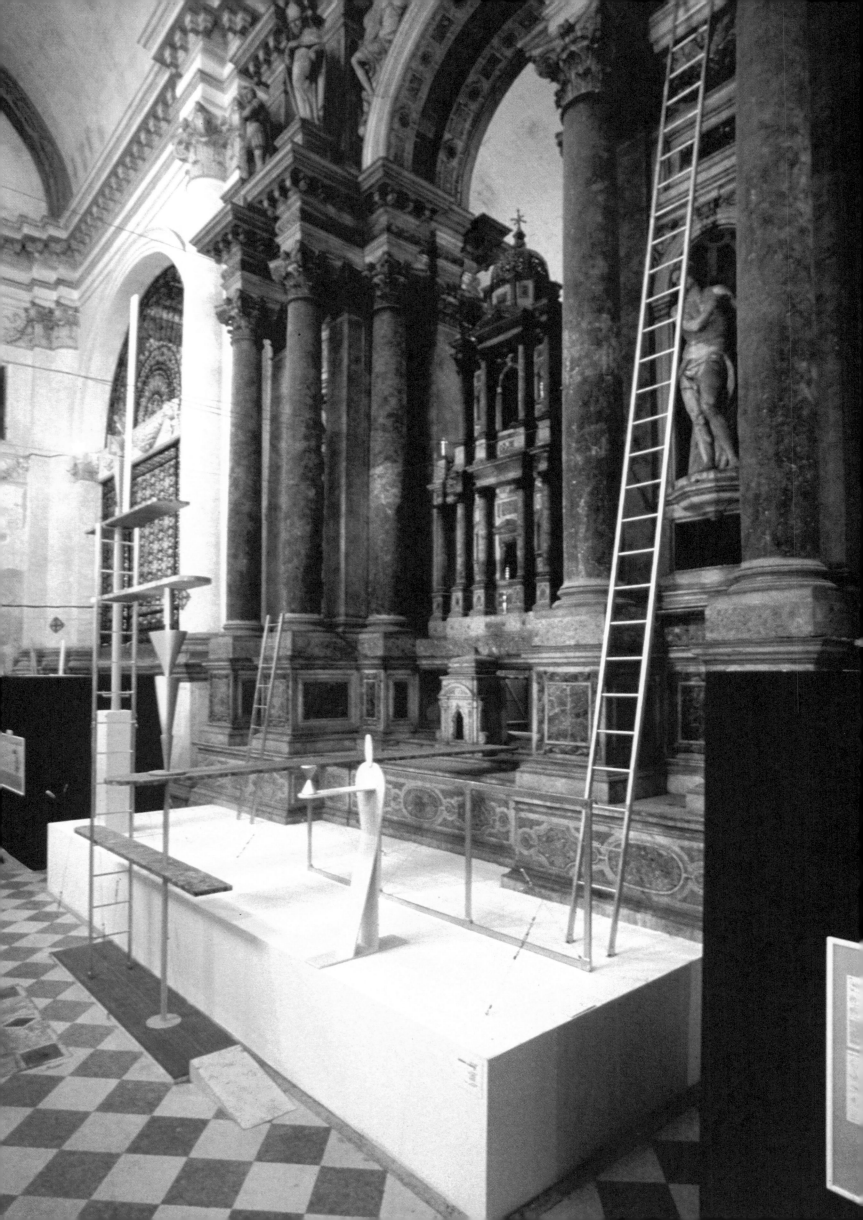

Records and Paradise installation on the baroque altar of the church of San Lorenzo, for the 1980 Venice Biennale.

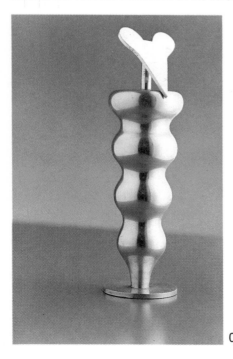

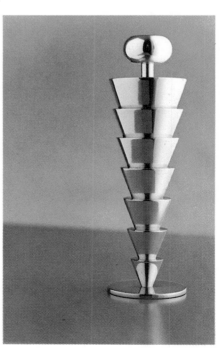

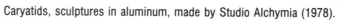

Caryatids, sculptures in aluminum, made by Studio Alchymia (1978).

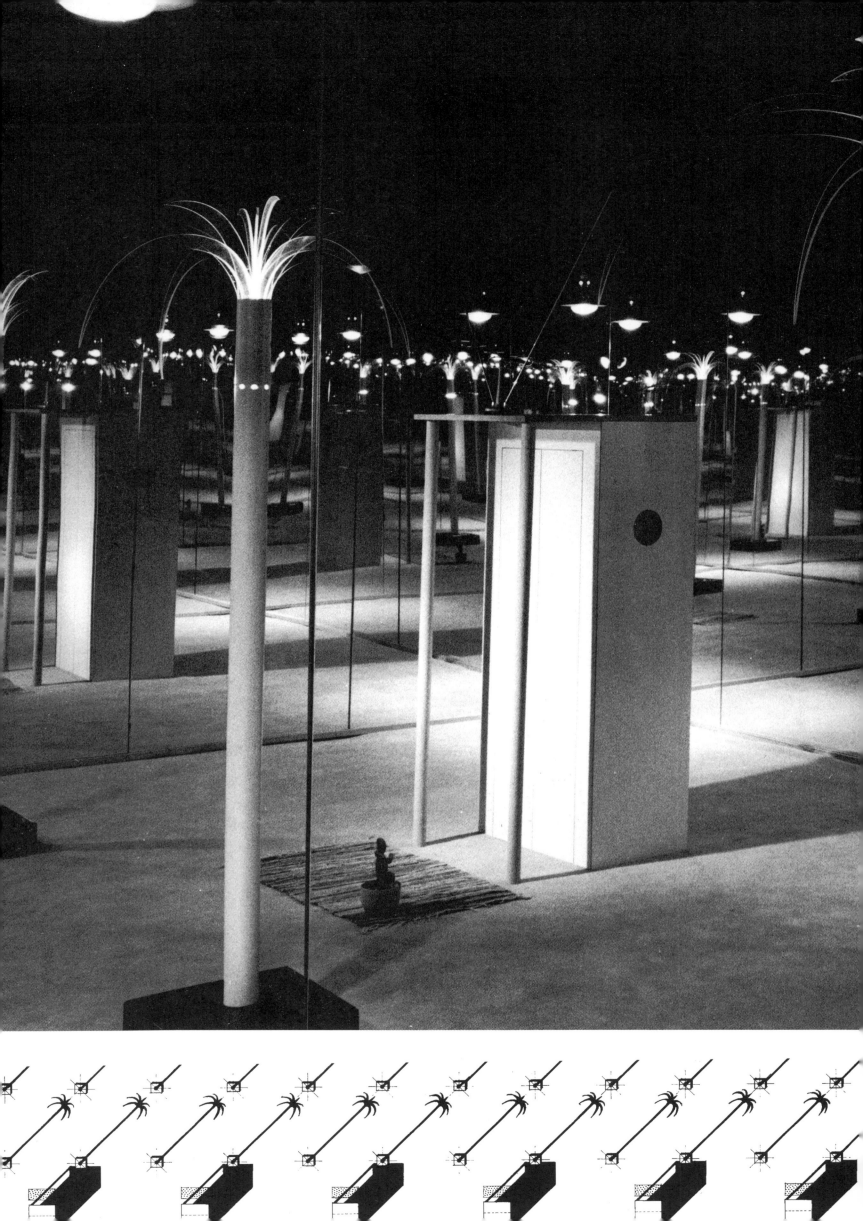

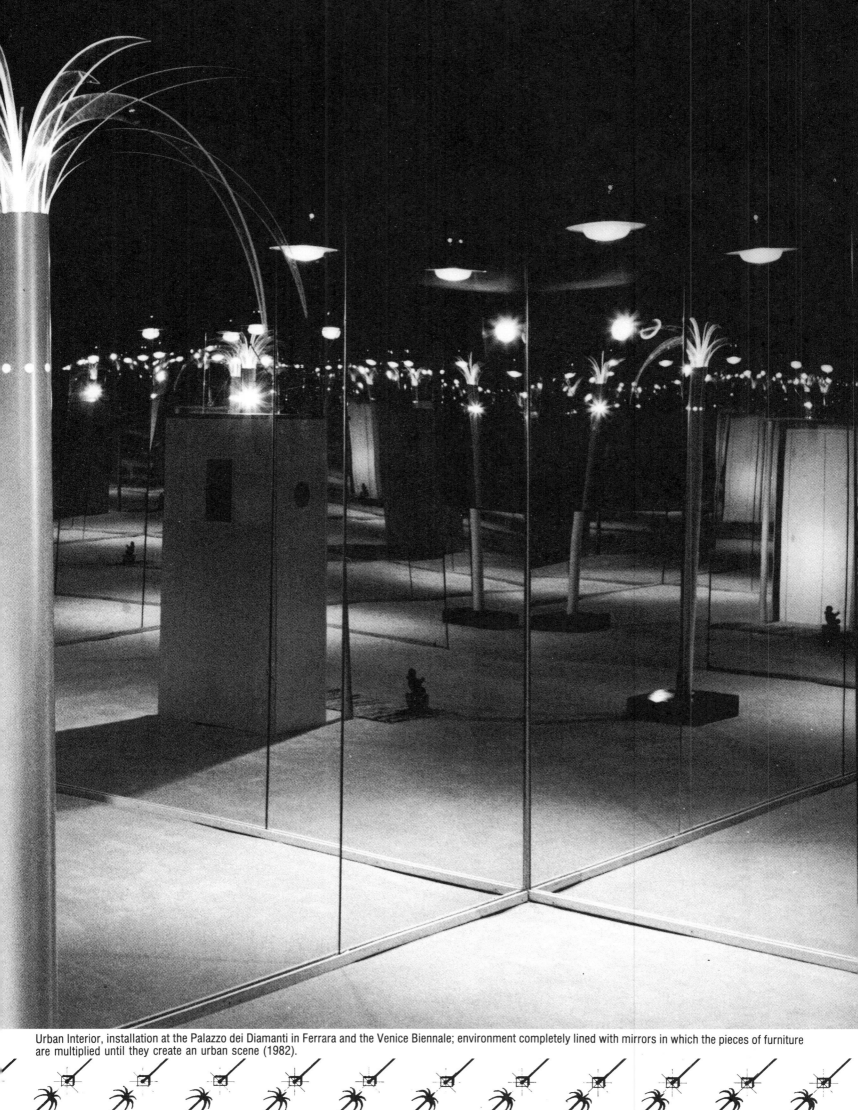

Urban Interior, installation at the Palazzo dei Diamanti in Ferrara and the Venice Biennale; environment completely lined with mirrors in which the pieces of furniture are multiplied until they create an urban scene (1982).

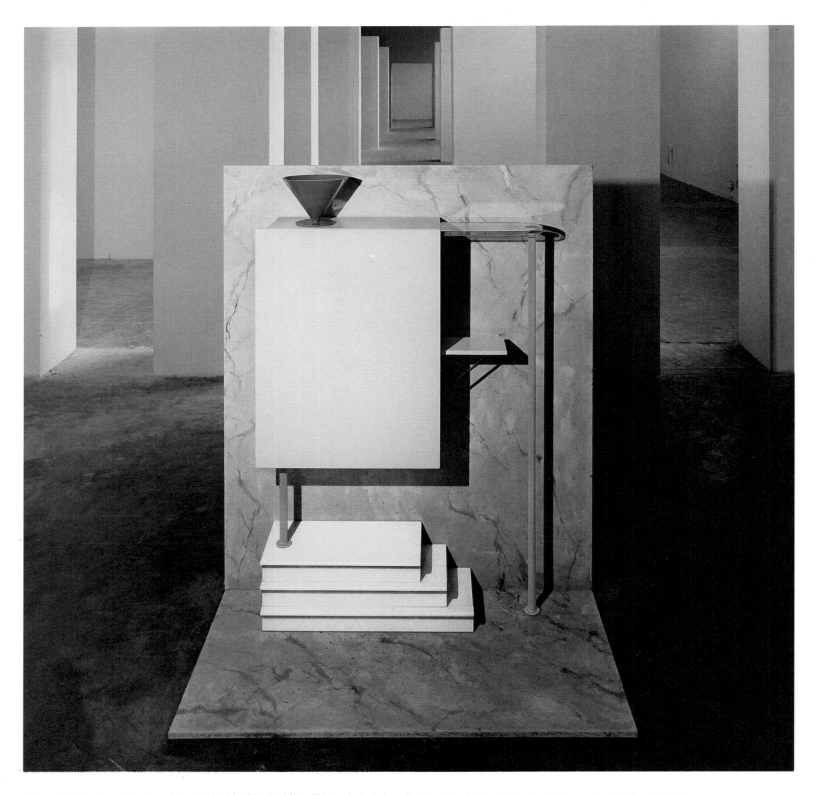

Above: "Milano" mobile bar photographed inside the Milan Triennale building. Realized by Studio Alchymia, Bauhaus 1 collection (1979).

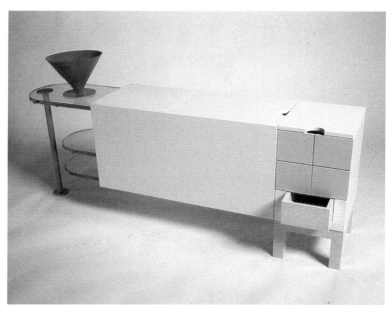

"Centrale" mobile bar, realized by Studio Alchymia, Bauhaus 1 collection (1979).

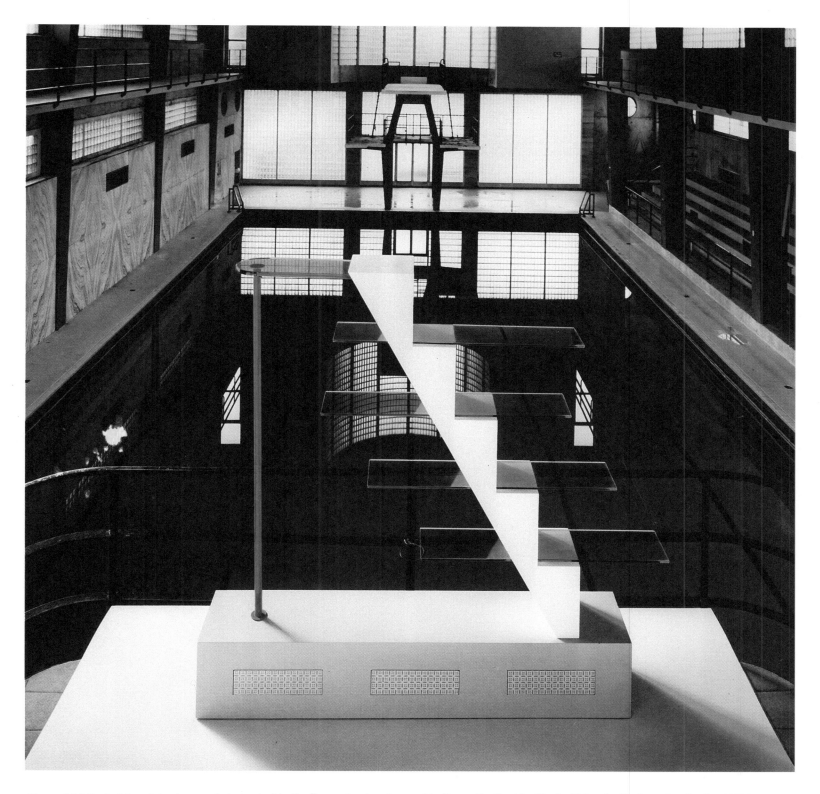

Above: "Adalberto Libera" bookcase, photographed in the Terragni swimming pool in Como. Realized by Studio Alchymia, Bauhaus 1 collection (1979).

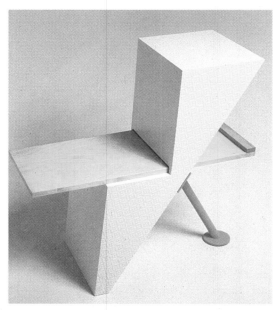

"Ginger" chair, realized by Studio Alchymia, Bauhaus 2 collection (1980).

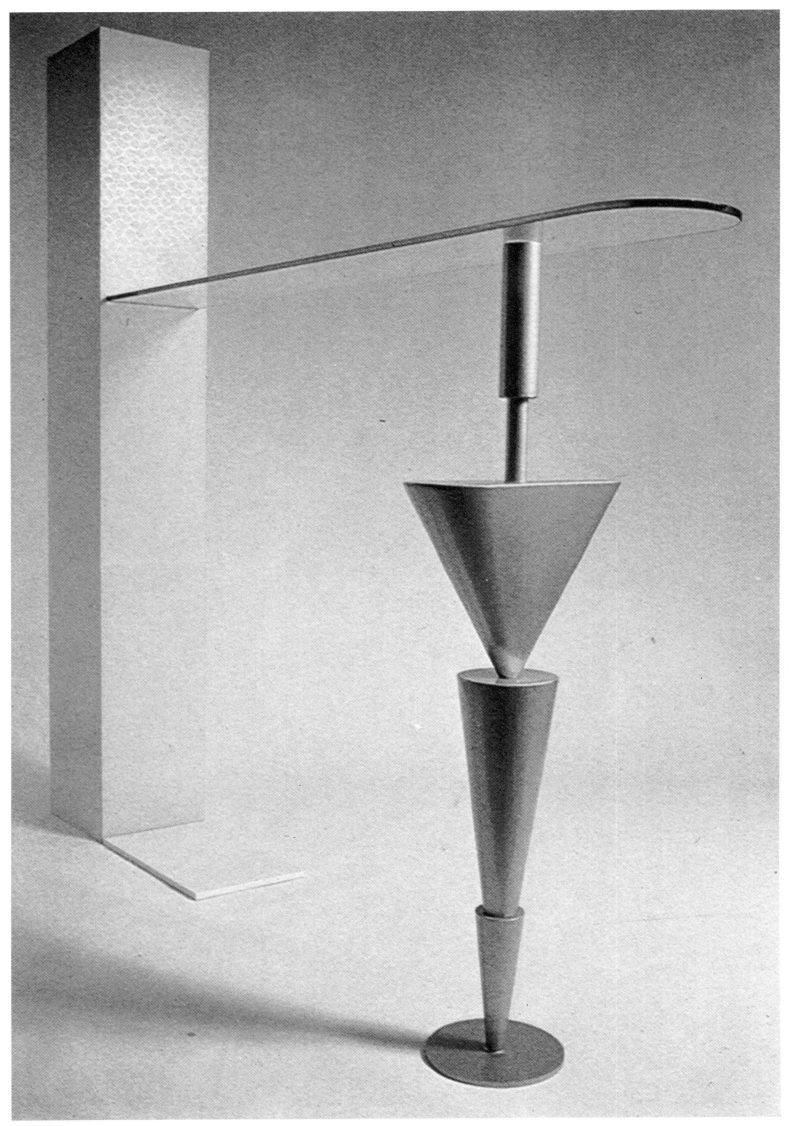

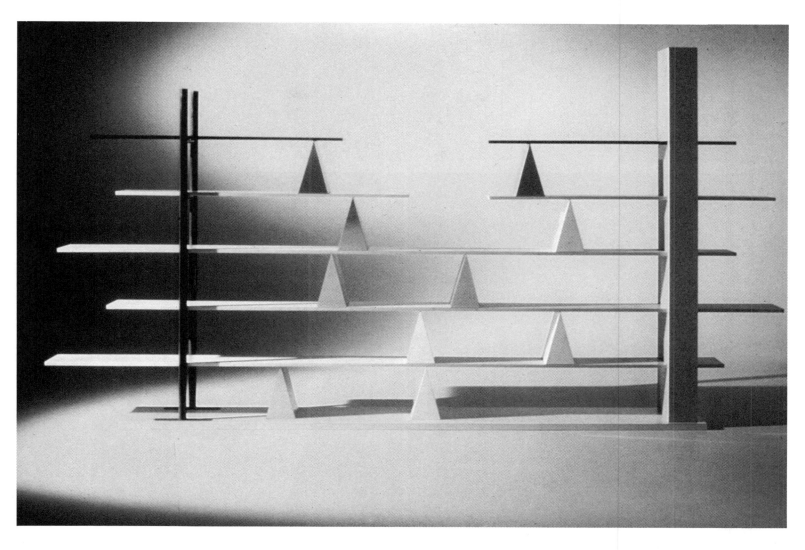

Left: "Oskar" bookcase, realized by Studio Alchymia, Bauhaus 2 collection (1980). Above: "Gritti" sliding bookcase, manufactured by Memphis (1981). Below: "Beach" chaise longue, manufactured by Memphis (1981).

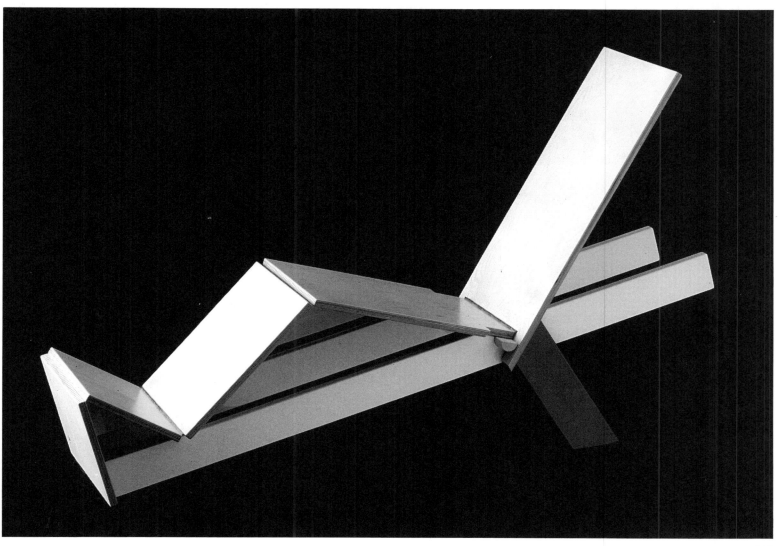

"Magnolia," bookcase with palm leaves manufactured by Memphis (1984).

"Labrador" silver sauce boat, manufactured by Memphis (1982).

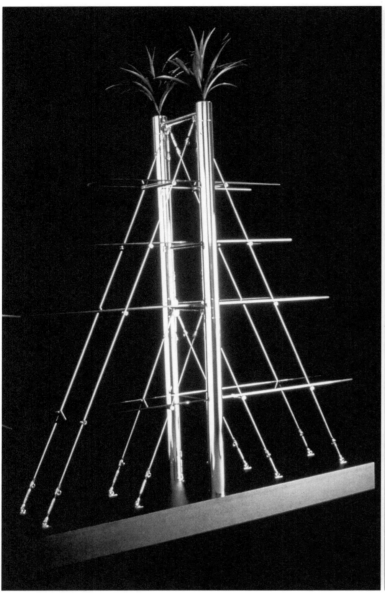

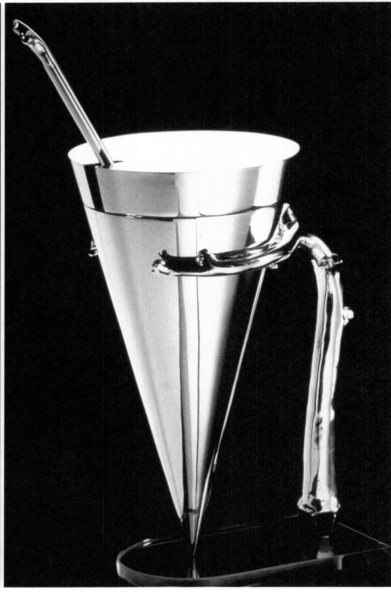

The so-called "applied arts" are perhaps the most important area of architectural refoundation. In years of fanaticism on a giant scale, they were erroneously defined as "minor arts." But since people began to realize that urban design and architecture had themselves become "minor arts," owing to their incapacity really to influence the quality of the environment, they have grown increasingly cautious in the use of unduly vague dimensional scales in the classification of arts applied to the environment.

The "applied arts" are the area of a possible refoundation of architecture precisely because the so-called "major arts" have reached such a pitch of environmental ineffectiveness, both technically and culturally, that a refoundation from "within" the building itself is necessary.

The chain which linked, in an optimistic progression, interior design to the building and the building to the city, has been broken, giving rise to a universe of objects on equal terms, be they furniture or towns, that no longer stay toge-

ther in a ratio of function and scale, but in a new ratio of similarity, regardless of function and scale; a ratio of likeness and contrast.

To design a chair or piece of furniture today is the only fully architectural action we can take. This stands to reason, moreover, seeing that architecture as a public language is already dead, and that Adolf Loos was right in maintaining that the only truly viable architecture is that of interiors, since civil architecture is not an active cultural part of the city any more.

All modern architecture stems from the applied arts. At the beginning of the century all the innovative moves were made by people who acted on the dimension of individual objects, and on the possibility of reconstructing through those objects a fresh relation between human labor and culture, between user and manufactured goods, between technique and expression.

When Gropius tried, through the Bauhaus, to put all these

"Century" sliding couch, manufactured by Memphis (1982).

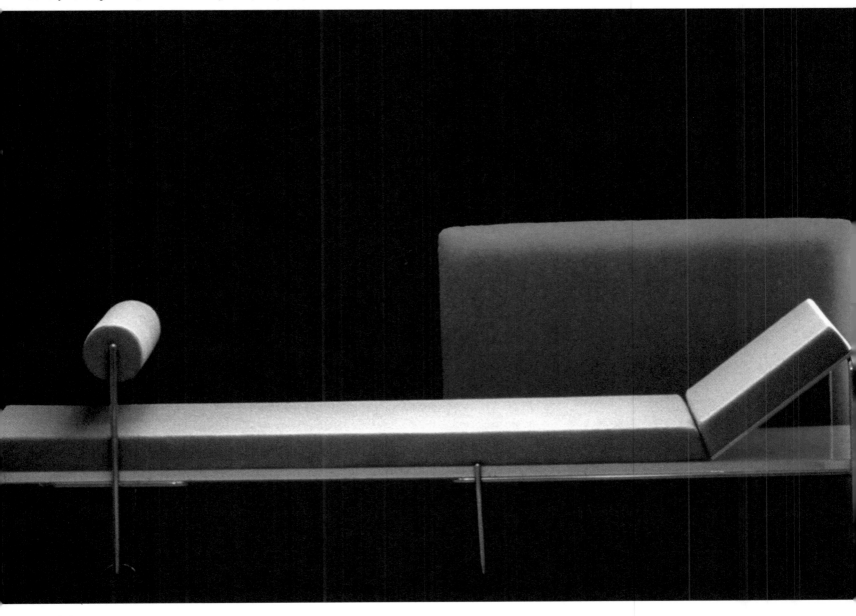

different sectors of expression together again in the architectural project, objects came to lose their property of being a separate variable, an autonomous expressive valence. Instead they were to become, with the awful results that we all know, a segment of that impossible unity of place and culture which architecture strove to attain for fifty years without ever succeeding. The greatest of all the mistakes made by modern architecture was, in fact, to try through its projects to achieve a possible "unity of technologies."

This myth came about at a time when all the other human activities, art, culture and science, were permanently abandoning their search for unity in order to work directly on "discontinuity." From this historical schizophrenia sprang the progressive incapacity to live in the contemporary world of modern architecture. This profound and painful, even heroic incapacity slowly drove modern architecture to the edges of the world, out onto a bitter as well as useless –

and hence still more agonizing – limb. The indifference towards modern architecture sounds today like a divorce obtained in old age, but which has its deep origins in a youthful though never confessed incomprehension.

One can, therefore, react to solitude in many different ways, even by making oneself up like an old music hall singer (Postmodernism) or by bringing maturity to bear in order to meditate upon past errors and by finding the strength and serenity to devote oneself to the senile pleasures of the "applied arts." In these pleasures, and not in the wild oats of an improbable belated youth, it is possible to find the guiding thread which can enable us to rediscover not the useless old myth of impossible unities, but that "lost grace" of making houses.

(From catalogue, *Architettura Innamorata*, Milan, 1980)

107

Project for the new premises of the firm "Focus," with furniture showroom, Munich. Building constructed out of wire mesh, covered by climbing plants. Left: segment of a theoretically infinite system of display structures (1981).

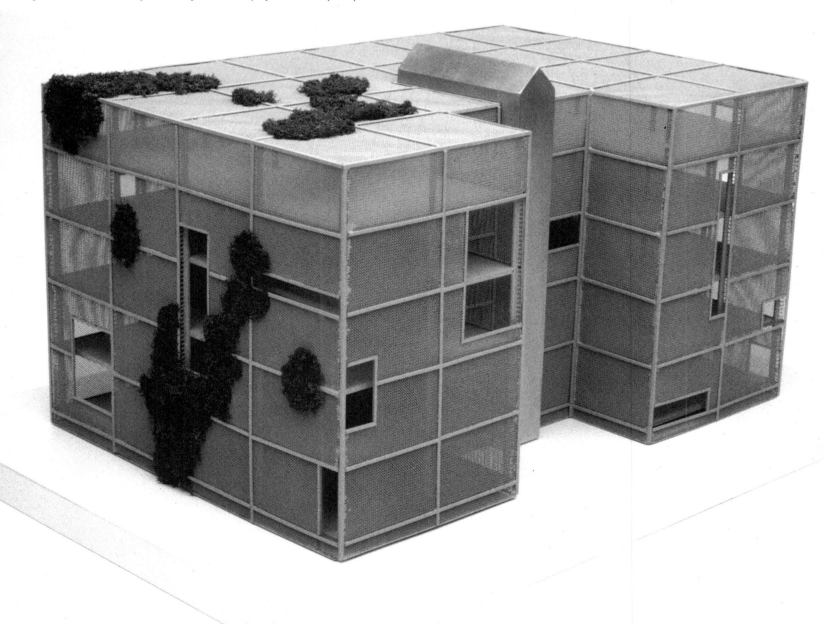

"Santini e Dominici" shoe store (with Sergio Cappelli and Patrizia Ranzo), Naples 1983.

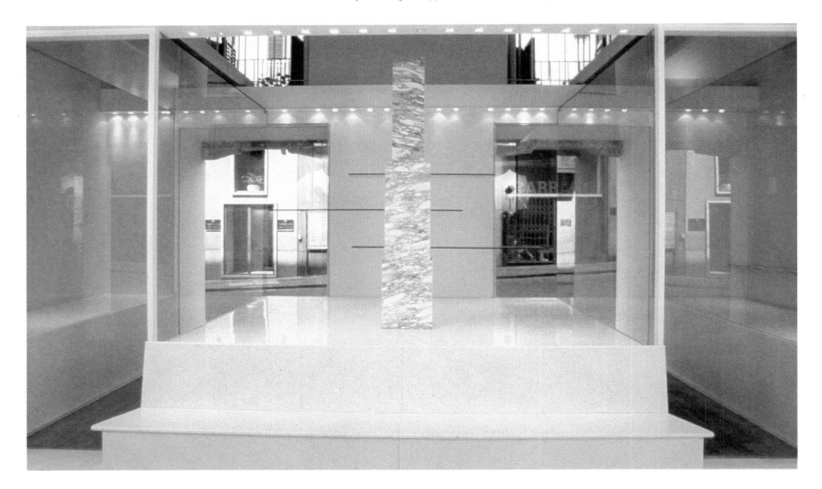

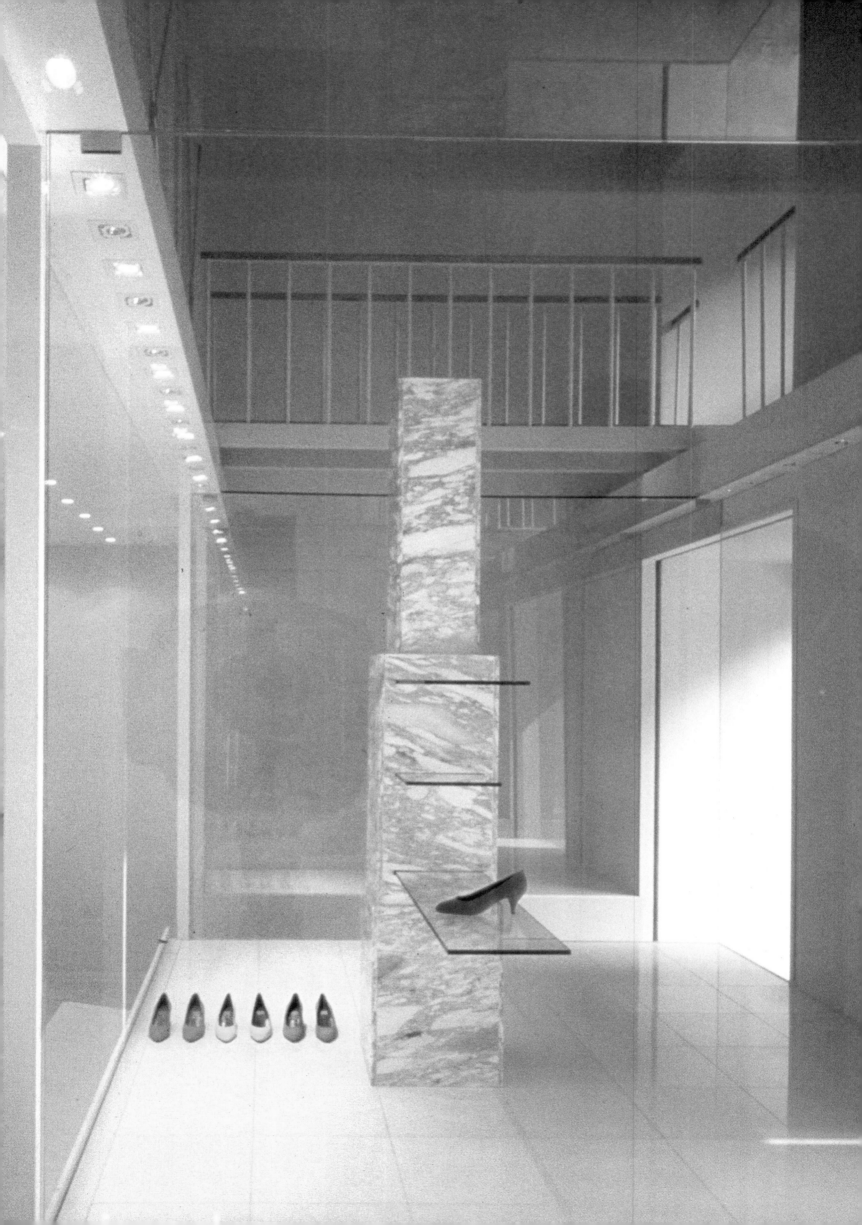

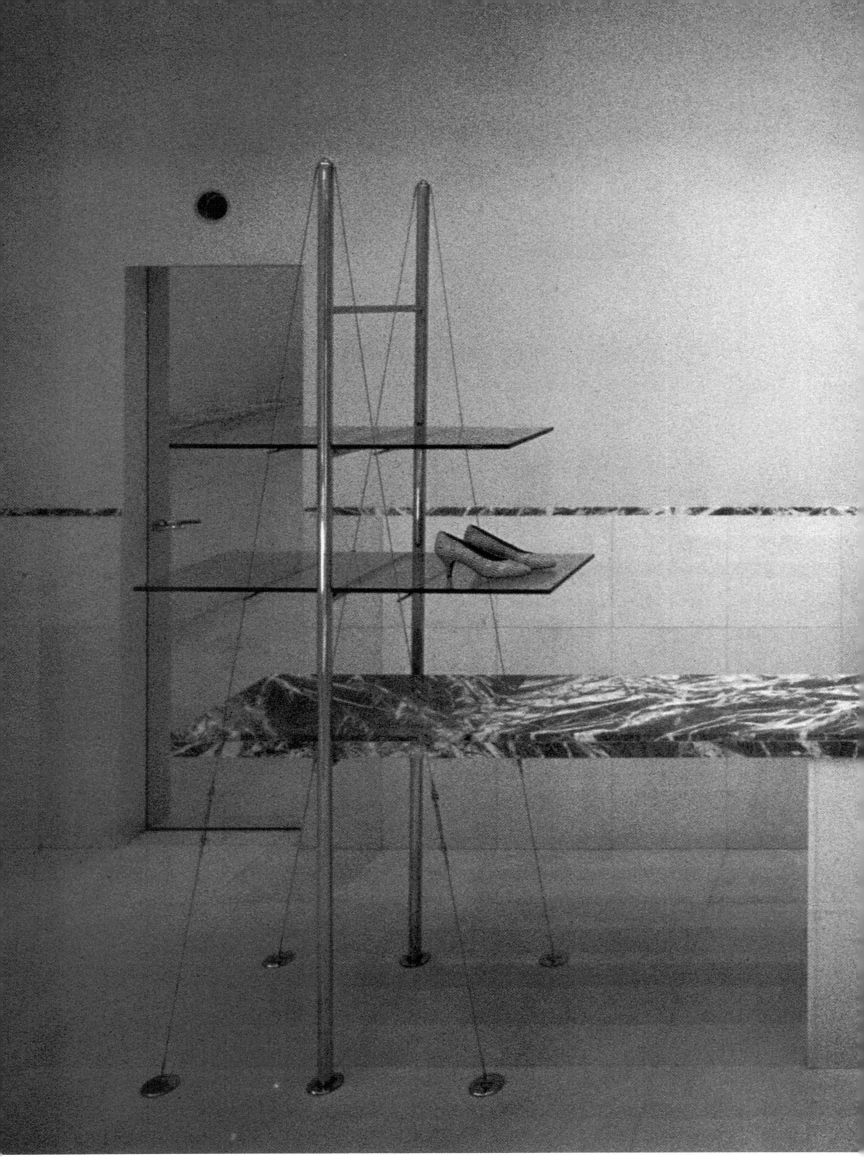

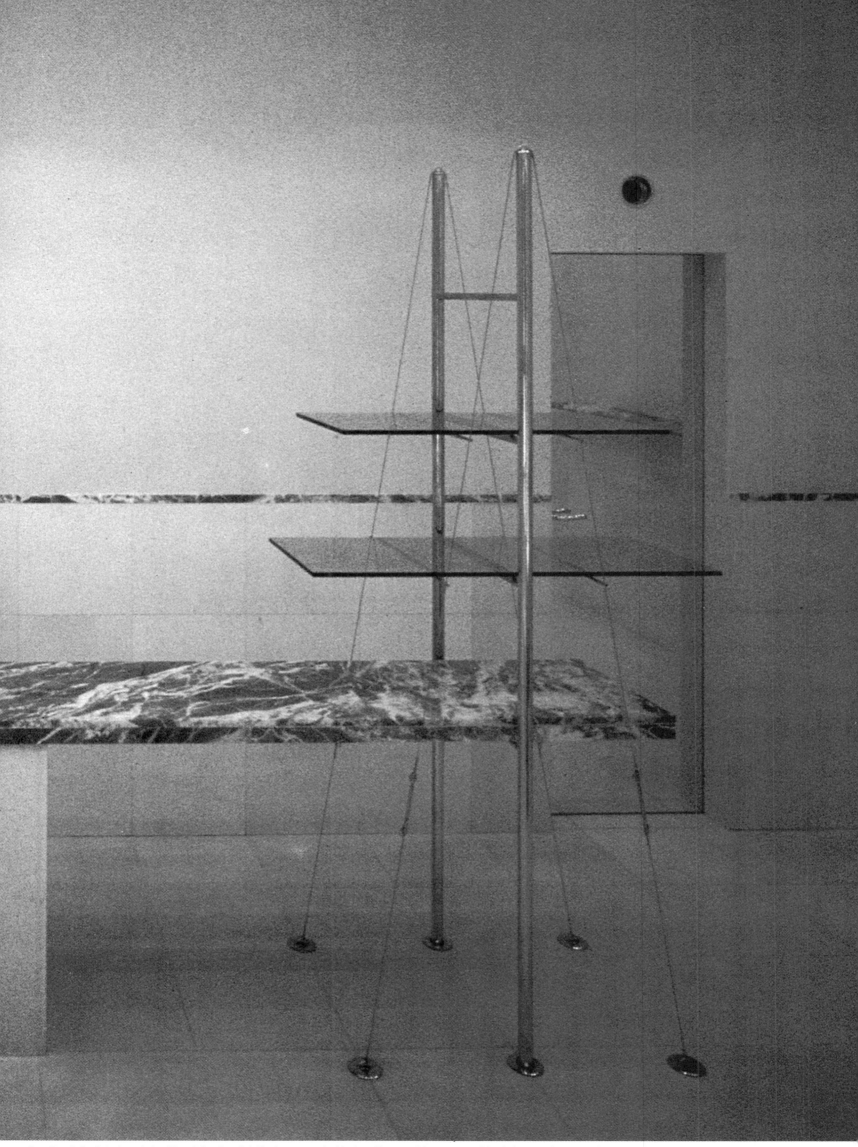

Details of the interior of the "Santini e Dominici" shoe store in Naples. Empty white space, with shelves and counter in malachite green marble.

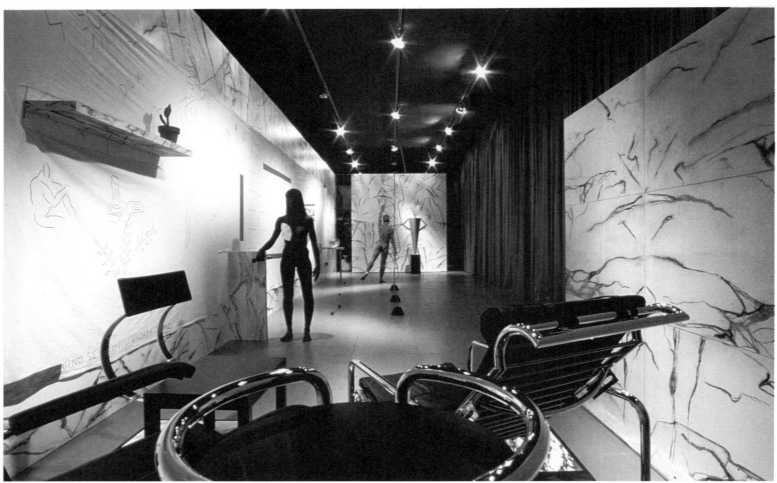

Mussolini's Bathroom, reconstruction in textiles of Mussolini's gymnasium at the Foro Italico, designed by Italo Moretti and Gino Severini in 1938 (with Studio Alchymia and others). Centro Domus, Milan (1982).

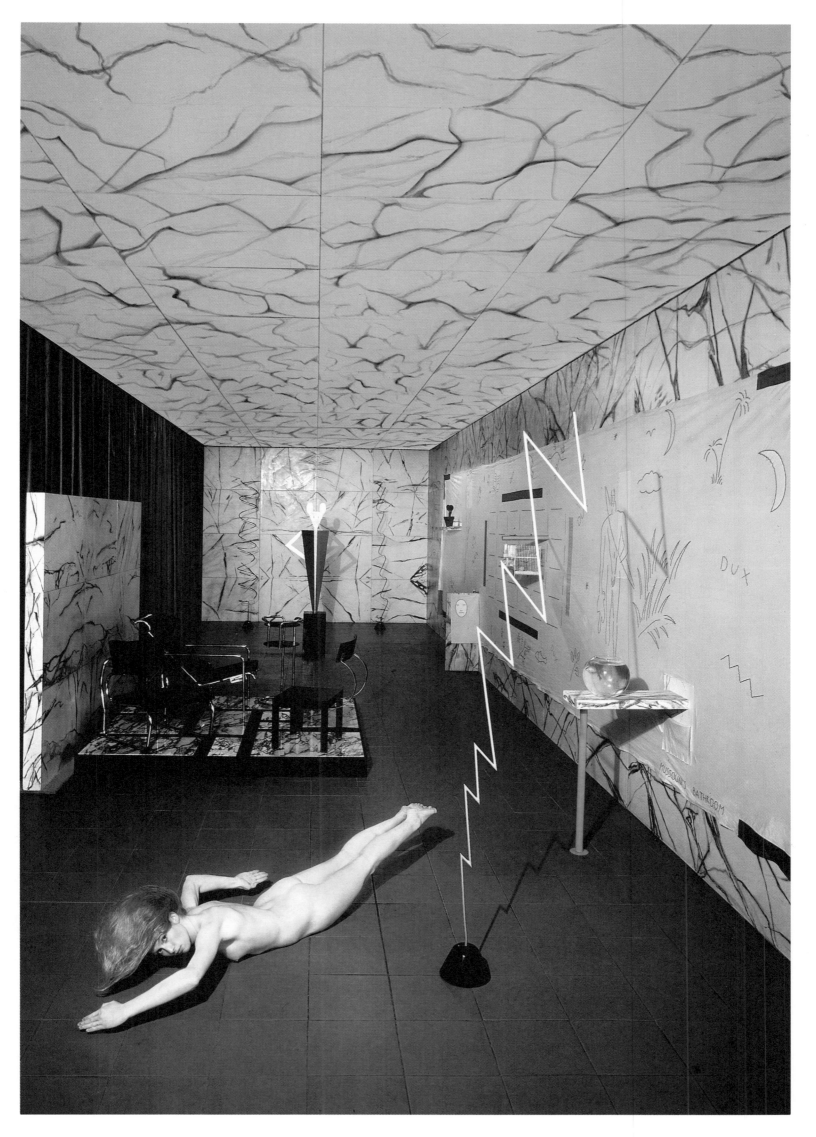

Project for the new Ponte dell'Accademia in Venice. Third International Exhibition of Architecture at the 1985 Venice Biennale. Large bent girder, with a sculpture inserted into the central junction (with Tullio Zini, Federica Doveil, Maarten Kusters, Marco Susani, Agata Torricella, and Mario Trimarchi). Drawing by Tullio Zini.

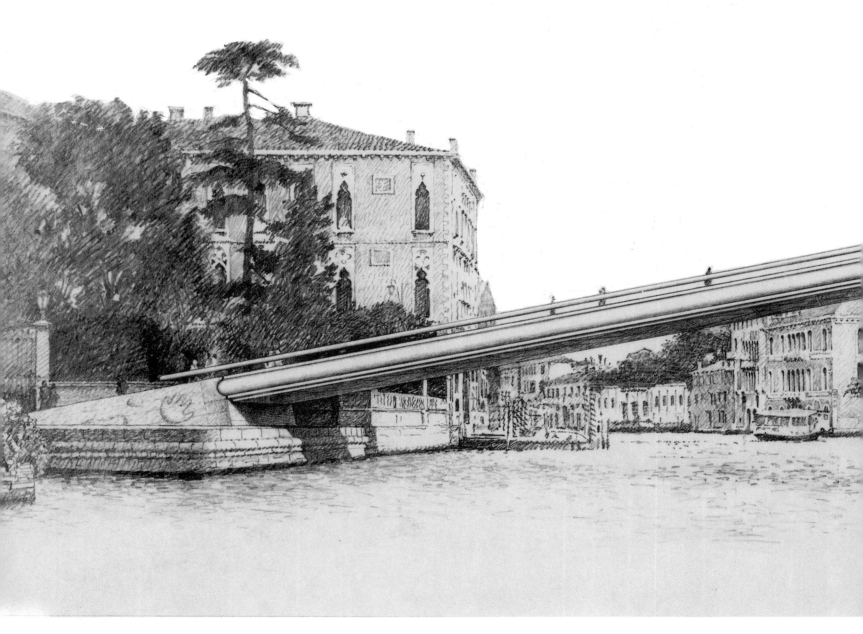

"The structure consists of an arch with three hinges formed by two pairs of parallel metal girders, meeting at the top, in the middle of the Grand Canal. The special angle at which the girders are set makes it possible to save space at the end, making the bridge shorter. They are box girders and are linked together by a secondary metal structure and a reticular system of purlins, left visible, in the part underneath. The steps are made of white stone, while the framework that supports and fills the gaps between them is in wood left open to view (planks linked by metal bosses).

"The two pairs of structural girders are used to transfer the load onto two supports in decorated stone that are connected to the existing paving. A broad metal handrail assists people in their ascent and descent and the screened lighting system is contained within it.

"The appearance of the bridge is that of a legible but discontinuous structure. The metal girders form a thin and interrupted architectural molding. The bridge becomes a hinge that conveys the concepts of continuity and fracture at one and the same time. We have set figures at its structural nodes in an attempt to enhance the feeling of tension created by the project.

"The colors are pearl gray for the maid girders and light emerald green for the secondary metal parts. The bridge appears continuous to anyone passing over it and conveys a growing sense of excitement until the point of descent is revealed."

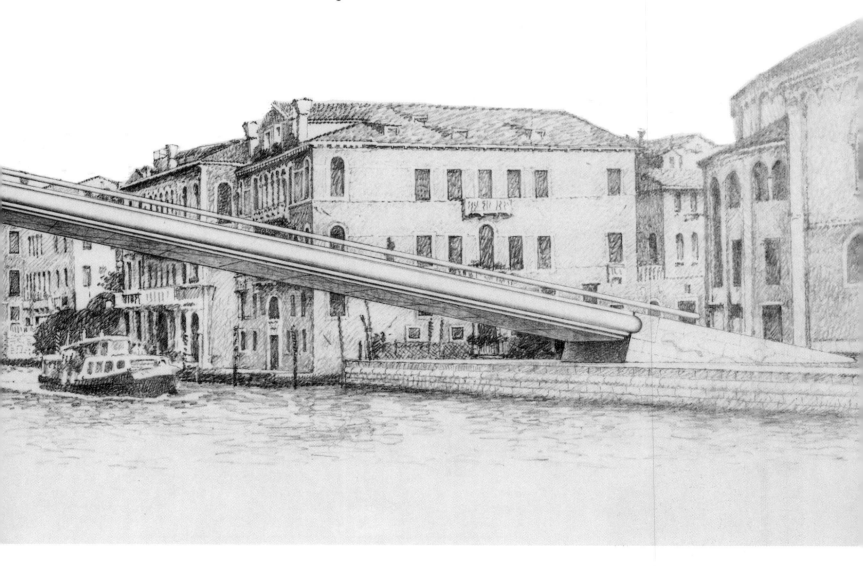

Having made Europe, we have to make the Europeans; this is why for some time now we have been meeting, sniffing each other and trying to embrace like brothers who are well-disposed, but also a bit suspicious of one another.

It is a fascinating adventure, but one that is difficult to manage, since we have not yet quite grasped whether we have to look for what unites us, or what divides us. In the sense that it is not clear (and to me especially) whether the union of Europe has to be forged by passing over certain defects and certain virtues proper to each of us, canceling out the ugly and beautiful histories that pertain to our own distinct national profiles, or whether on the other hand we have to remake ourselves to fit a different continental model, obtained through the summation and blending of the peoples of Eu-

NEW EUROPEAN DESIGN

rope. It is certainly true that the further we progress toward the unification of Europe, on the social and cultural plane, the more each of us is surprised to discover his own inalienable national identity. Yet at the same time we find this identity to be limiting and provincial in relation to the times that we Europeans are living in, and reductive with respect to the great historic adventure that a united Europe offers us.

So Europeans today look like timid heroes to us, noble but stunned by the venture that they themselves have conceived and set in motion. They are looking to the future while keeping a grip on the past – on a past, however, that no longer exists.

Towards the end of the sixties, when my own generation, all over Europe (but in the U.S.A. and Japan as well), first began to open up the optimistic certainties of classical rationalism to criticism, and to question, above all, the standardization imposed by the International Style, we made two important observations.

The first of these noted that what was called "rationalism" was merely a symbolic code, a set of civil and esthetic certainties that had nothing "scientific" or "definitive" about them, and that as such they were just a way of representing one possible future for the world. And it was precisely this future – standardized, orderly, and based on a single logic – that had entered a state of crisis, and that was incapable of containing us, the new Europeans, hybrid, erratic, and (apparently) irrational.

The second observation was that, underneath the grand linguistic system of the International Style, there was no longer any system of local language, no root that could be used to bring back to life lost traditions, flavors, and dialects. Only the more stupid of us went out to look for those roots in the countryside; the others adopted a different strategy, which within a short space of time gave rise to what is known today as the New Design. What this strategy involved was a full accep-

tance of our condition as hybrid, erratic, and (apparently) irrational Europeans, and then using just this state of complete freedom to bring back into existence new local diversities, new stylistic enclaves, resulting in an uncontrollable germination of spontaneous dialects. Our linguistic territories had new roots and new boundaries: the dialects of New Design were not going to emerge from the periphery, out of the countryside or the isolated province.

The dialects of a united Europe have been generated in the great cities, in the urban deposits of very high density, inside those artificial forests that are the post-industrial megalopolises.

Yet this too is one of the paradoxes of the post-industrial geographic condition: the rural areas, the small towns and cities, once a paradise of local diversity, of provincial ideas, have now been rendered totally uniform.

Life in Carcassonne is the same as in Bologna, Rosenheim is completely identical to Delft. What differentiates these small and medium-sized cities is their architecture and gastronomy, but the people, the languages, the modes of behavior, and the taste have become absolutely the same, homologized by television and by the mass myths of a large-scale commercial distribution that encounters no strong resistance in the small centers, meets with no feasible and credible alternative.

Paradoxically, it is the big cities, Tokyo, New York, Paris, London, Berlin, and then Barcelona, Milan, Düsseldorf, and Naples, that have become the new hothouses for autonomous languages, dialects, and ways of life. The new "artificial traditions" are born in the urban fabrics of high density, where local creativity is stimulated and subjected to the powerful pressure of complex systems, where opportunities, lifestyles, gestures, and signs breed in an obsessive manner, until there is no way to make a comparison between them.

These, therefore, are the capitals of the New Design: a design that plays a much

broader and deeper role than that of the design of new objects for industry.

I am interested in comprehending, above and beyond the renewal of the discipline, the overall significance that it represents: the meaning of this diffuse European culture, to be found in all the societies and capitals of the continent. It is perhaps a different significance from the way in which the public and even some of the critics see the New Design: as a culture of distraction, journalistic in character and committed to producing the unexpected, the entertaining. I have the impression that this image is a totally wrong one and that under the apparently playful and experimental surface, the New Design is transmitting cultural and generational signals to us that are extremely important and dramatic.

And this importance and dramatic force should already be clear from the very wide diffusion that the New Design has achieved all over the world in the last ten years, after a slow incubation in Italy, and then a propagation into the rest of the world through a sort of proliferation of young designers who, through their chairs and tables, have been conveying completely new structural diagrams, and who are seeking to create completely unexpected internal habitats that are of great emotional quality.

The crisis in the socialist countries of the East and their rapid disappearance is not a phenomenon that concerns solely those countries or the history of political doctrines: this phenomenon is having a profound effect on Western cultures as well, and those of Europe in particular. The idea that there might be a real or ideal alternative model to our own economic and cultural system has been a central factor.

The whole of modern culture, from the historical avant-garde movements to the great social-democratic monarchies, has worked to achieve, in various ways and by various means, a different and reformed society, a liberated and more creative one: the existence of a real alternative model

to this system has in any case represented a challenge, a competitive relationship, and made it possible to transform all the energies and internal tensions of society into positive political energy.

The analytical and enlightened tradition of Neoplasticism, created in the Bauhaus, reached, in different forms of expression, as far as the Memphis movement and its deregulation of form: formal deregulation of the object, as product of a culture that is striving toward a more general deregulation of the system, aiming at evading the system by starting from within it.

This complicated and very often unconscious strategy was based on the hypothesis that there was in any case a space outside the system, an alternative strategy that it was possible to implement or at least imagine.

Today the age of Revolution (and therefore of the avant-garde movements of which we are all the direct offspring) is over, and we are seeing the start of an age, yet to be analyzed, of Profound Transformations, of auto-regulation of the system, of the dramatic search for an environmental, all-embracing equilibrium for the system.

The contradictions of society remain, its monstrous social and cultural absurdities have become definitive, and the energy to which all this gives rise is no longer turned into analytical force, political growth, or liberating creativity, but stays trapped inside people's homes, in their modes of social conduct, in the twisting of forms. The energy produced by the injustices of society is becoming abstract, cold violence, no longer a liberating disintegration of forms, but an inner torsion, a spasm, an esthetic delirium....

(From *Formes des Métropoles – Nouveau design en Europe*, Centre Georges Pompidou, Paris, 1991)

In this page: Seminar: "Ceremonies for Europe: birth and death", Hochschule der Kunste, Berlin.
Right: preliminary studies for the "Domestic Animals" collection, 1985, and photograph of the first prototype in the Zabro workshops at Lissone.

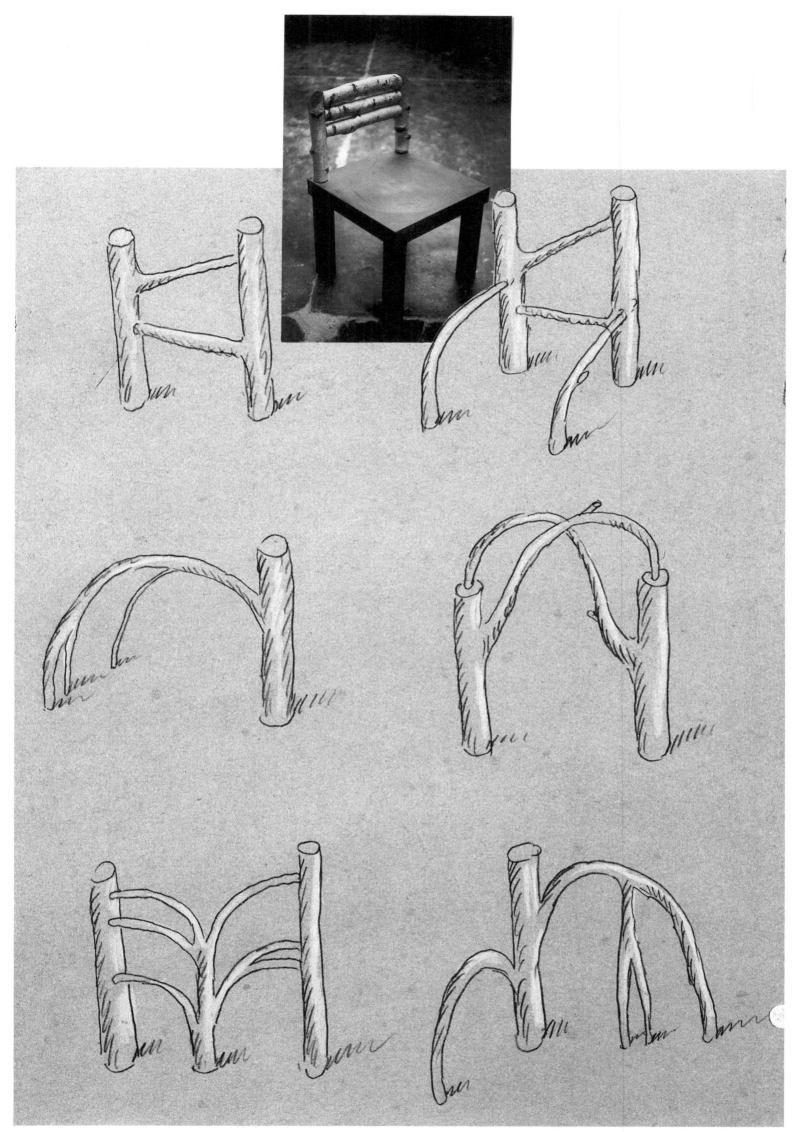

Above: layout of the exhibition by Giovanni Levanti.
Couch and armchair from the "Domestic Animals" collection, manufactured by Zabro (1985).

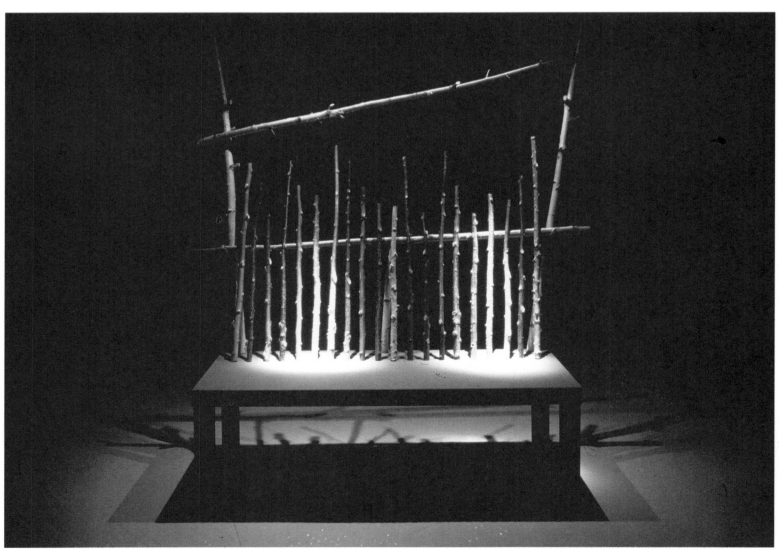

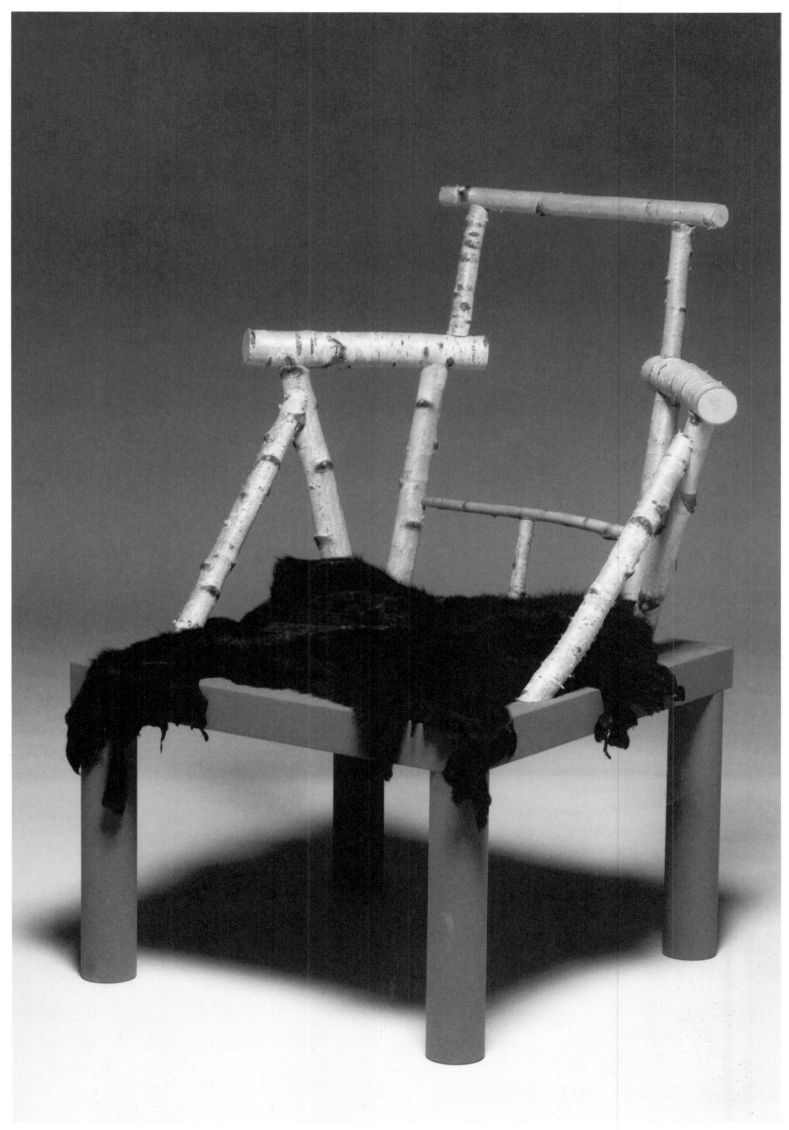

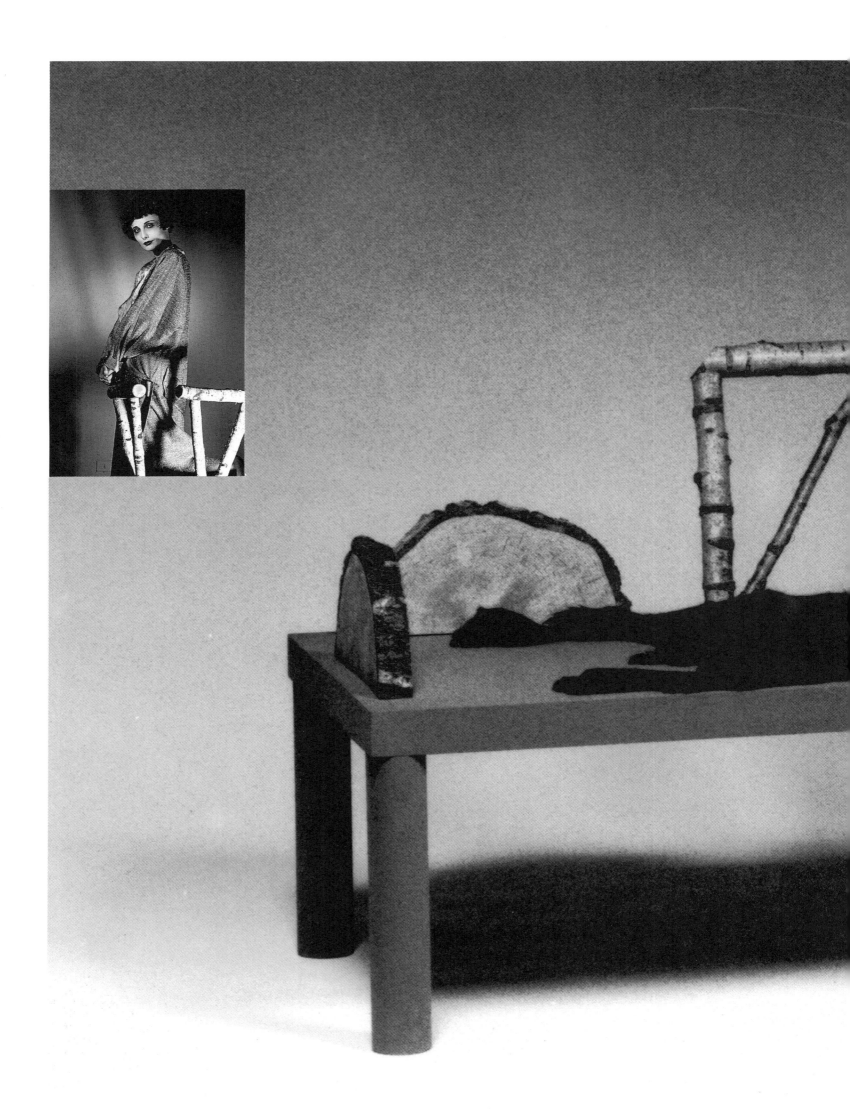

Inset: house dresses designed for "Domestic Animals" by Nicoletta Branzi. Made by Castellini.

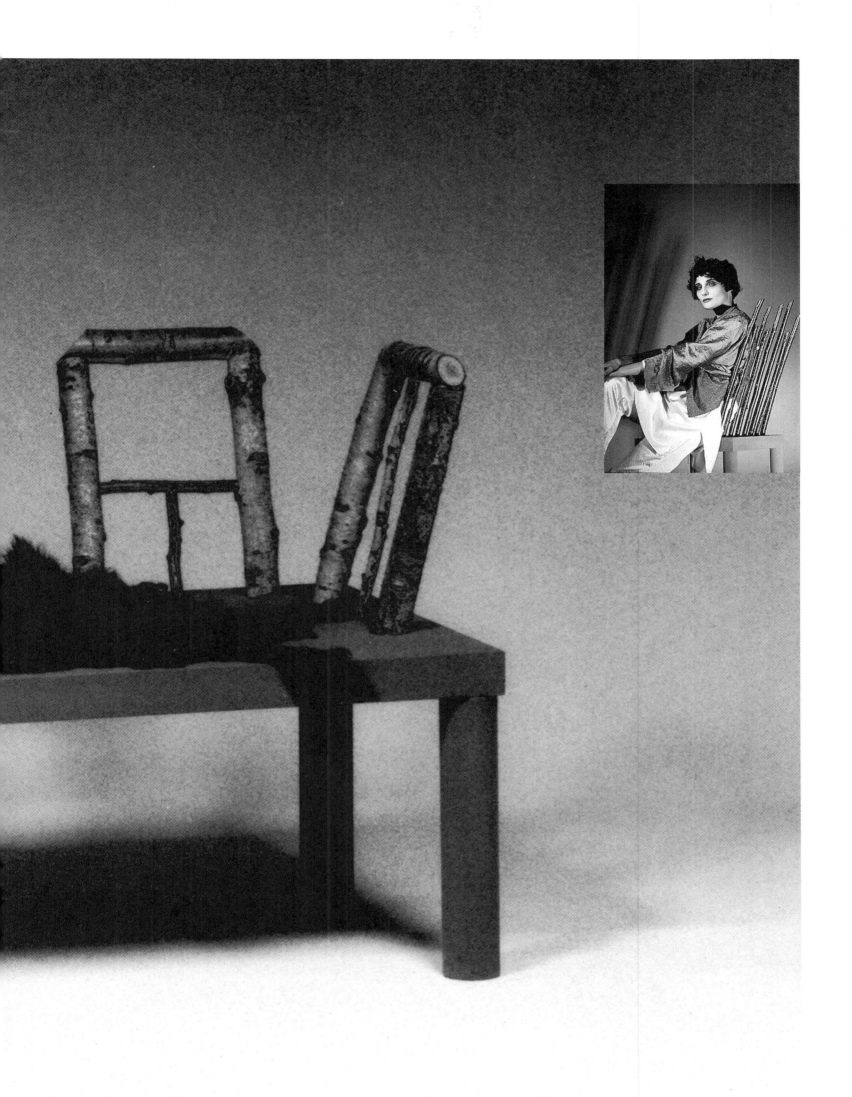

Couch from the same collection. "Domestic Animals" was based on the idea of hybrid objects, with an industrial base, and backs and arms made by craft techniques. The use of birch branches in the natural state made it possible to produce a "diversified series," since the exact repetition of forms is impossible in nature.

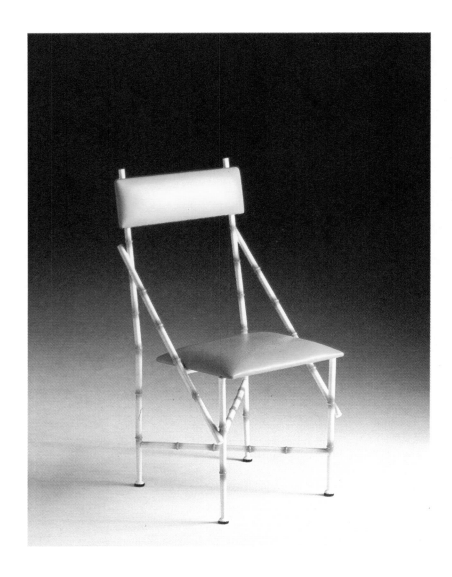

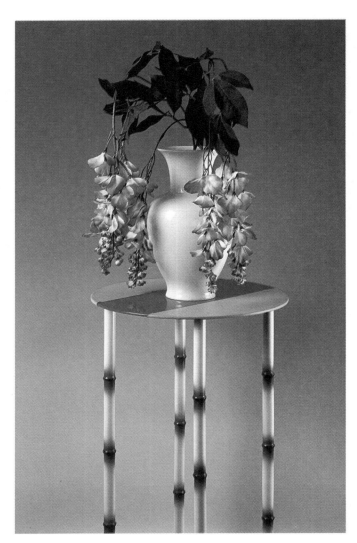

Above left: "Cairn" chair for the second "Domestic Animals" collection, manufactured by Zabro (1986). Above right: "Polinius" flowerpot holder. Below: "German Shepherd" bookcase and "Spaniel" and "Terrier," small pieces of furniture in glass.

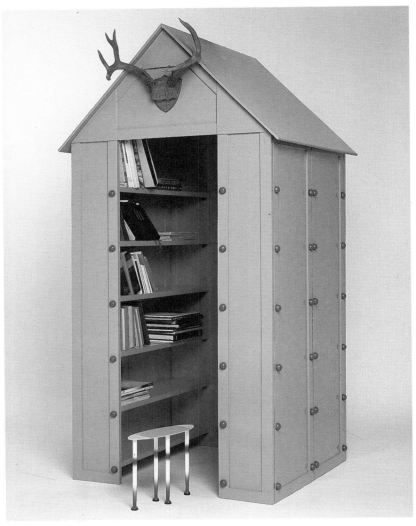

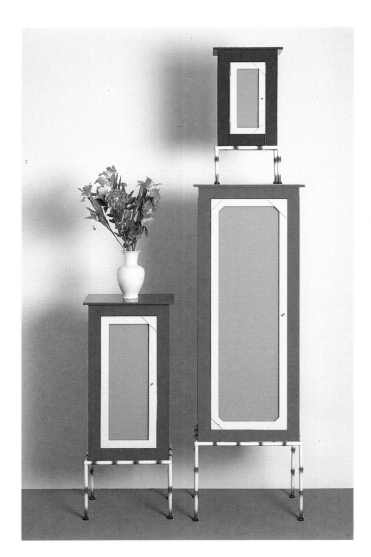

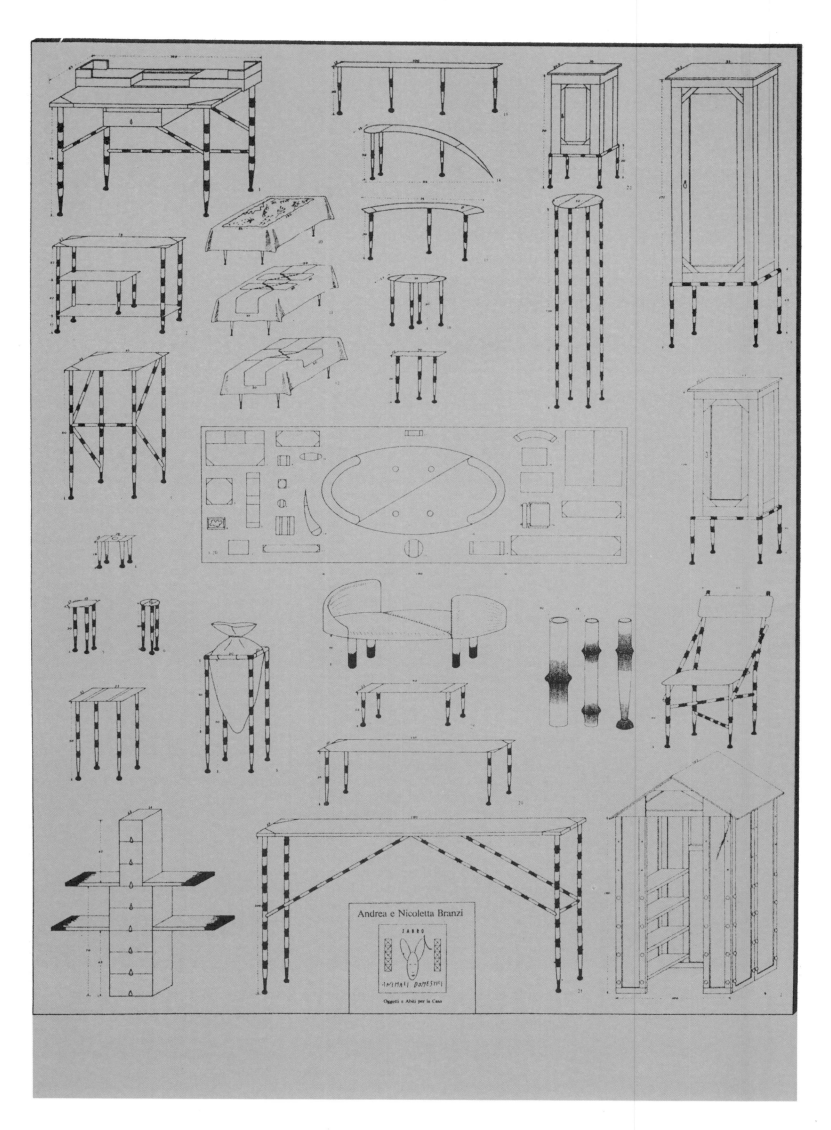

Andrea e Nicoletta Branzi

ZABRO

ANIMALI DOMESTICI

Oggetti e Abiti per la Casa

General scheme of the second "Domestic Animals" collection, consisting of twenty-seven products made out of imitation bamboo in metal, enameled in white and violet.

The new technology is part not only of the philosophy of science but also of the material culture that creates the artificial universe. Some aspects of it are going to throw into question two great principles of modern design – the principle of necessity and the principle of identity.

By principle of necessity I mean the following. Technology, with its strict limits of application and the inflexible rules to which it adheres, has represented a sort of scientific and moral certitude for generations of designers. In the face of changing circumstances, modes of expression, and attitudes toward the use of objects, the designer has always steered by the fixed star of technological reality as a unique and irremovable system for selecting the possible from the merely conceivable. Let us not forget that the very birth of the

TECHNOLOGY AND NATURE

neoplastic code at the beginning of the century, perhaps representing Classic Modernity more completely than anything else, based its legitimacy on reference to a principle of necessity; that is, from the supposedly indispensable, semantic reduction of reality into simple geometric shapes (spheres, cylinders, straight lines, and planes), making it possible for this reality to fit into the machine, to be mass produced.

The nature of the new materials removes this symbolic certainty. Technology is no longer the indisputable premise of the project. Rather it is one of the shifting variables, a point to be clarified, a cultural choice to which the designer has to give identity and certainty. It is on just this point that the threat to the other fundamental principle of modern design – the principle of identity – becomes clear. One certitude typical of the designers of the Modern Movement has been that their method of working, their inquiry into the limits and the structural and technological possibilities of a material, would lead in the end to the material acquiring a true and profound identity, and with it a number of cultural and social aspects that were bound up with the project.

The search for a profound identity of the object, its utmost limit where the choices are all constrained by the truth, has been a feature of design throughout this century, as a desire to cloak its own legitimate creative choices with a sort of scientific and therefore moral justification. From this paradigmatic viewpoint, the semantic reduction of the Modern Movement looked like an uncovering of the real nature of things, a revelation of the ultimate structure of the world, previously hidden by a mass of historical overlays. Today the most recent generation of new materials appear to form a screen on which we will have to project a possible identity. Often they are an expressive kind of ectoplasm that acquires a temporary identity, one of the many possible, only through the work of the designer. The abundant supply of materials, the

possibility of designing new materials to accord with requirements of design or expressivity, and the way that the new materials can exchange images with one another create a complex technological reality that possesses the Zelig effect – one that is ambiguous, mimetic, and often indecipherable. With the collapse of the principles of necessity and identity, the responsibility for expressive, linguistic, and formal choices falls wholly within the cultural purview of the project. The designer stands naked before the decisions to be made and will have to take them in an increasingly unrestricted fashion, making the task a still more difficult one.

This is not a simple operation but it is feasible. On the condition, perhaps, that we accept a number of conventions and a certain amount of modesty and restraint, to which we can give the name Second Modernity. What I mean by this term is an acceptance of Modernity as an artificial cultural system based neither on the principle of necessity nor on the principle of identity but on a set of conventional cultural and linguistic values that somehow make it possible for us to go on making choices and designing. Back in 1976, at a time when there was still no talk of the Postmodern, I wrote the following with reference to the future of architecture:

"It seems to me that, if there is anything significant about the historical and cultural period that we are passing through, it is the fact that for the first time we have a sufficiently clear inkling that modern architecture, as it has taken shape from the beginning of the century up to our own day, will remain unchanged in its most important features for several centuries to come.

"It appears that over the last fifty years a turning point has been reached that will determine the course of the next few centuries, a change similar to the one brought about by Brunelleschi and Alberti in the fifteenth century, which determined and conditioned a frame of operation that remained unaltered, within

"The leaves are watching us," pastel on paper (1986).
Left: "Lamp with feather" for CAIC, Buenos Aires (1986).

the limits of manners and variants, up until the last century.

"Unless the immediate future brings a series of profound social modifications, hard to foresee at this moment, the linguistic and compositional framework of the Modern Movement has entered a phase of profound stabilization, that seems difficult to alter. This is not so much because a level of lasting beauty has been attained, but due to a situation of neutral stall, of wavering equilibrium within a disciplinary crisis, that seems to offer no openings for dramatic solutions (as might still have seemed possible up until only a short time ago).

"If we look at the course the theoretical debate has taken over the last twenty years, it becomes clear that it has been moving in a quite explicit direction. From a rediscovery of the social contents of the Modern Movement at the beginning of the sixties, it has moved on to a critical verification of its limits (1968) and has now arrived at a formal adoption of these limits. These limits have been accepted precisely because they are constraints, linguistic institutions within which to operate with variations of style. We are already seeing a de facto acceptance of the Modern Movement as a permanent condition and limit, simply because, by accepting it, the prophecy on which the Modern Movement itself was based is eliminated. This prophecy was for a continual growth of architecture in society, and of the two together in a relentless process of civilization.

"Hence what is being created is neither a society without architecture, as was suggested by the radical avant-garde, nor still less a society all architecture, as predicted by the prophets of the Modern Movement. Rather what seems to be taking shape is a society for which architecture is in fact dead (in other words, a cultural structure that is no longer active). In spite of this it is accepted as one of the conditions for the maintenance of equilibrium in a historical and inherited context, a context that is not questioned but only used dispassionately as a repertory of operational instruments.

"In this sense one would say that the crisis we are going through is neither a temporary nor a fatal one but a condition of current architecture that is permanent and that emerged as a theory of the absolutely relative, projected by events into a dimension of stability, thereby eliminating its provisional nature. All things considered, this last constituted its hope and salvation, as if a sick body had been placed in suspended animation, and then preserved in history for a future age that will know how to deal with an illness that is incurable today."

I have quoted this at length since, even after ten years, I still hold the analysis to be a valid one. It is likely in fact that there will be no profound social upheavals in the near future, and that there will be no revolutionary innovations in the field of hard technology. Indeed, I feel that we are heading toward an improvement of existing conditions, toward their progressive extension to all levels of society. Among these existing conditions there is also Modernity, regarded as a set of languages and symbols selected by convention on a purely moral basis. What is going to change profoundly is the attitude toward the modern and the way that it will be handled and revised.

(From *Learning from Milan, Design and the second modernity,* Cambridge, Massachusetts, 1988)

Design for tapestry in two parts, on the theme of the "Couple," realized in Tibet by Gruppo Speciale, Bari (1988).

Top: "Tatzine" and "Tatzone," manufactured by Tendentze (1986). Bottom: setting for the "Dervishi" table, manufactured by Tendentze (1987).
Right: "Balance" and "Gemelli" brooch and earrings for Memphis 1986, manufactured by Acme U.S.A.

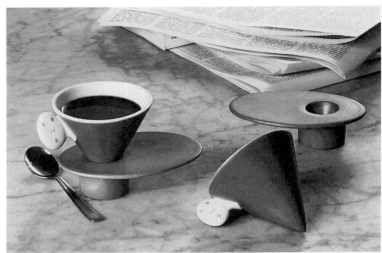
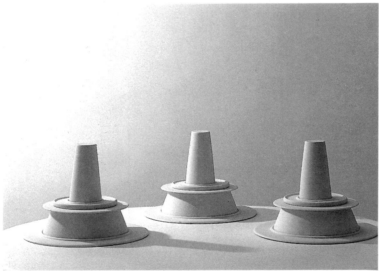
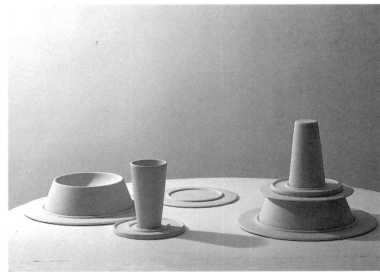

Bottom right: "Priapo" ring-holder, bronze, manufactured by Alessi, 1990.

Overleaf: "Judolia" and "Neolia" manufactured by Zanotta (1989).
Andrea Branzi and Giovanni Levanti: "Cufia" wrought-iron chair, Sibari Collection, manufactured by Gino Gigante, Lecce (1988).

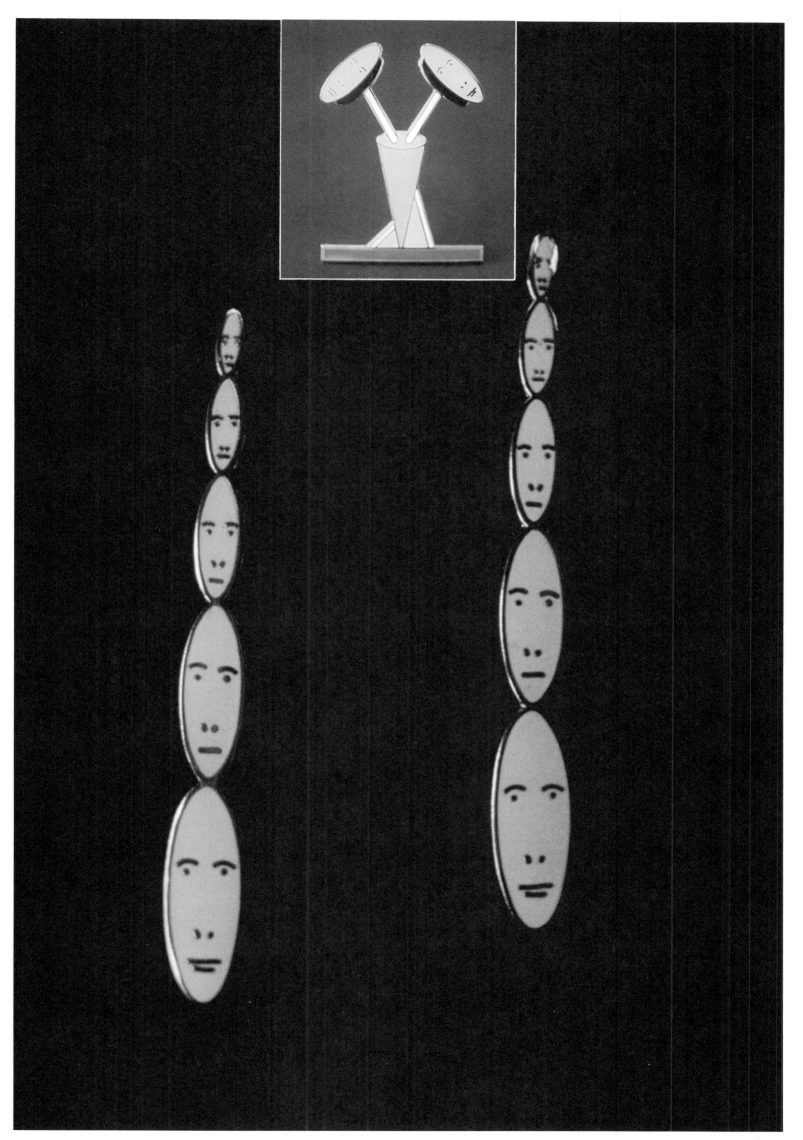

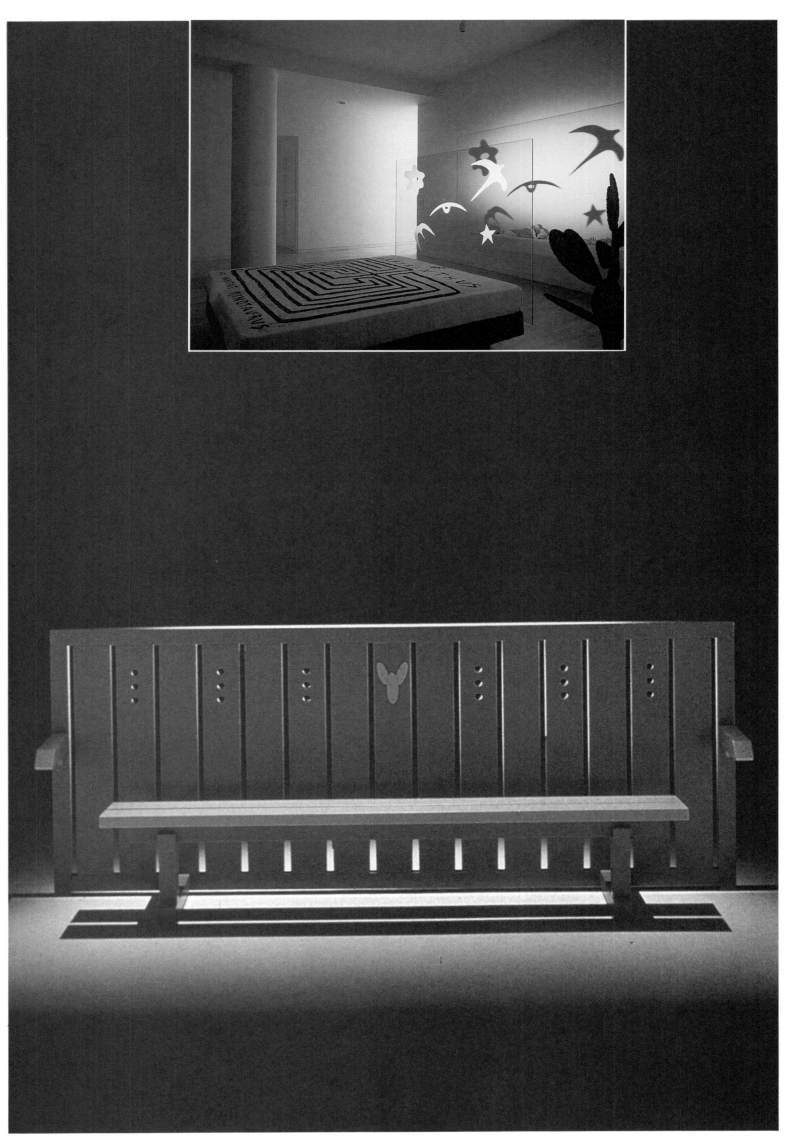

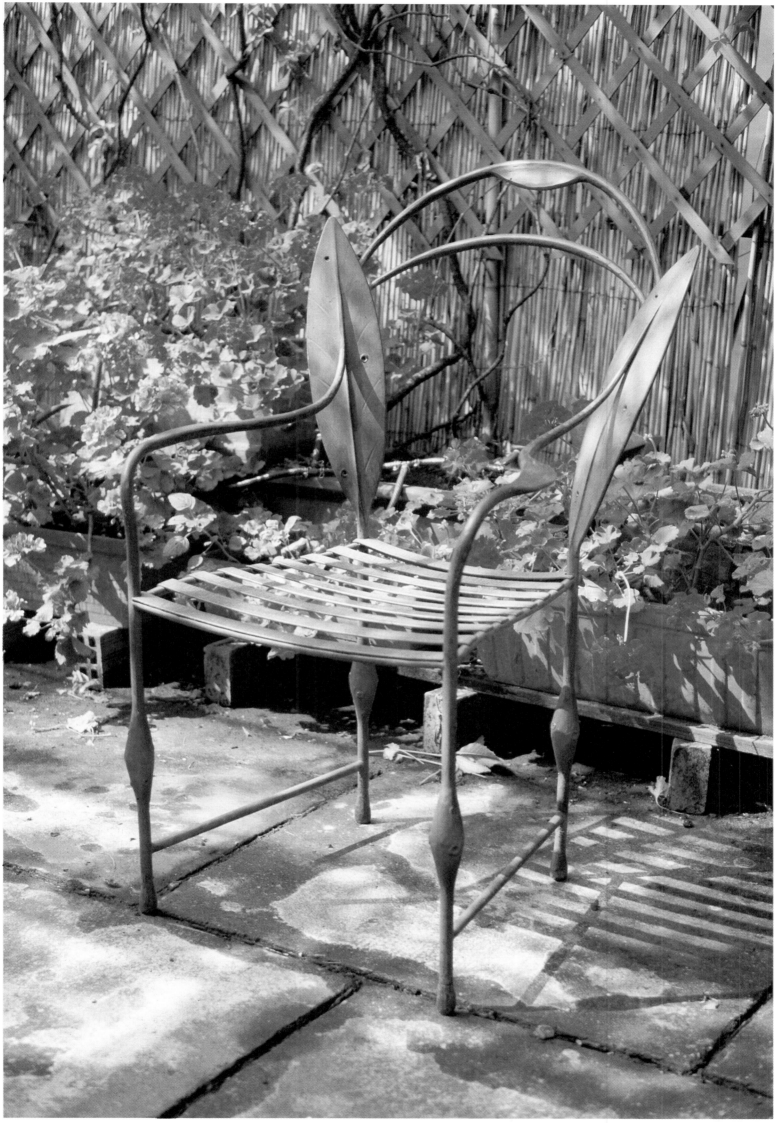

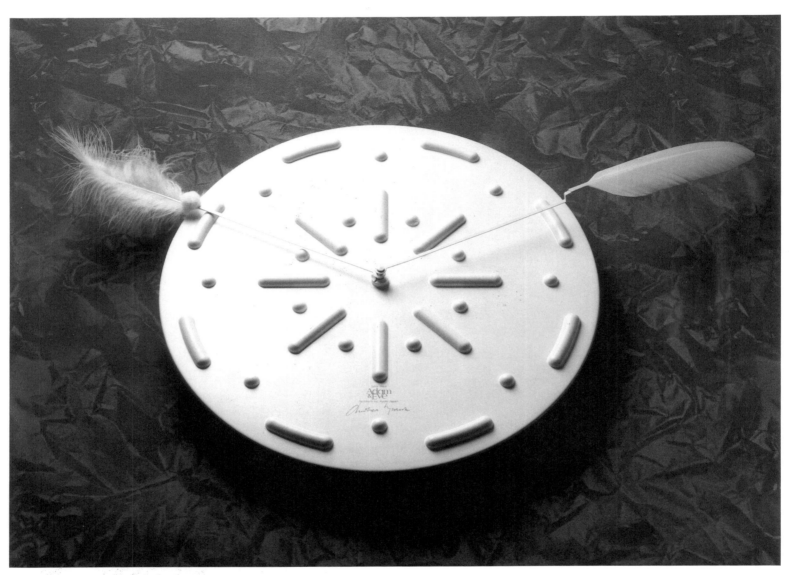

Clock made of melamine and feathers, manufactured by Adam & Eve, distributed by Seibu, Tokyo (1986).

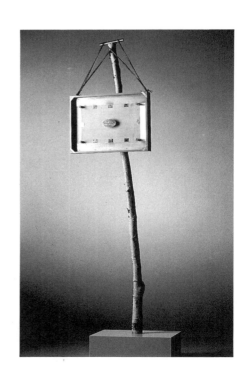

"Italia's Trophy International Design School Cup," first version, 1986. Made by Alessi.

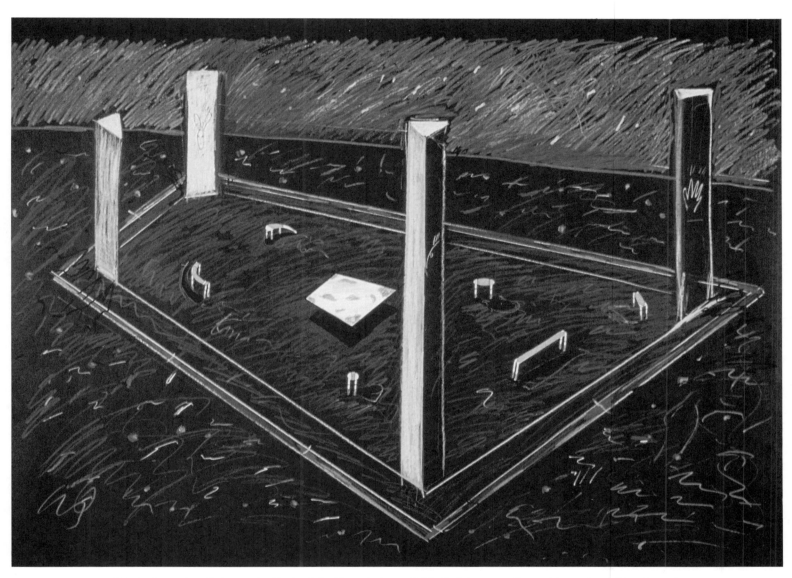

Project for the Large Hybrid Carpet installation at the Musée Saint-Pierre in Lyon, 1986. (Collaborators Giovanni Levanti and Clare Brass.)

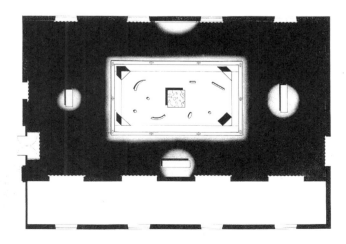

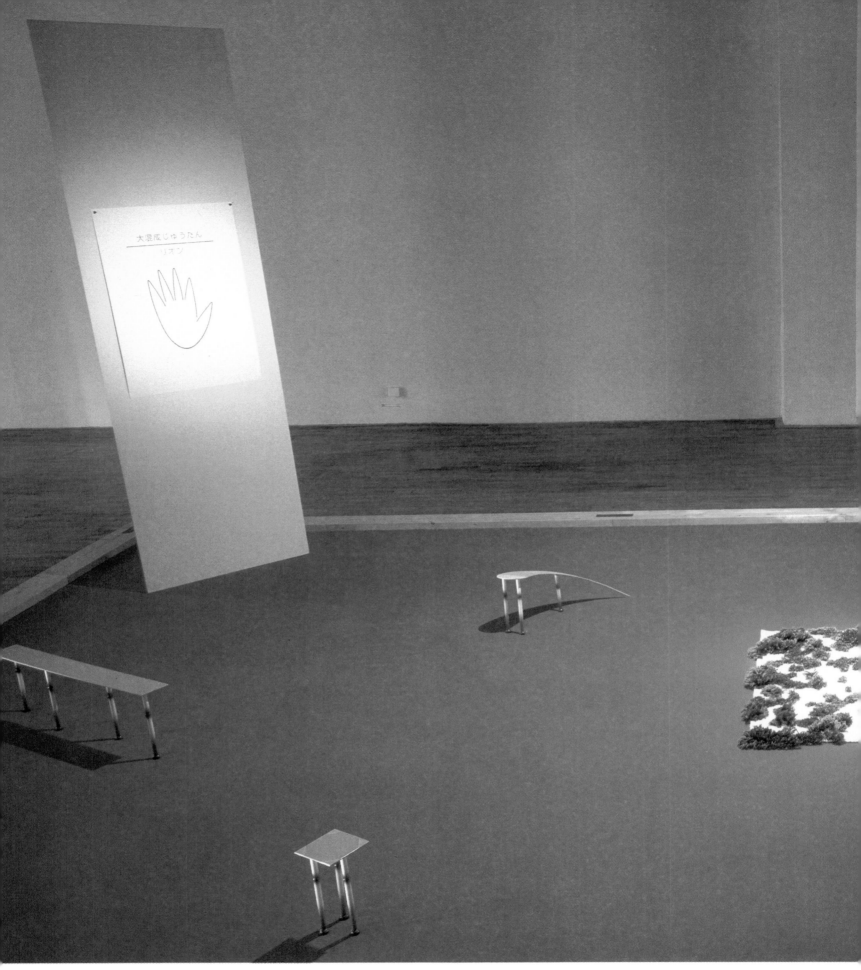

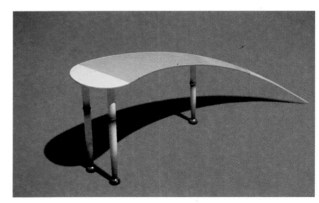

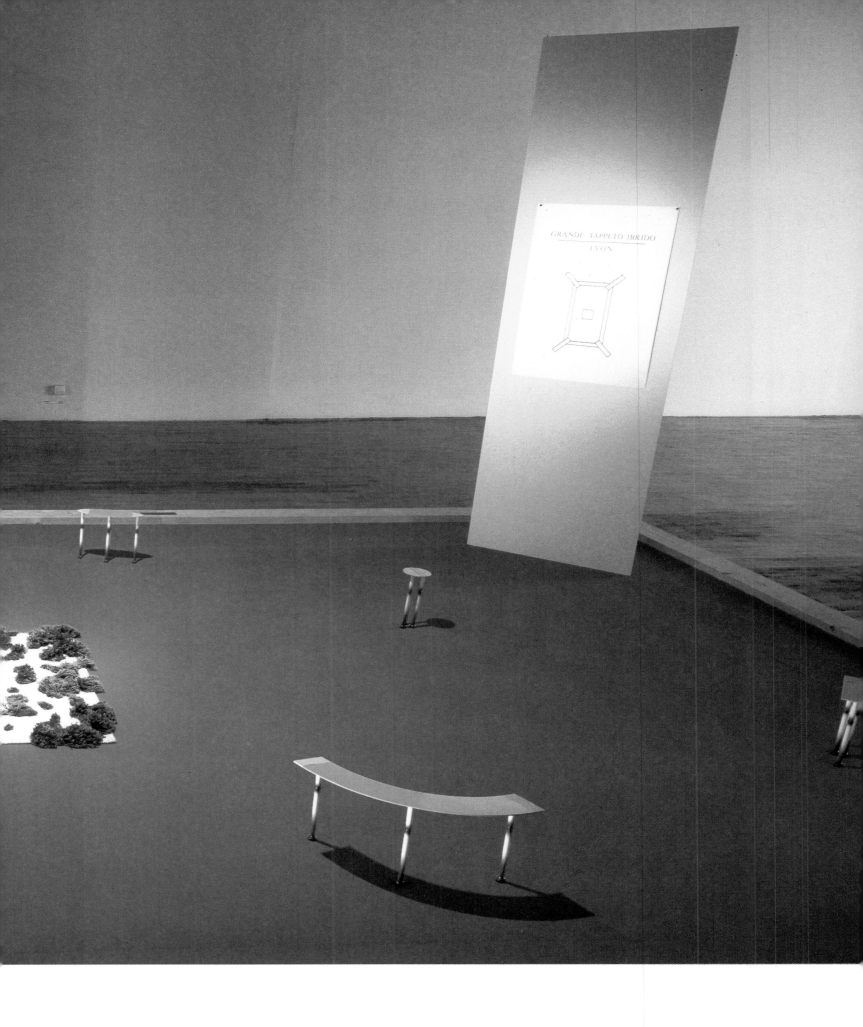

The Large Hybrid Carpet consisted of an archetypal structure, which could be a house, temple, or urban location, with four pillars on a triangular base, and a small handmade carpet of grass in the middle.

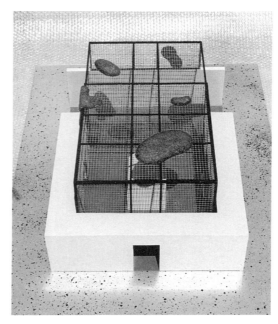

On this and the following pages: models and studies for "Houses on a Central Plan" (1986). Theoretical drawings on the theme of the dwelling as a poetic and affective place. Houses set within a perimeter or around a charismatic nucleus.

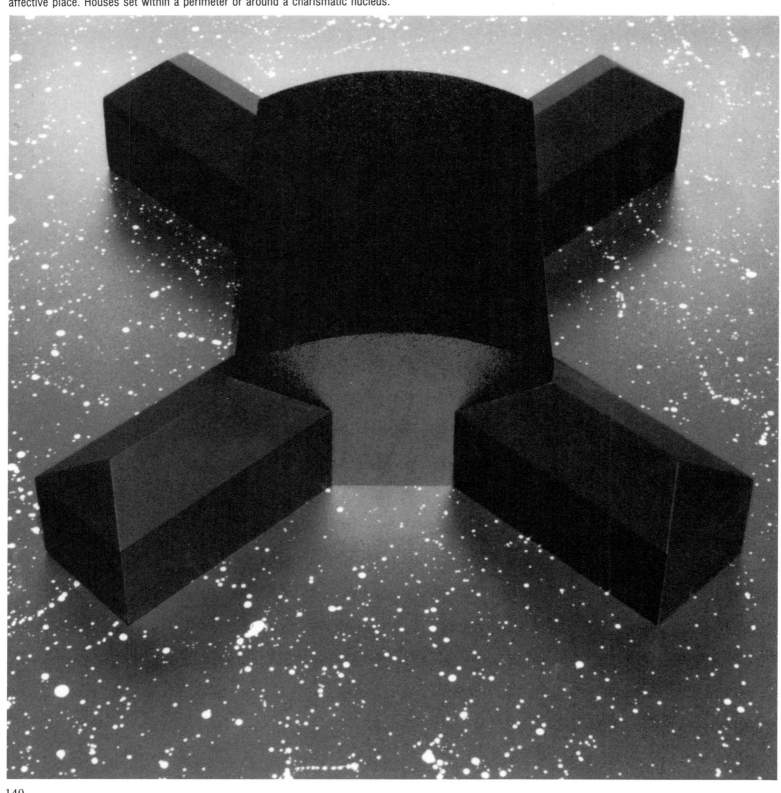

These "Houses on a Central Plan" are "mandalas of architecture," that is symbolic drawings, intended to convey the spirit of a place. The emotional center of these houses is often a domestic object (a table, a carpet). It has the capacity to be the "founder of the house," in other words a presence able to lend meaning and cultural relevance to all the other domestic functions.

Studies for "Houses on a Central Plan."

143

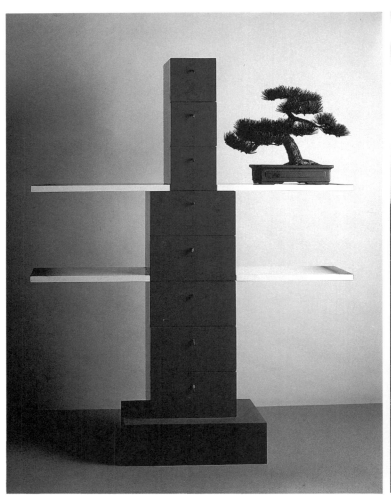

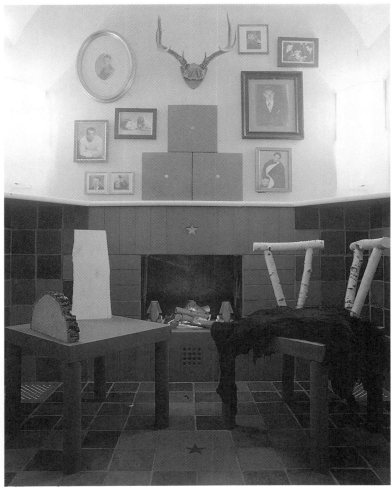

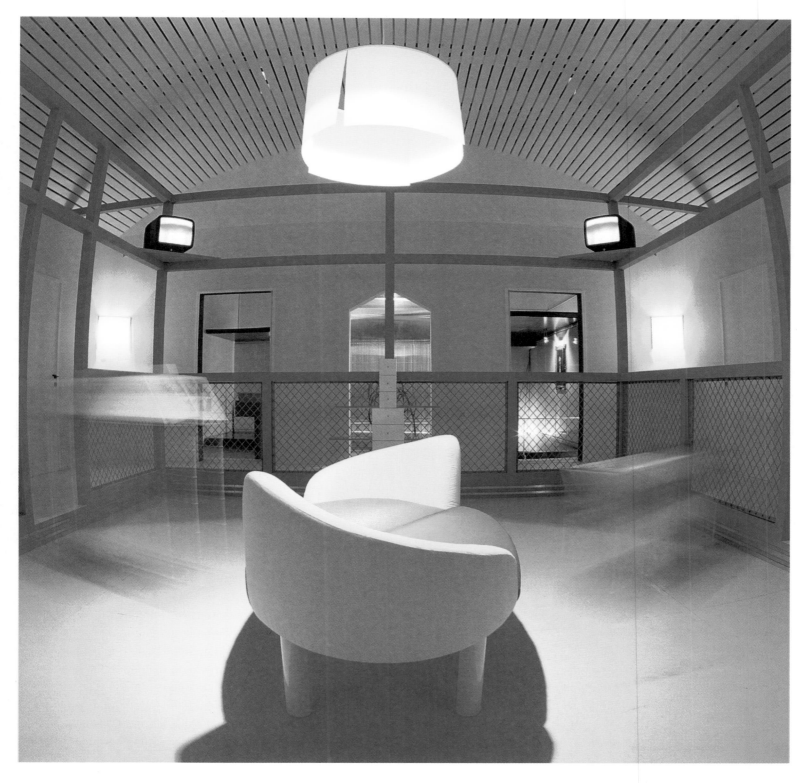

"Remote-Controlled House" for the exhibition "Domestic Project," 17th Milan Triennale, 1986 (collaborators Giovanni Levanti and Clare Brass). This, too, is a "house on a central plan," in which a couple is placed at the center of the house and summons objects by remote control.

This project won a competition (held on the occasion of the 800th anniversary of the city's foundation) on the theme of the fate of the urban area of the Berlin Wall. The project, drawn up with Theodora Betow and Dante Donegani, provided for part of the wall to be preserved as a symbol of 20th-century culture – seen

as a frontier culture, between utopia and tragedy, on the borderline between freedom and dictatorship.

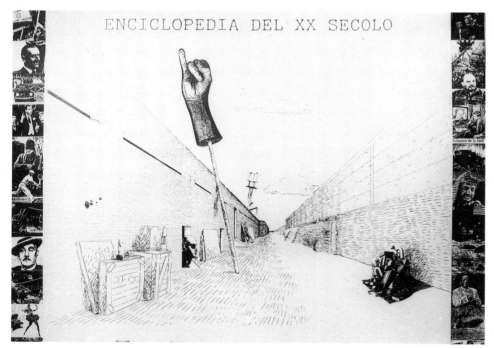

ENCICLOPEDIA DEL XX SECOLO

Above: control panel for electronic regulation of the microclimate; case with toad, manufactured by Ceramiche Ronzan (1987). Below: ceramic box with flies, manufactured by Ceramiche Ronzan (1987).
Right: "Leaf" electroluminescent lamp, produced by Memphis, made by Sinel (1988).

Left: prototype of bent-wood chair for the exhibition "Sedie-Chair News" of Promosedia, Udine (1989), made by Novalia of Moimacco.
Bottom: "Andrea" couch, manufactured by Memphis. Rigid back made of fiberglass, top of metallized plastic laminate, and revolving table (1987).

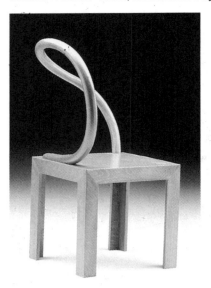

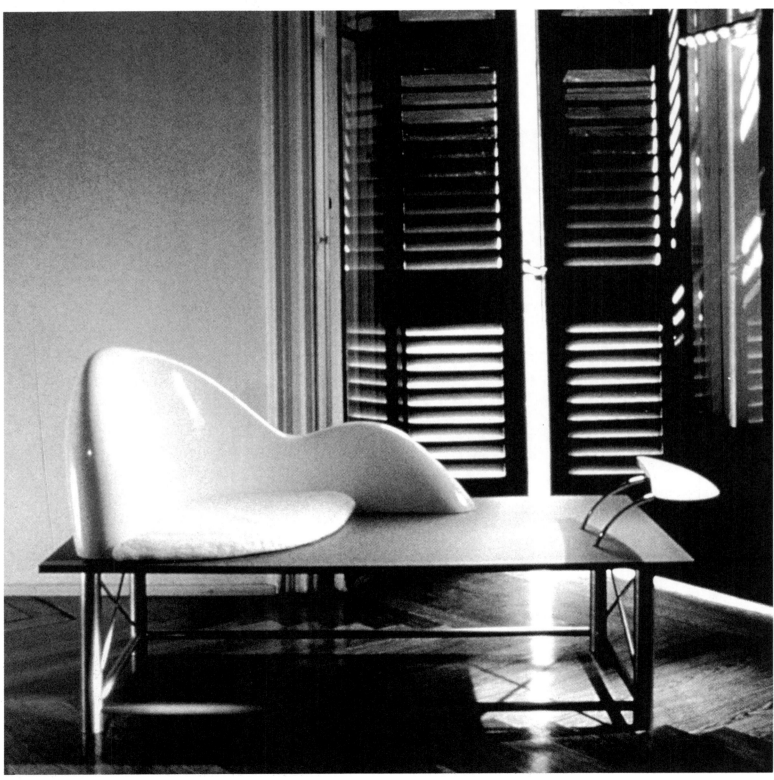

"Martina" fountain, manufactured by Up & Up (1989). Below: "Quadrio" stone table, awarded the Baden-Württemberg prize in 1991. Manufactured by Up & Up (1989).

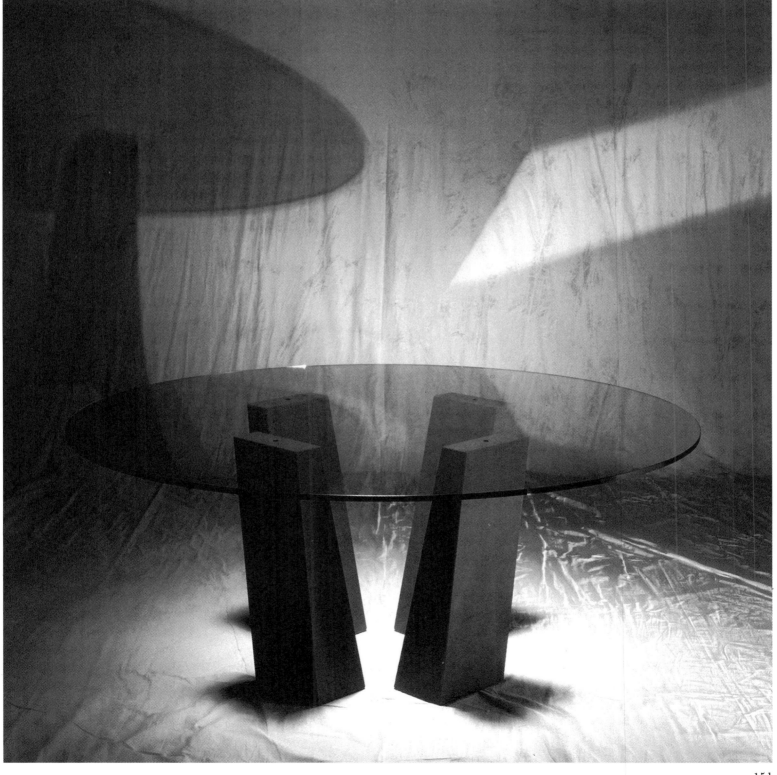

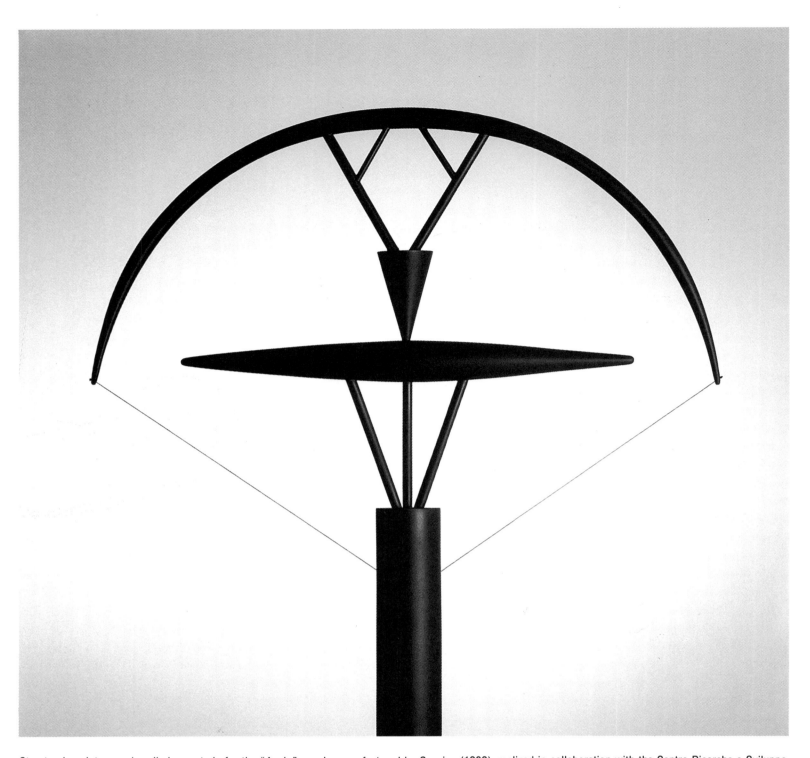

Structural sculpture and preliminary study for the "Axale" couch, manufactured by Cassina (1989), realized in collaboration with the Centro Ricerche e Sviluppo Cassina between 1986 and 1989. The theme of the research was how an archetypal structure, the stretched arch, could be used as an expressive and structural base for the product.

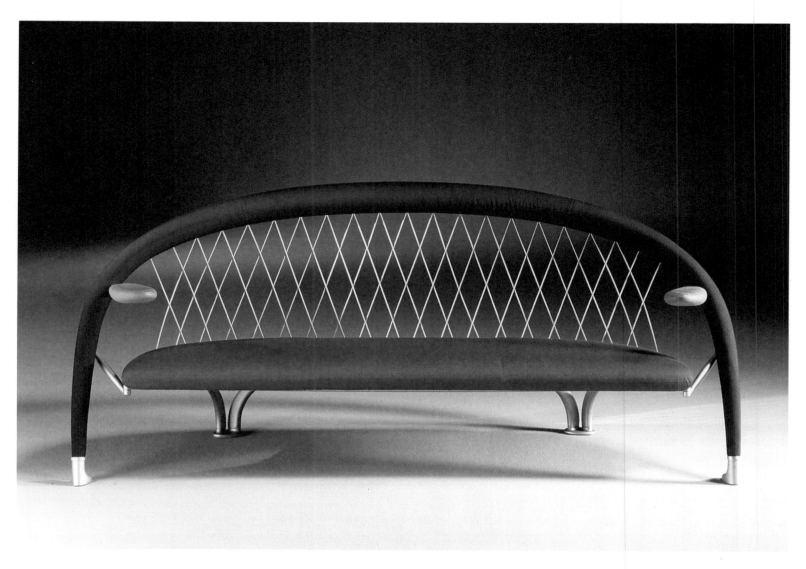

Top: "Axale" couch, manufactured by Cassina. Below: "Eucidi" tables, manufactured by Cassina (1989).

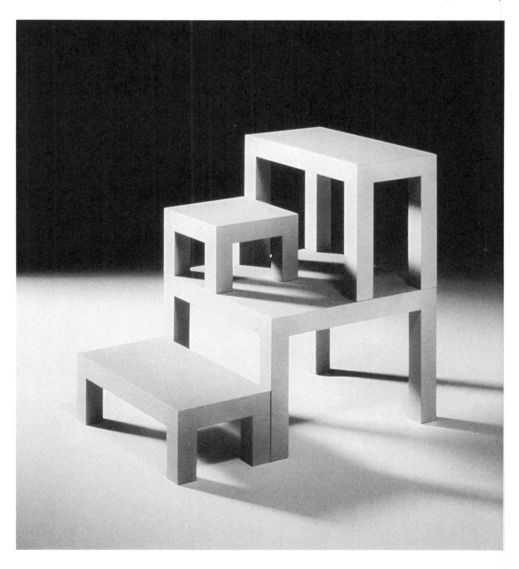

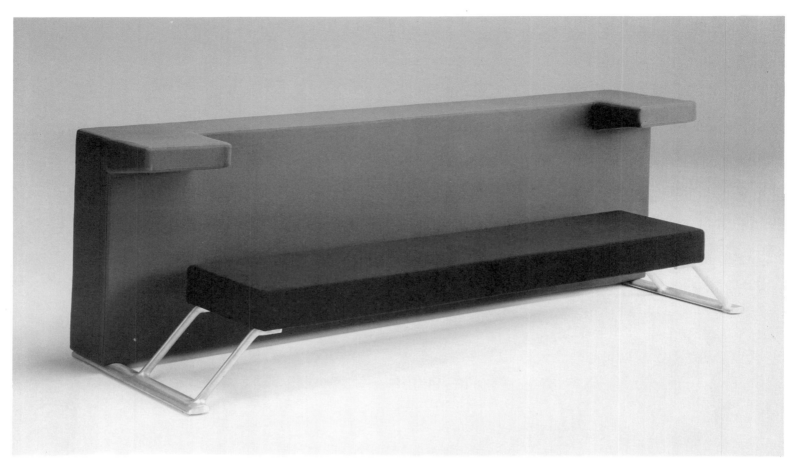

Top: "Berlino" couch, manufactured by Zanotta. Below: the "Axale" and "Berlino" couches photographed in the Cassina showroom in Milan.

Top: study drawing for the "Berione" bookcase based on the archetypal theme of the "portal." Bottom, version manufactured by Cassina (1989).

Overleaf: "Grande Grigio" theoretical environment, realized by Abet Laminati in 1988, on the theme of the new "Diaphos" transparent laminate, adopted here as a unifying element for all the components of the environment: objects, walls, doors, windows.

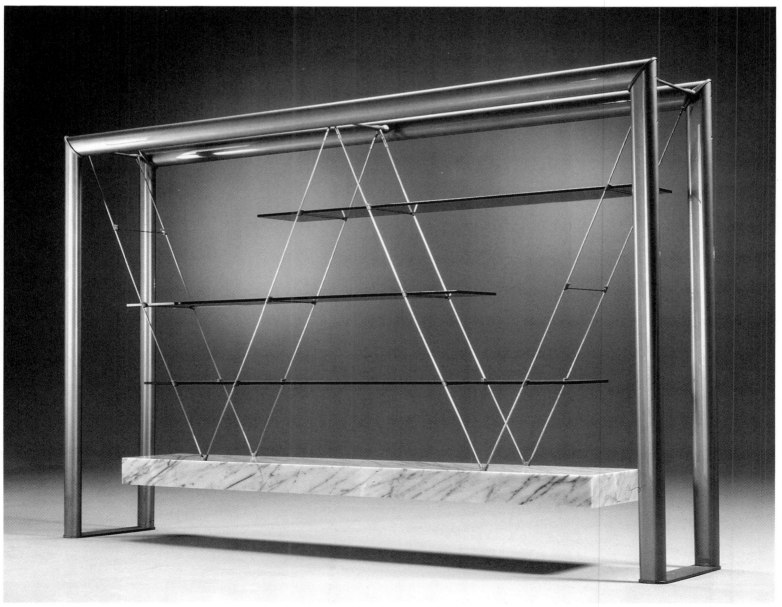

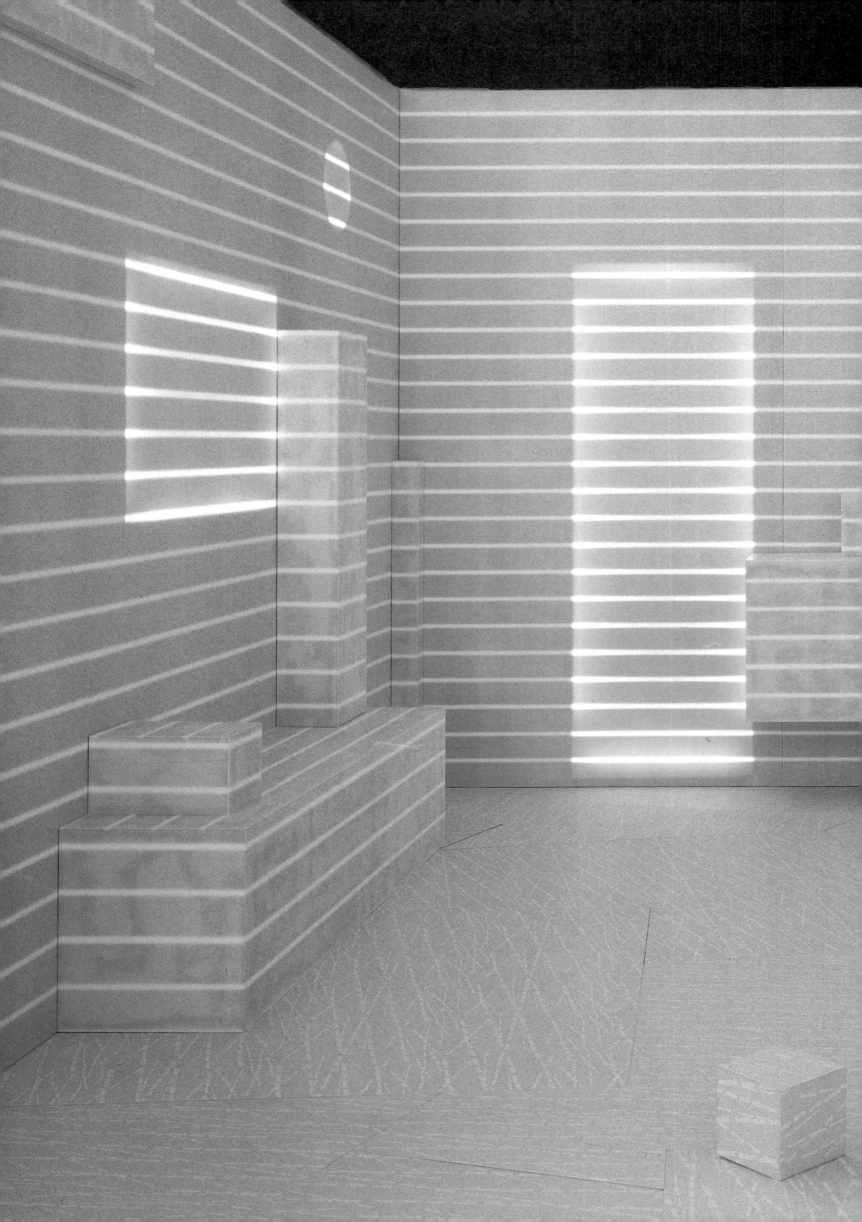

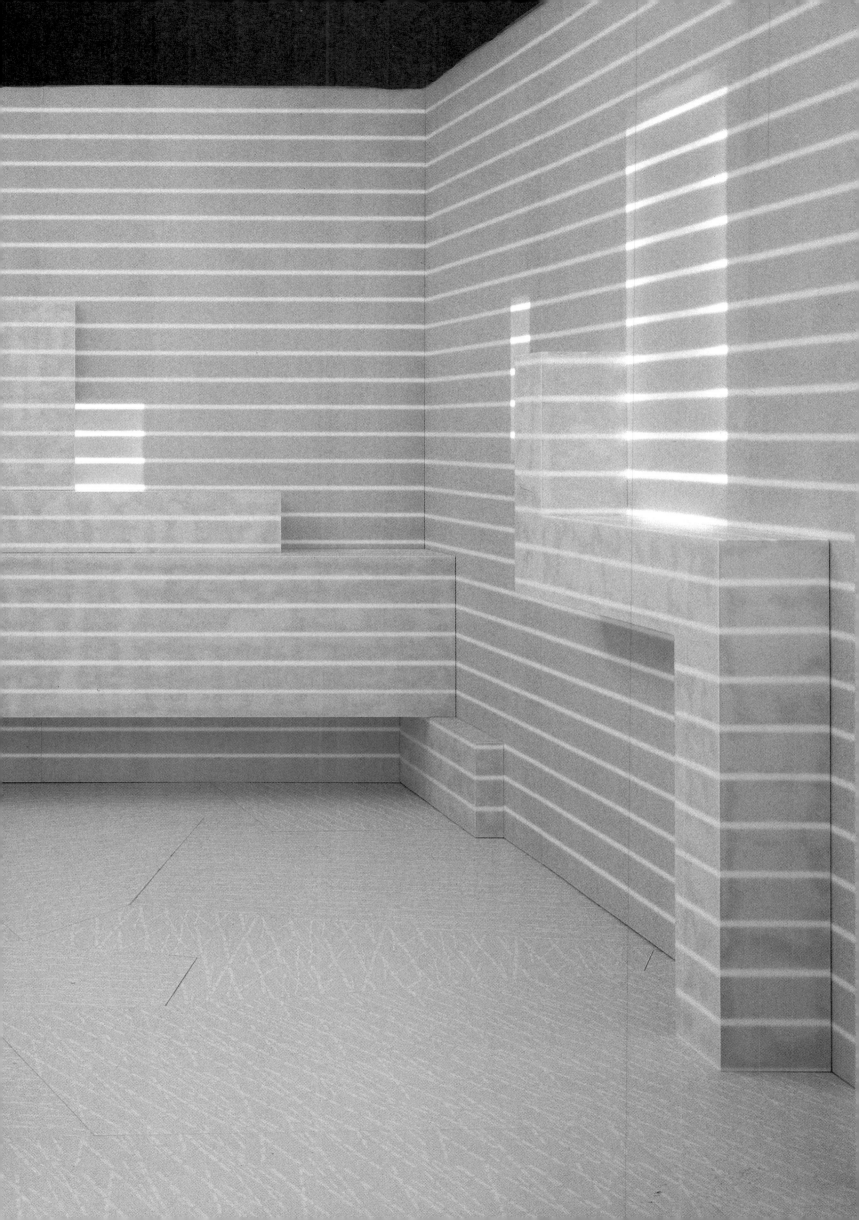

Experts and designers from different European countries met recently in Munich to discuss the common European House, as a metaphor for the encounter of different European cultures, and reached some conclusions on design that are intended to promote the development of cultural and civic cooperation on a wider scale.

These conclusions tend to confirm the historical role played by design in the major choices open to society and in the elaboration of models of development for modern societies. European design is a balance between the technological and the humanistic aspects of culture. It has always aimed to make the industrialized world both human and habitable, as well as to provide a better quality of life within an artificial environment. Design represents, therefore, one of the most far-

ECOLOGY OF THE ARTIFICIAL WORLD

reaching ethical foundations of European thought, as well as offering one of the most problem-oriented points of reflection with regard to the planning of modernity in Europe. From its genesis, design has always been deeply concerned with all parts of contemporary life: with the economy as well as ecology, with traffic and communications, with products and services, with technology and innovation, with culture and civilization, with sociological, psychological, medical, physical, environmental, and political issues, and with all forms of social organization. Given its complexity, design has meant working on the past, the present, and the future.

In the face of the great political and cultural changes that we are witnessing today, those of us involved in design must adopt a new mode of thinking and designing, and we must find an ethical basis for planning a united and more extensive Europe.

What we must also understand is that the search for a balanced and ecological model of development for our industrial and social system goes hand in hand with the awareness that the system we live in has both physical limits, beyond which lies nothing but environmental disaster, and political limits, beyond which lie dysfunctional forms of social coexistence and dictatorship. If we do not take this into consideration, we run the risk of turning design into a discipline dedicated to producing strategies of social legitimation.

The role of design is to deal with the new problems faced by society and industry, stimulating them to come up with new qualities of profound significance and to create a more advanced ecological balance between human beings and the artificial environment they inhabit.

The investigation of an ecology of the artificial world must be seen as part of this debate. What is called for is an ecology able to come to grips with the major cultural problems of the future, an ecology that is neither reactionary nor punitive, but rather problem-oriented and dyna-

mic, founded on three humanistic theorems.

Let us call the first theorem "*ecology of complexity.*" It proceeds from the observation that, *as in nature*, the artificial environment that surrounds us is based on a polycentric and highly differentiated logic. In the metropolitan setting of our post-industrial society, apparently contradictory logics of production and technology coexist and balance one another: production on a large scale along side small-scale runs; mass products alongside one-off pieces; standard languages alongside anarchic ones; high technology alongside archetypal technologies; codified modes of behavior alongside nonconformity; definitive products alongside seasonal ones; handmade alongside industrially produced goods; the historical object alongside the throw-away one. It is in terms of these contradictions that we have to look at a new dimension for design.

This diversity has a positive value: such complexity is an anthropological condition to be exploited, not to be eliminated.

We therefore have to work to find the right temporary and experimental balance in our environment between these different logics of technology and production, a balance that accords with a rich and emotionally satisfying view of the artificial environment.

We shall call the second theorem "*ecology of the project.*" It proceeds from the observation that, *as in nature*, humanity establishes a highly complex relationship with artificial objects through the use to which it puts them. This relationship is never confined to the technical and ergonomic functions of these objects, but is enriched by fundamental symbolic, literary, affective, and psychological elements.

This complexity of relations has a positive value, it is a resource to be developed, and not to be resisted.

Thus society today is faced by the challenge of creating a rich interface between humanity and the artificial world.

"York" bookcase, manufactured by Acerbis International (1990).
Bottom: glassed ceramics, produced by Ceramiche di Capraia (Florence, 1989).

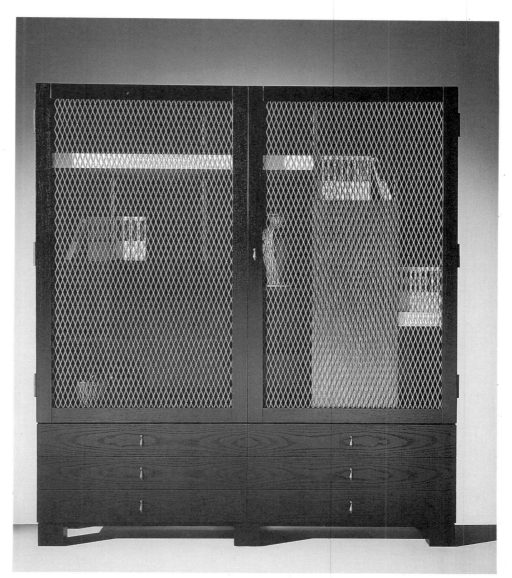

To achieve this result, design must find a new sensitivity and change its methods of working and the languages it uses. What matters is results, not respect for some particular methodology.

Design will have to develop new professional skills and approaches to education.

The third theorem is that of the "*ecology of relations.*" It starts out from the observation that, *as with nature*, people today have to reconstruct a well-balanced relationship with the human environment. The processes of industrial automation are resulting in a great migration of the manufacturing population away from large and small factories toward the service companies and commerce, in the heart of the post-industrial metropolis.

This historic human migration produces an environment that is densely packed with human interfaces.

Robotization, therefore, is engendering a great increase in interpersonal relations. The ecology of human relationships and the ability to generate new codes of behavior will become one of the major themes of the culture of design and planning.

The old form of ergonomics, concerned with solving problems of scale, and proxemics, concerned with describing the personal spaces of the individual, must both move into a new area of research, concerned with defining the modes and forms of a new behavioral culture. This will enable us to tackle the metropolitan future, without the risk of a collapse due to an uncontrollable excess of human contact.

What we want to assert with the "Munich Charter" is design's role as a culture that is concerned with the relationship between humanity and the artificial world: a discipline set at the heart of the great problems of this century and a crossroads for Europe's role in the world.

In our society, the development of this new dimension of design will become the yardstick by which the quality of life may be assessed.

(From "*An ecology of the artificial world,*" with Michael Herloff, The Munich Design Charter, 1990)

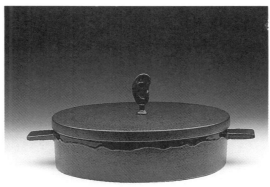

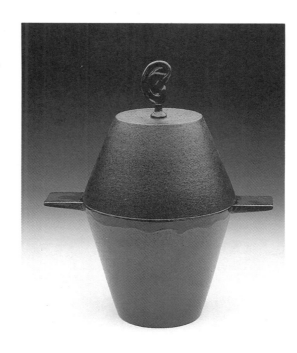

Plan of the Cassina showroom, consisting of a few large walls and a large ear, which is center of attention in the space. Milan (1989, collaborator Paolo Pagani).

Casa Fontanella, restructuring of an old town house in Biella (collaborator Paolo Pagani, 1990).

Fireplace with marble frieze and bookcase made out of wooden volumes.

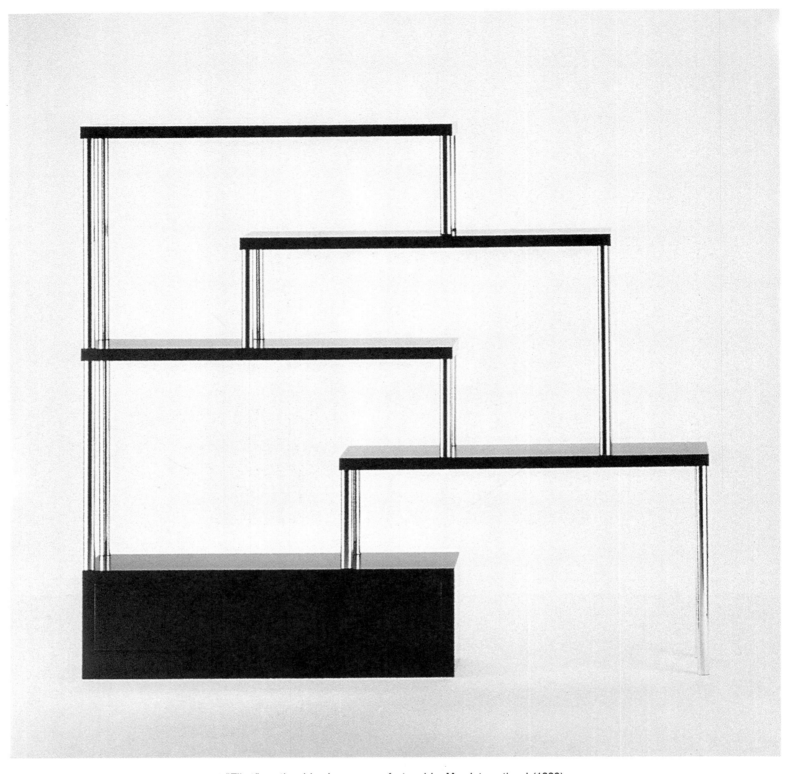

"Tibet" sectional bookcase, manufactured by Max International (1990).

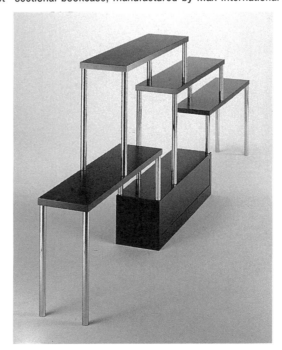

Above: prototype of Body-Shop at the exhibition "Habitat Immagine" in Arezzo, in "Diaphos" and plate glass in collaboration with Andrès Salas (1990).
Below: "Toothpick holder" in wood and metal, manufactured by Twergi (1991).

Overall layout of the exhibition "Dialectes métropolitains – Les Capitales Européennes du Nouveau Design: Barcelone, Düsseldorf, Milan, Paris," at the Centre Georges Pompidou CCI Paris, 1991, and at the Kunstmuseum in Düsseldorf.
Curators Andrea Branzi and François Burkhardt (with the collaboration of Andrès Salas and Palma Giarratano).

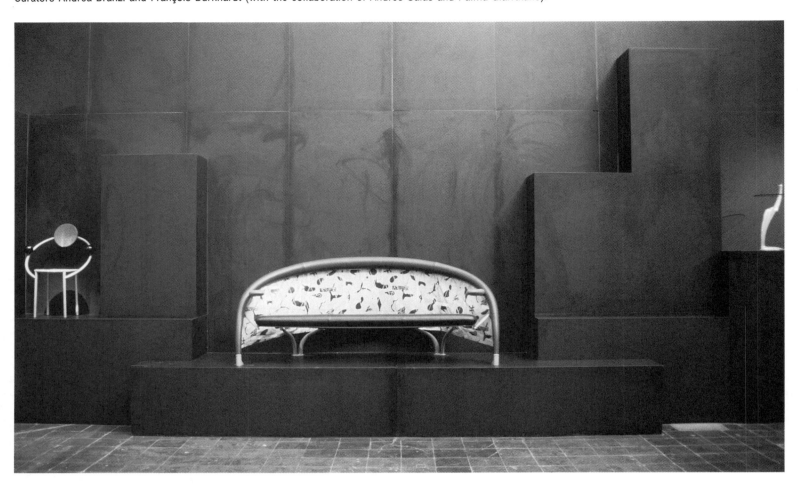

The theme of this major exhibition was the comparison of the different dialects of expression created by the New Design in the great metropolises of Europe.

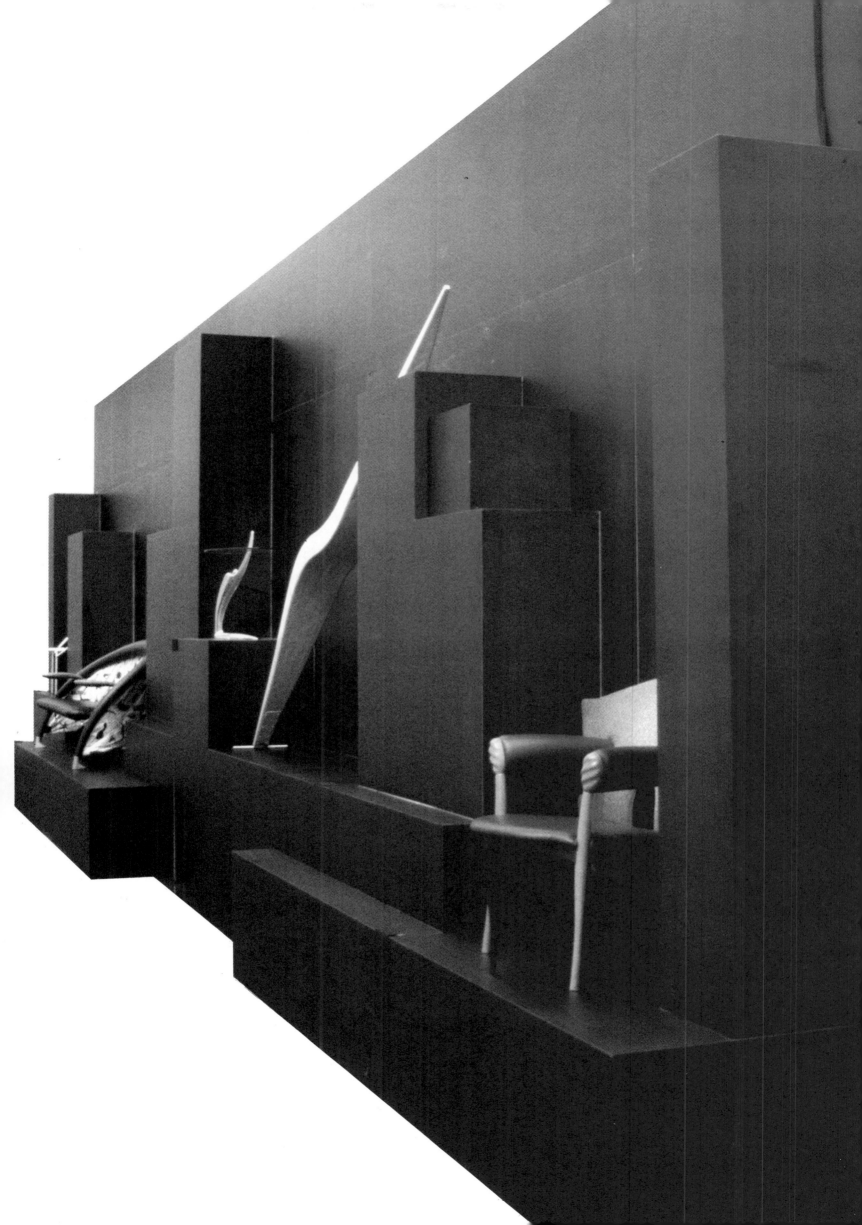

As time passes, we will think back with growing regret to that happy era when Le Corbusier could still dedicate his Ville Radieuse "to the Authorities." It was as if he were saying: Here is my plan, this is my idea of how cities and the homes of men would function better; now it is your turn, Authorities, to accept the responsibility of putting this idea into effect.

Back then, the city was an object, a single mechanism, admittedly complex and delicate, but one which would still fit into a single sign and a single dream; society was undergoing a profound transformation, but it could still be founded anew in the context of a political program. And the Modern "movement" continued to move happily in that direction – as if in a clearly understood relay race, architecture and urban planning passed from one to another the baton of a great and

THE DOLCE STIL NOVO

unified design for reform. And this perhaps is the feature that most sharply sets us apart today – we are surrounded by a metropolitan and social context that demands a design, but which seems to resist all unified plans and proclamations. The age in which urban planners developed City Plans, architects designed Houses, and industrial designers invented Chairs (since that was what the world was made of), came to an end some time ago. Now, the world that surrounds us is composed of a massive "protoplasm" of technologies, structures, services, information, and language – it is all a dense world, a hazy solid, a polluted aquarium, in which bob the flotsam and jetsam of design and anarchy, of technology and magic. We stand amidst a reality that man, in all his history, has never before experienced. Man stands defenseless before this overwhelming freedom; man lacks powerful and appropriate ethical foundations, and is unable to find critical points of reference and traditional perspectives.

Perhaps now as never before, man is aware of the impossibility of making a mark, of how useless are his efforts to leave a single sign and dream; at the same time, man feels the surge of energy that all this triggers within him, and instead of resigning himself to drift on the tide of huge numbers, man is once again lighting a fire to illuminate the primordial shadows that hem him in. Perhaps this is the common denominator of our generation of architects, a generation that I would dub that of the Dolce Stil Novo: working on design that hovers at the brink of an impossible existence.

Ours, therefore, is also a happy and fortunate generation, which closes a century and opens a new millennium. Happy and fortunate because it is a generation that is summoned to choose – aside from its design decisions – between silence and environmental strategies, between the collapse of all utopias and the possibility of saving the world with new qualities. Our generation is opting out of architecture in order to rebuild it in other dimensions.

And our strategy is based upon two different progressions. On the one hand, we are moving along the vast front of environmental components (signs, sounds, lighting, color, information, structures, services, and functions), and thus, we are composing – through this vast and diffuse availability – a new narrative, a gripping fiction. This results in certain dense environmental enclaves that may well be provisional (though this matters little), but which derive their power from their very diversity and the fact of their being alternatives to that which surrounds them. An artificial environment, a sound upon which to rebuild an island of sense, amidst the background noise of events which spread out with no clear destination. And on the other hand, we are taking a segment of this universe of artificial detritus, and upon that segment we are impressing a powerful outpouring of design. It is almost as if we were performing a profound and sudden cloning of ourselves – a powerful and mysterious image, which is more valuable for what it does not explain and what it conceals, than for what it clarifies and illuminates. Metaphors, designs, but also immovable boulders. The distinctive feature of our sort of design is, in fact, that it creates – through sites, objects, and architecture (which are all minor nodes in an invasive flood of organized detritus) – realities that are capable not only of being perceived as functions and services, but which also provoke a poetic, symbolic, psychological, and spiritual use of themselves.

Our strategy is therefore lateral with respect to architecture and design – they are merely tools in a grand humanistic design, a cultural theorem which goes far beyond any individual discipline. And this sets us apart from those who see "architecture" as an end in itself, and not just a means, of creative planning.

But then each of us follows a specific strategy as he travels this path, encountering objects and technologies in a chaotic manner, fluctuating in that great artificial universe that is the post-industrial metropo-

Idea Books garden, Milan (1989).

lis. We do not anchor ourselves to the terra firma of the islands of marketing and taste analysis – we are totally immersed in the breakers of the market and the spores of language, of which we ourselves produce great quantities. Indeed, we try to create order by moving around like frenetic particles, we try to make the atmosphere crystalline while ourselves producing pollution. Twenty years ago, we waged a victorious war against an International Style that was based on an elementary and reductive language well suited to the mass consumer. We also discovered, however, that beneath that gray and chilly mantle, local cultures had ceased to exist; familiar languages and regional technologies had been destroyed. Only a few went to the countryside to search for them in vain, while all the others understood that we ourselves would have to reconstruct these local specificities, by founding new styles and new metropolitan traditions. The qualities of life no longer came to us from the warmth of the past; we had to search for them in the compact discs of the present. In practical terms, we are trying to reconstruct differentiated cultures, based on international materials (the only materials available). We are trying to "dance in the battle" (as Nietzsche would have said), but we are in fact amidst innumerable armies, and we cannot even be sure which is the enemy. After all, this is the substance of which the Hybrid Metropolis that contains us is made, and this is its paradox – different places, settings, opposite corners, separate neighborhoods, stylistic enclaves and ghettoes. Each is different from the others, to the point where they become, by virtue of their very diversity, equal to one another, and interchangeable.
The brink of the abyss upon which designers "dance" is that of the plunge into the generic – their different signs, their separate fictions, in the end wind up being homogeneous, and the Hybrid Metropolis that contains these diversities once again becomes a "generic metropo-

lis" (the Fourth Metropolis), in which all things resemble each other, though they may be different.
In this magma, where everything has already been invented, manufactured, sold, and tested, the only room for growth and truly creative planning, and for creating the new, is found in the spaces of ethical imagery. Those spaces created by culture, the dreamy stage settings of a world that does not exist but could exist, which we can begin to plan, starting from the infinitely small, from the premonitory signs of livable and intense spaces.
This is our heritage as imperfect animals, as always, ill-suited to and intolerant of the environment that surrounds us. Unlike insects, which are condemned to live in the immobility of a perfect relationship with nature, we imagine and constantly search for something that does not exist, and that is why we design and produce history. That is why an architect exists as long as he succeeds in producing new qualities that are profound, intense, and always real, even though they are improbable. And this is the source of our "Dolce Stil Novo," as a token – expressed through sites, objects, and houses – of our determined active resistance, of our rejection, through design, of the vulgarity and violence of the world; an attempt to halt the perennial expropriation, to stop all signs from being dragged down into darkness, to prevent devastating intrusions into the house of man. We do so by illuminating – if only briefly – the walls, the floors, the squares, by following a narration that links man once again to the mysteries that he loves: his life in the cosmos, his house in the world, the twilight of pleasure, the archetypes of his body, and the magic of technology.

* *Translator's note: the Dolce Stil Novo, marked by a relative realism and a use of spoken language rather than Latin, was developed by a thirteenth-century school of Italian poets; Dante Alighieri was a "stilnovista" early in his poetic career.*

(From *La quarta metropoli*, Milan 1990)

Sketches on the theme of the "Ear" as a symbol of the Sensorial Revolution, frequently used in projects as a listening element in the surrounding space.
Right: Yatai for the Universal Exhibition in Nagoya, Japan, 1989 (collaborator Paolo Pagani). Constructivist tower with ear for the display of musical instruments in the space coordinated by Shigeru Uchida.

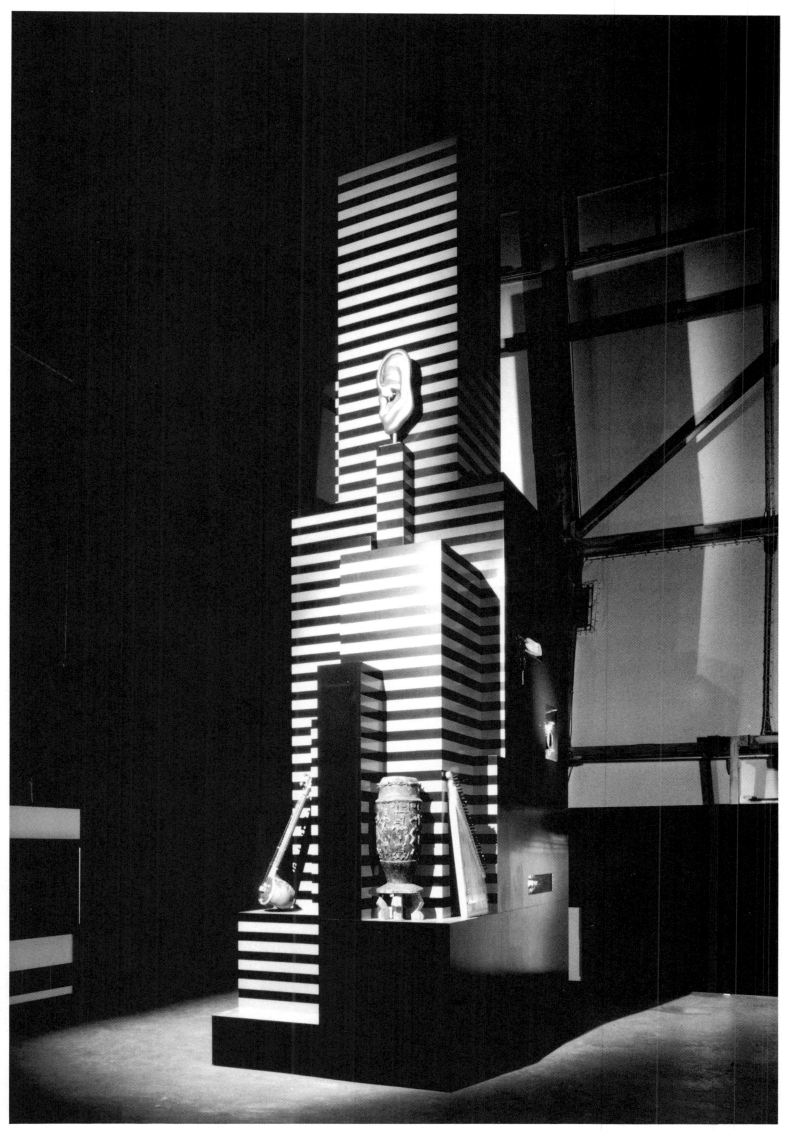

Tokyo International Forum Competition, 1989 (with Tullio Zini and Franco Lani, collaborators Grazia Franzoni, Michele Zini, Claudia Zoboli, and Daniela Ascari). Large gray and anonymous building surmounted by a dish antenna in the shape of an ear. Inside, stone gardens, waterfalls, and luminous spaces.

Above: photograph of the model. Below: Forum International in the setting of Tokyo.

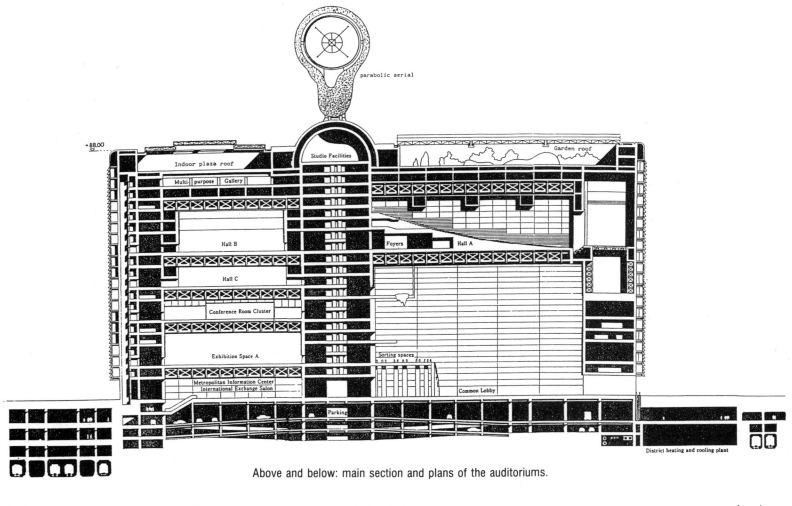

parabolic aerial

+88.00

Indoor plaza roof

Studio Facilities

Garden roof

Multi-purpose | Gallery

Hall B

Foyers | Hall A

Hall C

Conference Room Cluster

Exhibition Space A

Metropolitan Information Center
International Exchange Salon

Sorting spaces

Common Lobby

Parking

District heating and cooling plant

Above and below: main section and plans of the auditoriums.

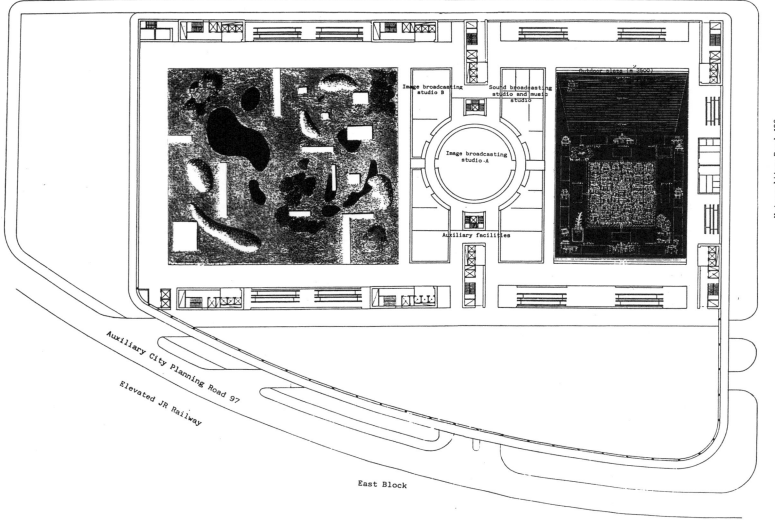

Office Bldg.

Office Bldg.

Office Bldg.

Metropolitan Road 402

Image broadcasting
studio B

Sound broadcasting
studio and music
studio

Outdoor plaza (±4500)

Image broadcasting
studio A

Auxiliary facilities

Metropolitan Road 406

Auxiliary City Planning Road 97

Elevated JR Railway

East Block

Above and below: section and drawing of main front.

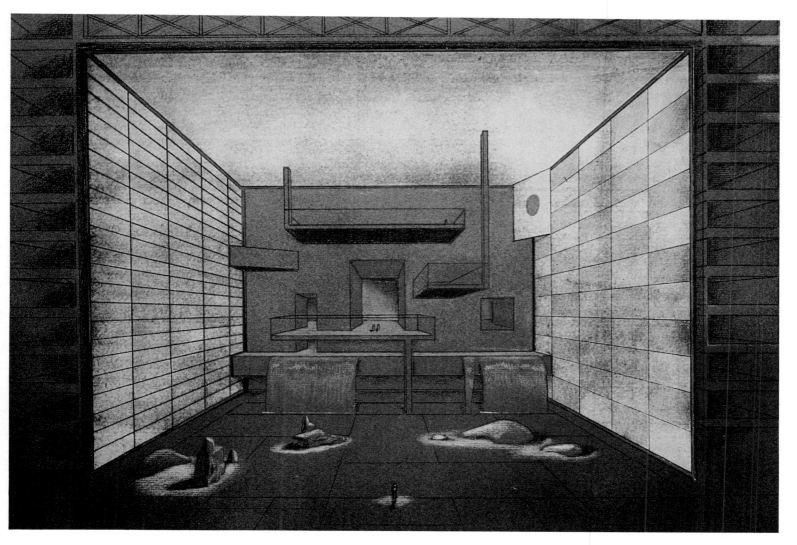

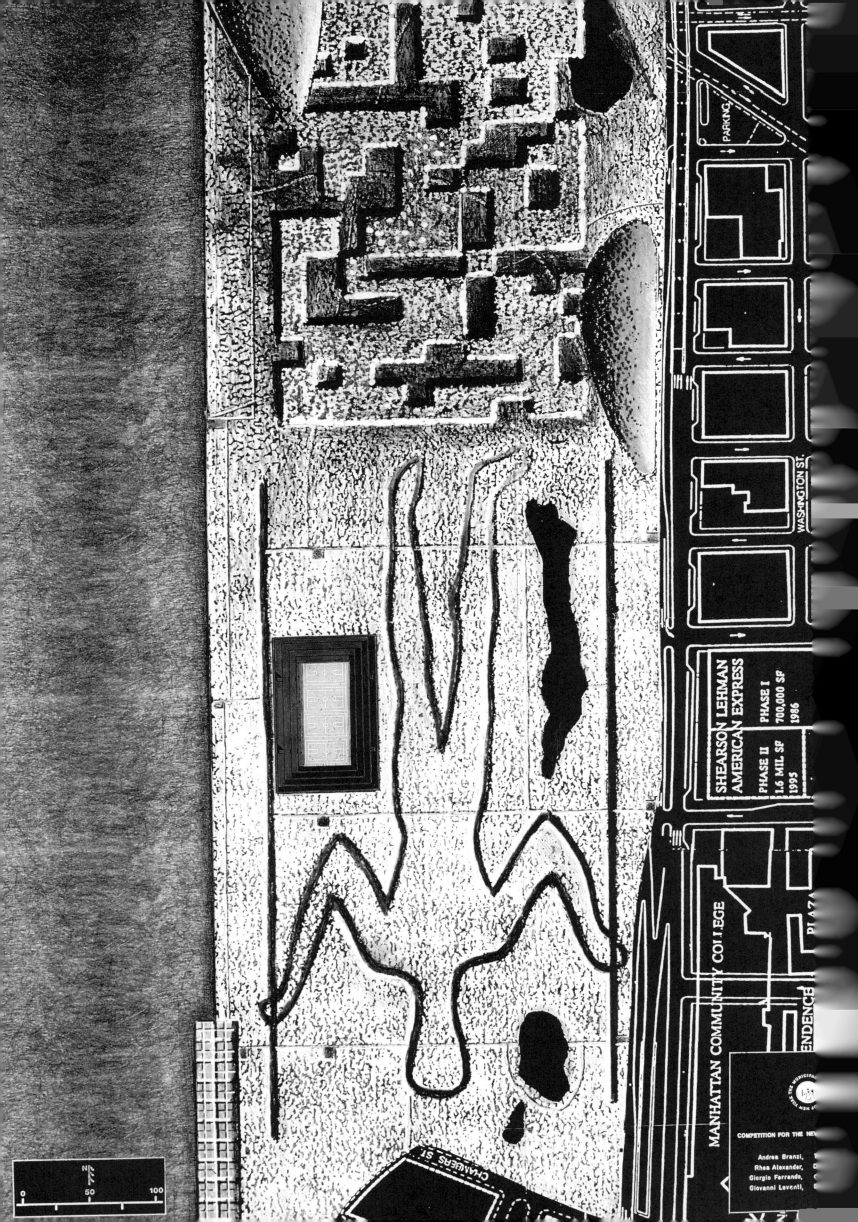

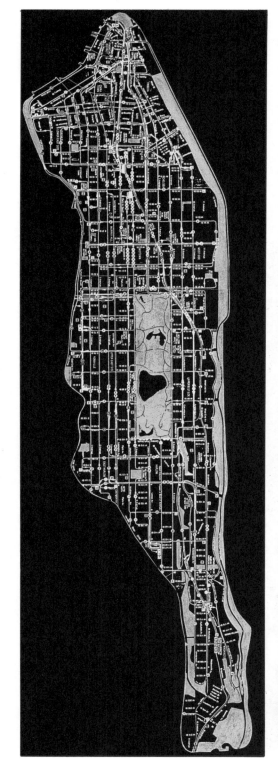

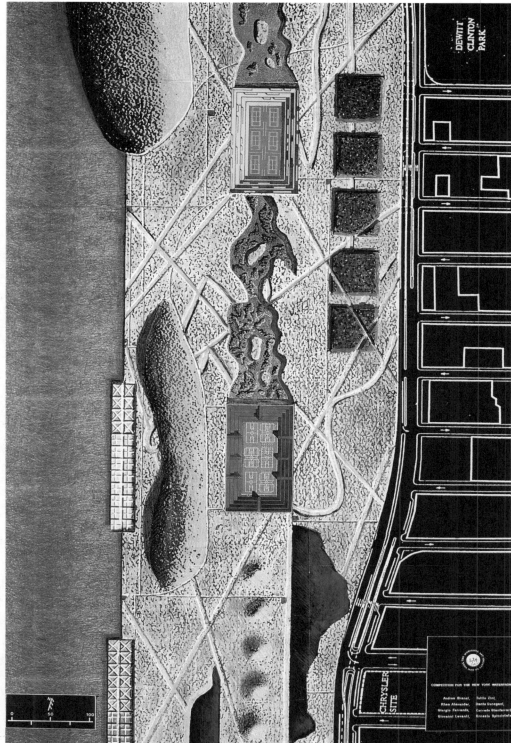

International competition for the layout of the west waterfront of Manhattan, New York, 1988 (with Tullio Zini, Rhea Alexander, Dante Donegani, Giorgio Ferrando, Corrado Gianferrari, Giovanni Levanti, and Ernesto Spicciolato).

The basic idea is that of creating an artificial park along the west-side waterfront of Manhattan, connected to the other big green areas of New York – Central Park and Riverside Park. It consists of a submerged base that contains the general services for New York and those of the neighborhood (parking, shopping, offices, theaters, museums, stadiums, meeting places, restaurants, cafes, sports facilities) for a depth of nine floors for a total of eleven million square meters of covered surfaces, artificially lit and ventilated.

This platform runs along the outer edge of a fast urban freeway, while the inner edge is connected to an existing roadway.

The cover of this great basement is constituted by a park with hills, woods, lakes, paths, and covered spaces, interspersed with large graffiti symbols. We want, in fact, to furnish the banks of Manhattan for the new frontiers of the third millennium: a great horizontal platform open to the sun, that emits strong signs towards the skies, representing man living in the artificial nature of New York in the twenty-first century, a sign like that of the Statue of Liberty, which for this century has represented America to the world.

This project responds positively, therefore, to the necessities of the growth and life of New York; but it also offers a response to modern architecture, trying to push it to the mental and constructive limits of the composite tradition, towards great technical and cultural horizons, to realize new imaginary territories and virgin lands.

(From the report accompanying the project for the Manhattan waterfront)

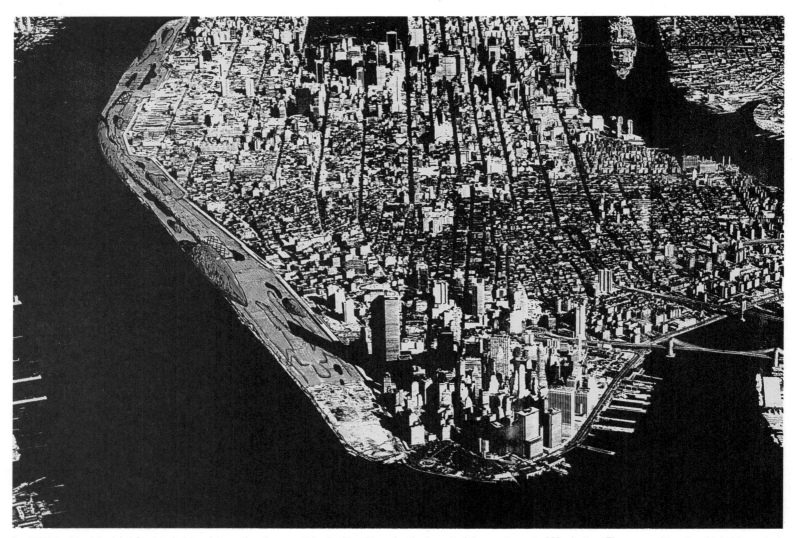

In 1987 the Municipal Art Society held an international competition inviting ideas for the layout of the west coast of Manhattan. The competition, in which this project won second prize, was intended to stimulate reflection on the city's future, starting with the west waterfront, at present the location of numerous wharfs that used to be part of the now disused commercial port of New York. It is an extremely important area from a functional viewpoint, as well as from that of the urban landscape.

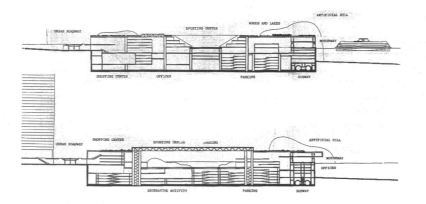

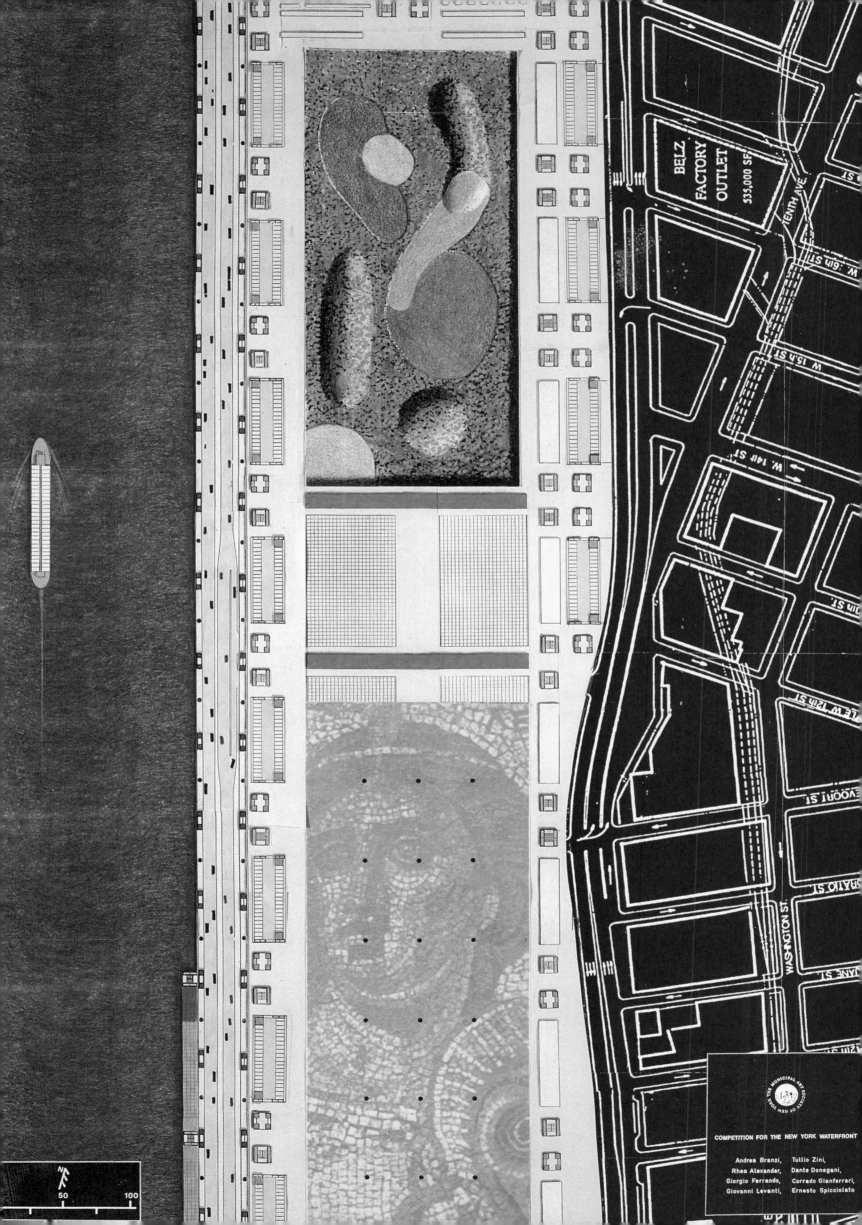

COMPETITION FOR THE NEW YORK WATERFRONT

Andrea Branzi, Tullio Zini,
Rhea Alexander, Dante Donegani,
Giorgio Ferrando, Corrado Gianferrari,
Giovanni Levanti, Ernesto Spicciolato

Studies for the new Galleria d'Arte Moderna in Arezzo, 1989 (with Franco Lani, collaborators Giovanni Levanti, Guillermo Crosetto, Piero Rossin, Santina Bonini and Cinzia Cecconi). The project envisages locating the new gallery inside the former Chiavi d'Oro hotel in the historic center of Arezzo.

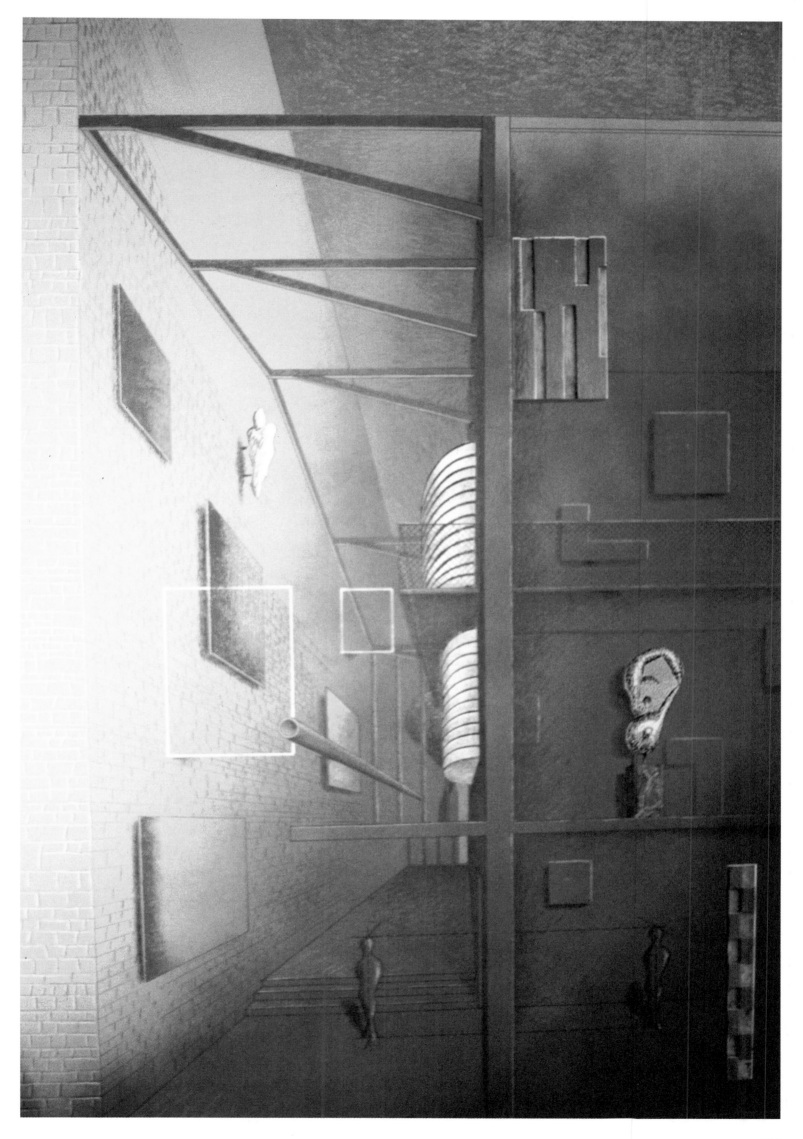

Permanent exhibition of designer jewelry in the archeological excavations under the parvis/cemetery of the church of San Francesco in Arezzo, 1990 (with Franco Lani, collaborator Guillermo Crosetto). The exhibition structure is suspended from the existing ceiling and pillars, so that it does not touch the archeological excavations.

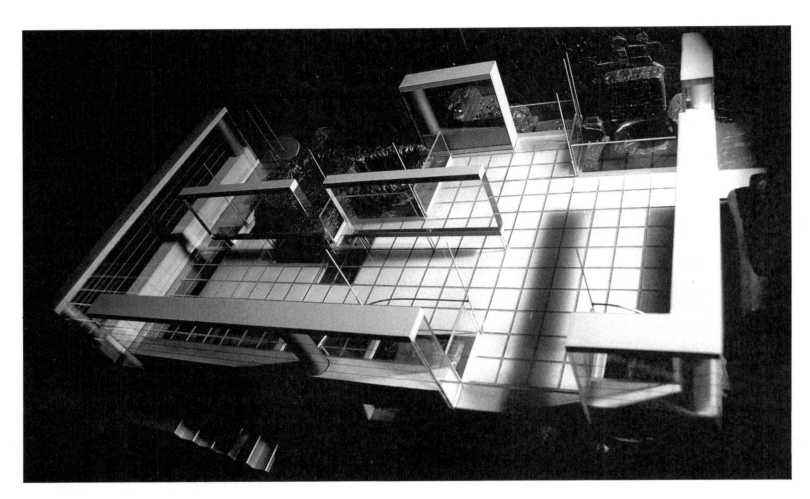

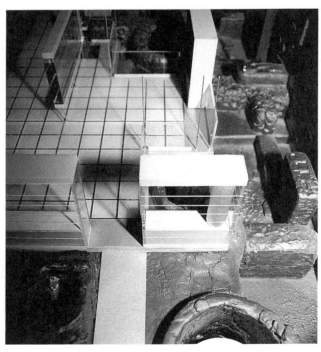

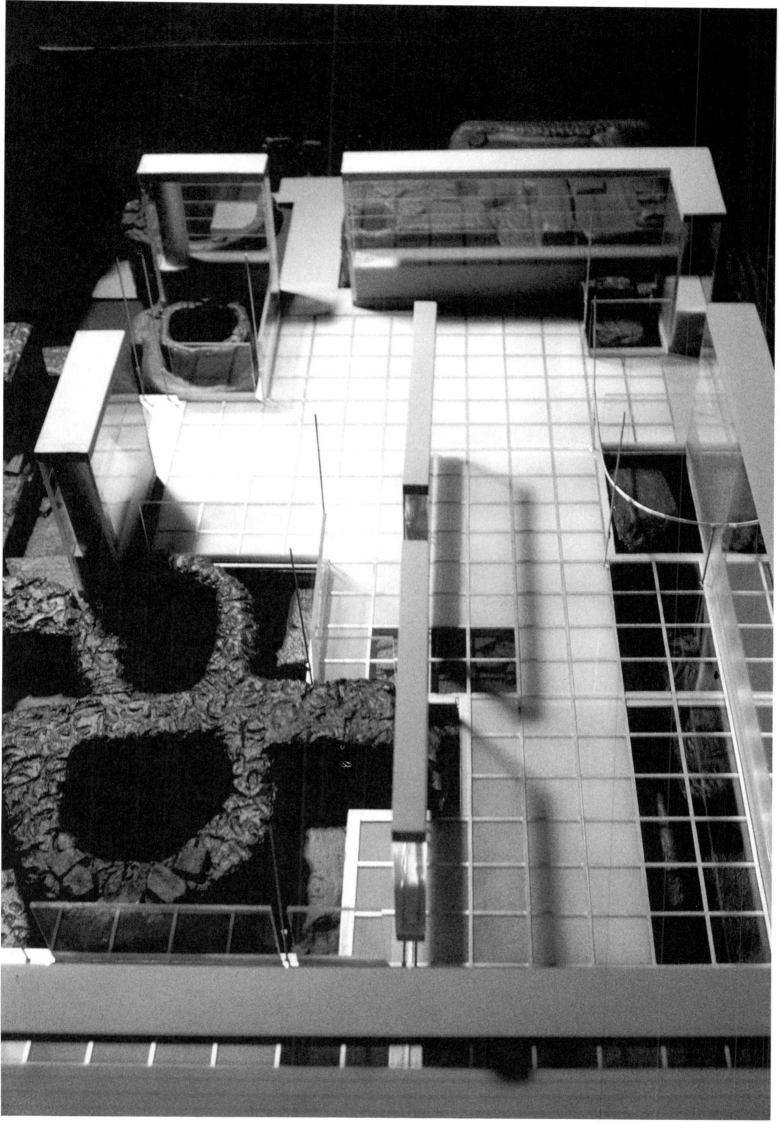

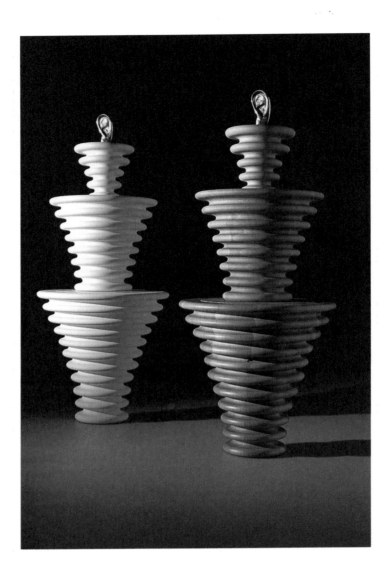

From the exhibition "Amnesias" at the Design Gallery Milano (collaborator Monica Moro, 1991); right, metal bookcase with tree trunk; above and below, vases in turned aluminum with numerically controlled electronic machine.

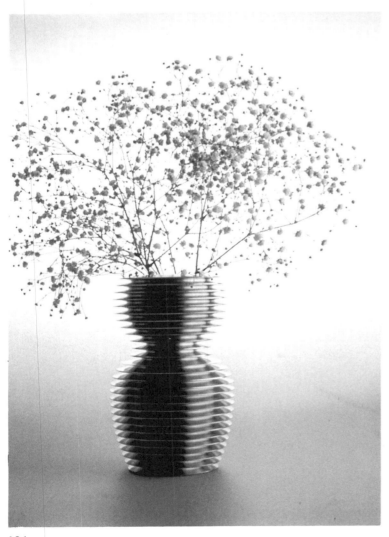

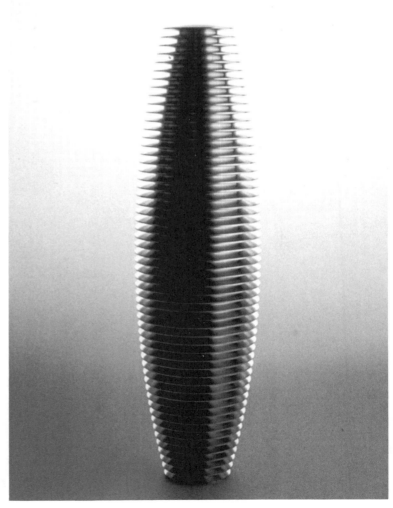

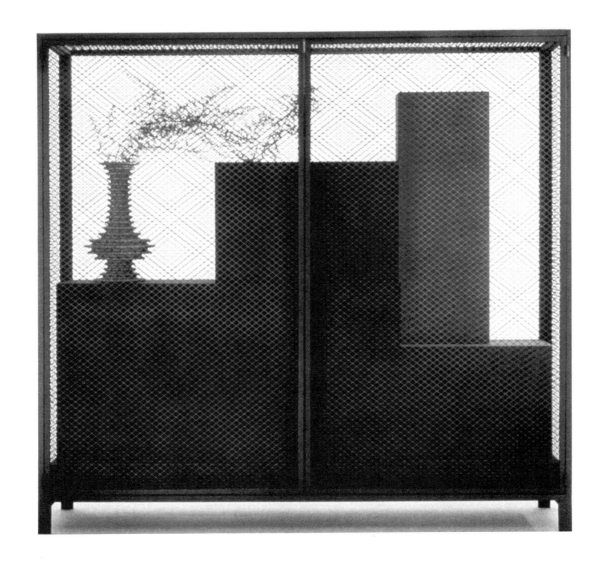

From the exhibition "Amnesias" at the Design Gallery Milano: above, "Big Cage;" below, "Big Arch."

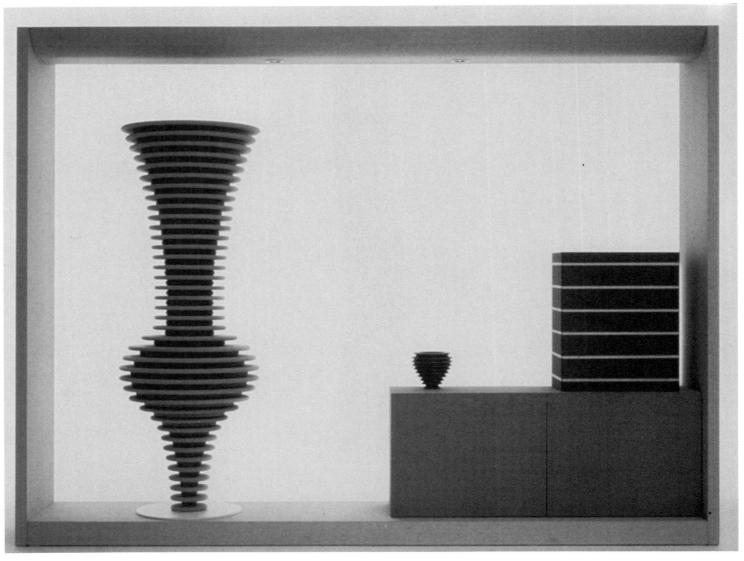

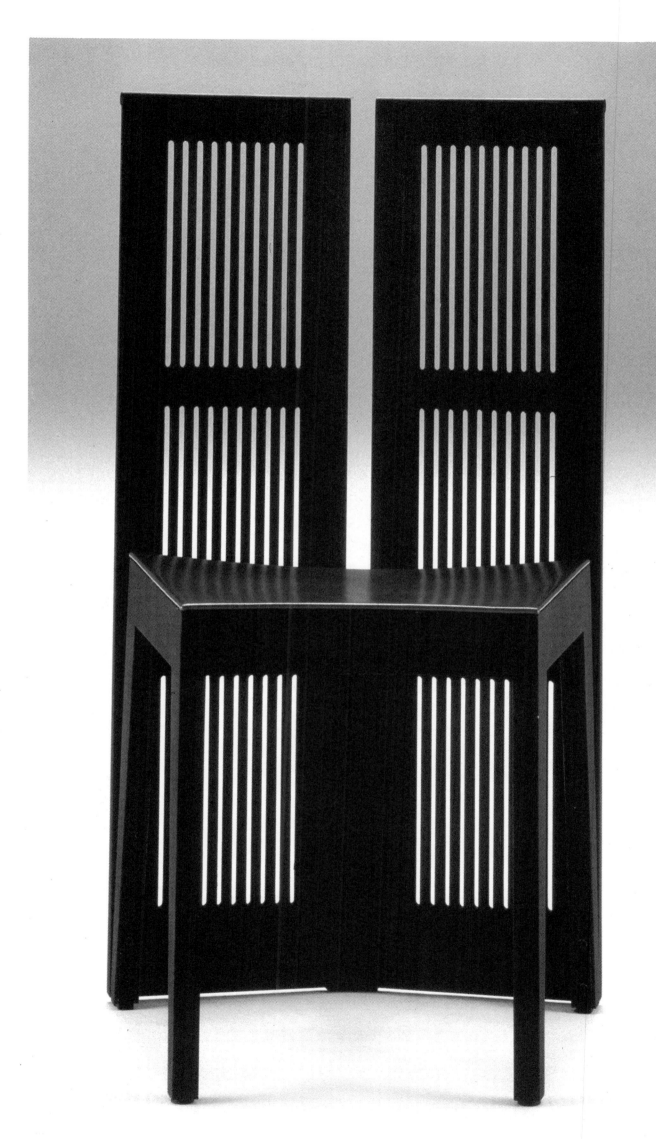

"Lubekka" flexible wooden chair, manufactured by Cassina (1992).

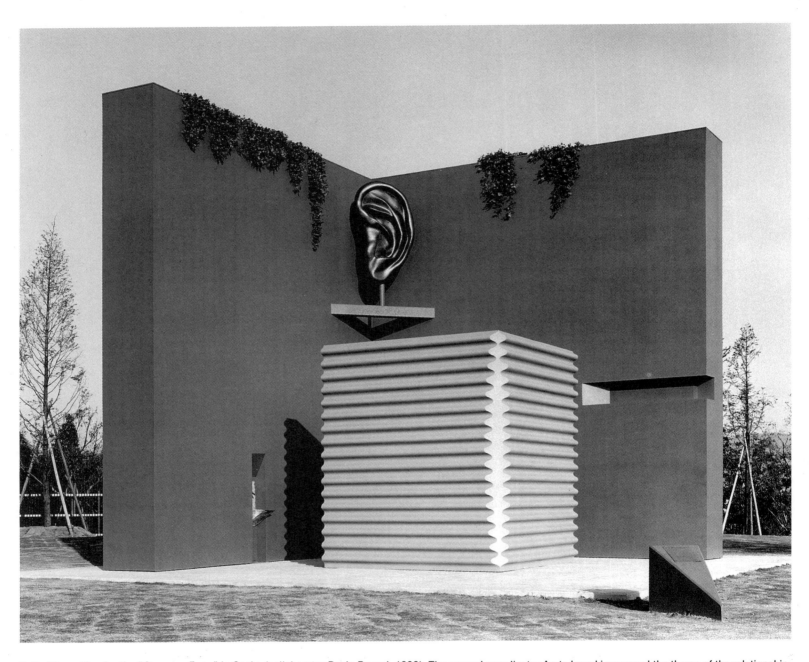

Folly 10, pavilion for the "Greenery Expo" in Osaka (collaborator Paolo Pagani, 1990). The general coordinator Arata Isozaki proposed the theme of the relationship between artificial nature and the natural world. The project envisages a large gray wall with a listening ear in the corner.
On one side, a small copper and silver fountain made by Alessi. In front, an undulating wall encloses a meeting-seat.

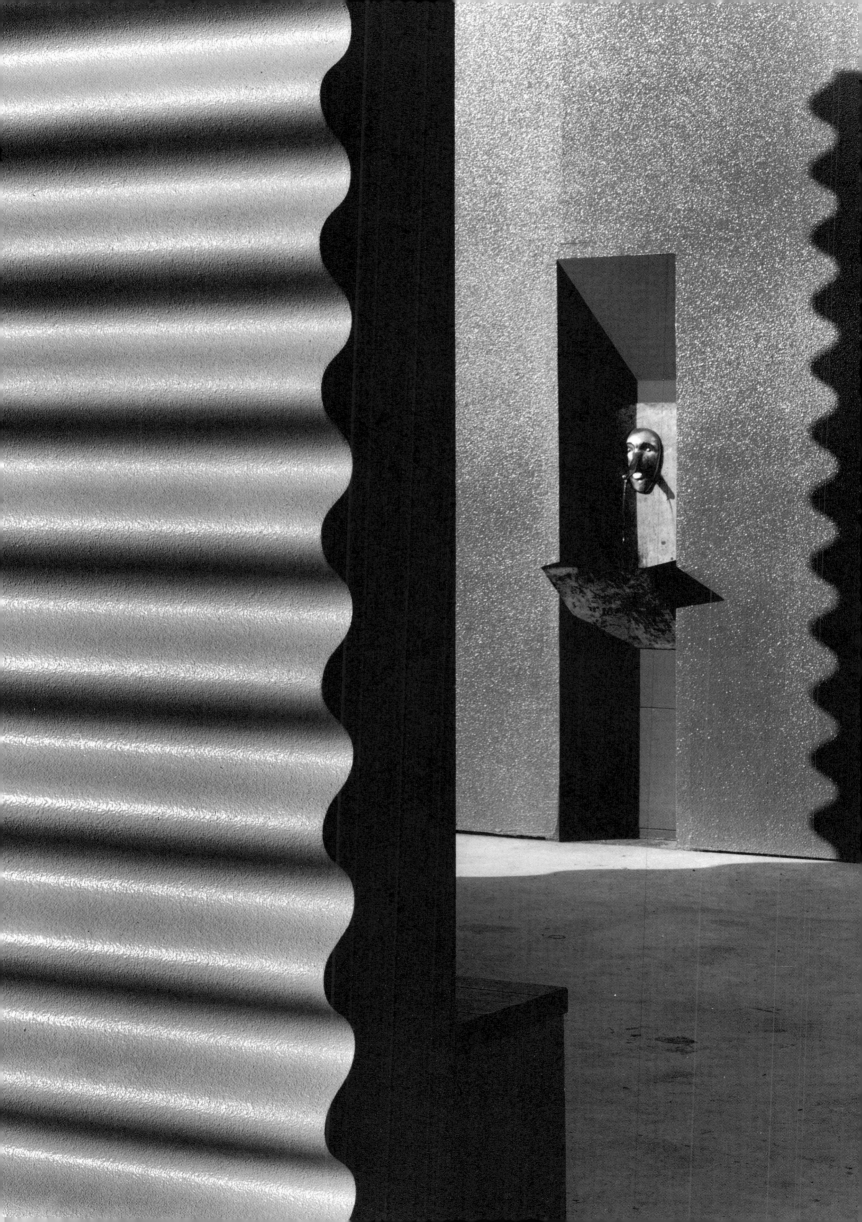

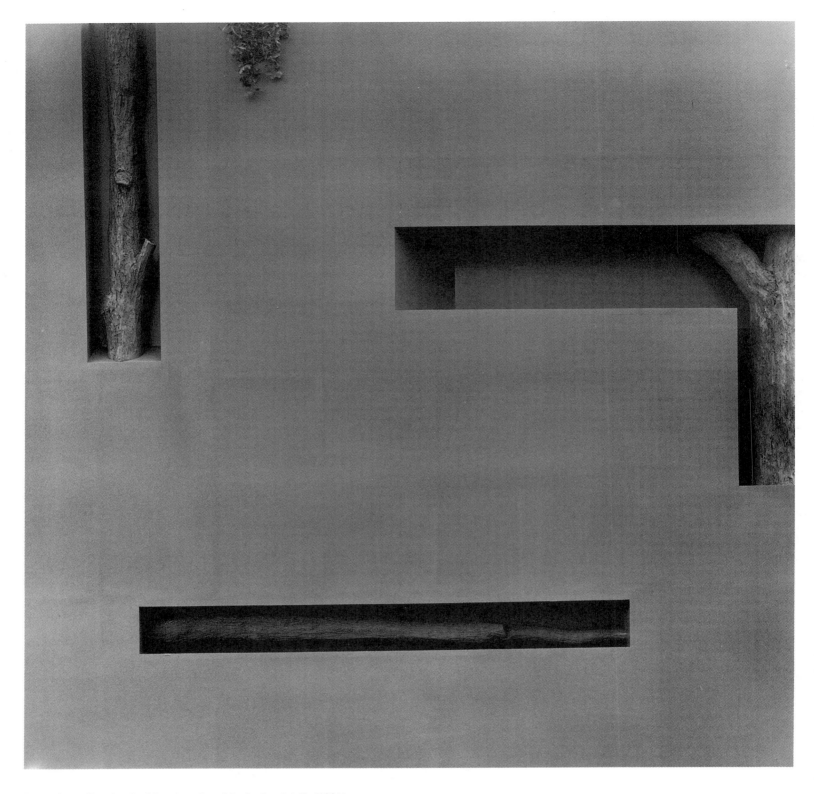

Folly 10, pavilion for the "Greenery Expo" in Osaka: details (1991).

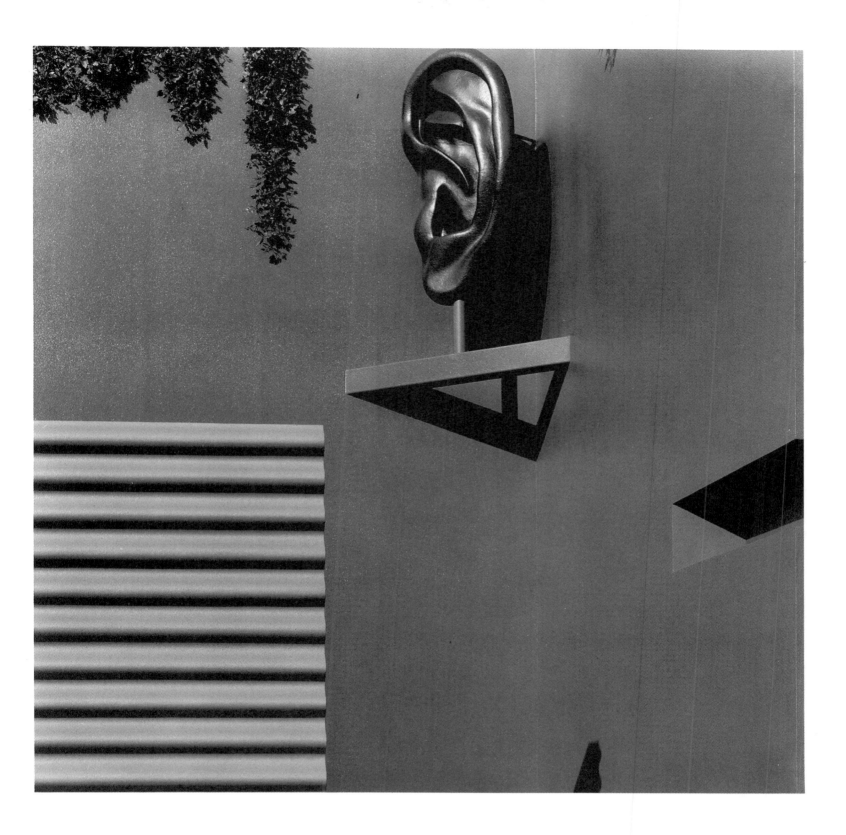

THE SECOND MODERNITY

Let us traverse this immense metropolitan territory that covers our planet without a break. An artificial, vigorous, and sturdy lichen carpets the sphere of stone revolving in the void. All of this no longer has any connection with our medieval roots, with that "dream of the village" that still comes to us when we fall asleep in Buenos Aires or in Tokyo. We are surrounded by a layer of architectural debris, a great, gray milkshake of contaminated signs; a solid mass of protoplasm with which architecture has not yet found a way to establish a relationship. Even just to look at it, to open one's eyes and be prepared to see it (from the ground we are standing on and not from an external, "bird's-eye" perspective) involves a courageous and painful decision. This vast stretch of scenery has already been described and predicted, and therefore exorcized, but it is hard to accept it in the flesh: the fact is that it is not just the serene and blaring affirmation of capitalism, but also the definitive and inexorable end of the anthropological era in which we were born. The end of an era crushed by another, which has been born and has grown up without any consciousness of itself, without any clear destiny, without a purpose and without any apparent hope. We see this new age laid out in front of us ready-made, and now it is up to us to adapt to it with all the pain that this entails; but also with the delirium of freedom that all this brings. This totally fragmented, planetwide scenario proceeds by hiccups and broken phrases; but every so often it leaves open a clearing in which the metropolis seems to create "an island of meaning," a self-contained stylistic enclave. Yet in reality this is never more than an attempt that, instead of bringing order to chaos, demonstrates that it is produced precisely by the uselessness of any order, whether it be general or particular.

Everything is different and alternative to what surrounds us, and for this very reason everything turns out in the end to be identical, homogeneous, generic, and banal. So where does this sudden surge of joy that runs through us come from? What is the source of this unexpected courage, this sense of panic freedom that drives our pencils and our heads? Is it just a brief shiver produced by the "endless nothing" that we see being constructed all around us? Or is it the scent of a new era that makes us happy? For us it is the joy of seeing in every case the works of humanity, its indestructible capacity to build and demolish, its intensely serious concentration on the realization of extremely complicated, cosmic theorems. Many people complain that these cities are not "on a human scale;" they do not understand that nothing resembles us more closely than a skyscraper, an anonymous crossroads in Patagonia, a parking lot. These cities are lovable precisely because they are so like us. Thus the old humanism is finished, but out of it is born another of a new dimension, one that emerges out of the acceptance of the dimension of human deeds and misdeeds, out of its production of this artificial nature that surrounds everything and renders it voiceless, uniform, and vague. It is a humanism that takes its cue from the greatest maturing that history has ever seen, and from the painstaking construction of enormous cathedrals out of nothing. So humanity is at the center of this (artificial) nature. This is what makes us different from the environmentalists. For we are humanists, not environmentalists. Saving the environment to the detriment or in the absence of man is the most unacceptable thing of all.

This endless traversal of an anonymous metropolis also provides us with the evidence that schizophrenia is the new dimension, not of madness, but of freedom. A freedom that is born precisely from the "divided self." From our essential nature that accepts the definitive and painless separation of its own ethical and existential core: a separate, shattered self, but one that reproduces its overall unity in every splinter; like the hologram that, broken up and ground into pieces, reproduces the original image in every fragment of itself. It is hard, therefore, for our architectural culture – a culture that has always asserted the unity of the project as the supreme good – to accept that it now has to operate by means of alternative separations and spatial autonomies.

The interior and the exterior are universes of separate experiences, just like the public and the private, the whole and the detail, the sense and the narration. History as a fiction, and vice versa. But then everything is brought back together, since with everything being different, in the end it amounts to the same thing. And the chaos that surrounds us has to be accepted: we must dive into this polluted and stormy sea. Without fear, for chaos is not the end of the story, but its beginning. Chaos is no longer the unknowable: fractals reproduce the laws of its formation, as a dynamic producer of infinitely diverse

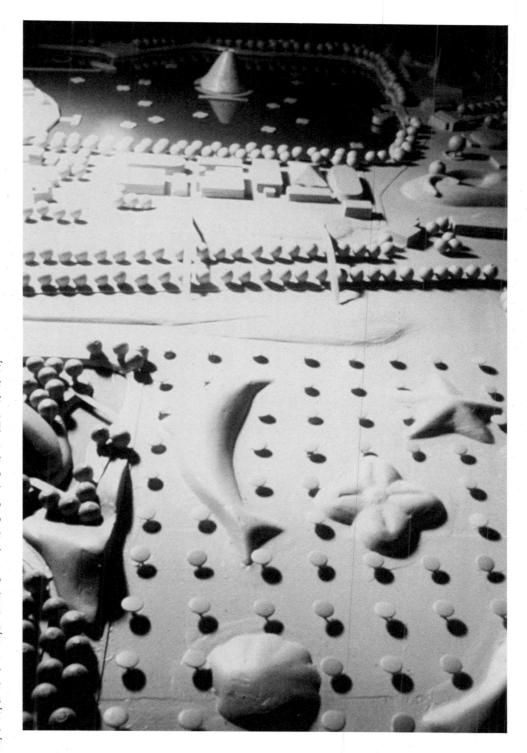

forms. In the same way that the placing of the medieval world within a perspective led to the creation of a different age, the Renaissance. Thus our electronic fractals, halfway between gadgets and universal laws, contain the present world in a sign. Hoping that it will change. A world made up entirely of architecture and that has no relationship with architecture. To the joy and the desperation of the architect. Who still does not accept the fact that it is no longer architecture that represents "the synthesis of history," but Tornado fighters, chemical weapons, and genetics. And us? What should we humanists do with the Dolce Stil Novo (D.S.N.)? We who are experiencing the withering of all our roots, of all our commitments, as an endless freedom? We are aware at once of our uselessness and our indispensability, for we are not on the side of the Tornadoes, but of the rose, and therefore, at the heart of everything, the Tornadoes as well. That is to say we are the other side of the coin of this new Middle Ages contained in the fractals: we are on the side of the indispensable component of history, of that apparent uselessness that no one has been able to get rid of, to eradicate. Bearers of a sensibility that is always changing and that is shifted into advanced technology. We ourselves are putting our roots and our traditions to the test. Humanity lies at the center of (artificial) nature then. A different humanity from that of Plotinus's classical antiquity, which endured the metaphysical universe as an external and different reality to itself.

A different humanity from that of Galileo's Renaissance, enigmatic and sensory center of a scientific and symbolic universe. A different humanity from the one produced by Kant's first modernity, the creator of rational order in the capacity of the creator of metaphysics.

The humanity (which is us) of this second modernity seems to be everything (and the opposite of everything). Great producer of extremely imperfect systems, the only ones that allow it to make the world grow according to a theology without god, a morality without ethics, an art without esthetics. It consumes history with the senses of its own body, and judges on the basis of flavors, odors, and touch. Science as art, and art as science; morality as physical force, and physical force as the only morality. The sole stability, continuous change. The sole profound difference, the sign of the zodiac. In a majority made up of minorities that cannot be compared with one another. In a normality that is abnormal and paradoxical: and in a centrality that is always and eternally peripheral. Within an absolutely homogeneous complexity. And the opposite of all this. No longer "a man without qualities," therefore, but a man who has virtues as terrible defects, but also defects as the only hope for improvement. Before the sky, which he had scaled, falls on his head like a rickety ceiling, collapsing in the end onto the ground, the only solid thing that can support the stars as well.

(From *Terrazzo*, New York, 17 March 1991)

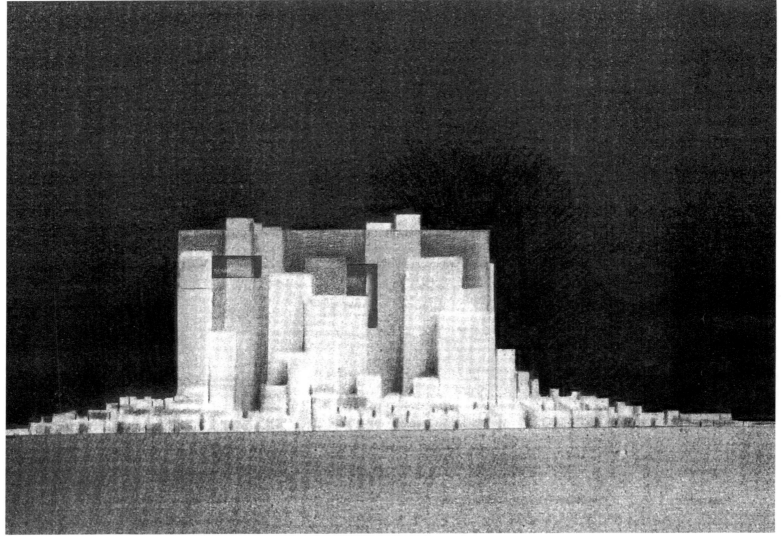

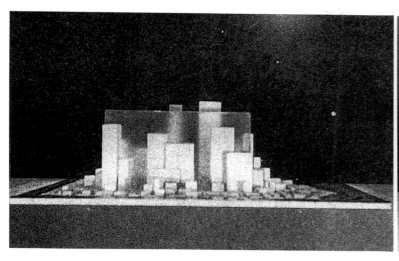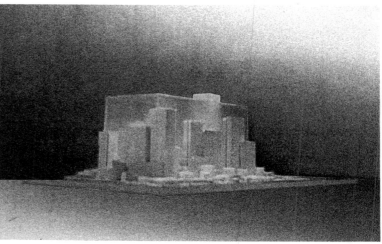

"Tokyo X," meta-project for a new settlement on a site of 17 hectares in the bay of Tokyo (in collaboration with Clino Trini Castelli and Tullio Zini, coordinator Isao Hosoe, 1990). The program proposes a new district made up of a lower town and an acropolis, consisting of a group of tall buildings set inside a large microclimatized greenhouse.

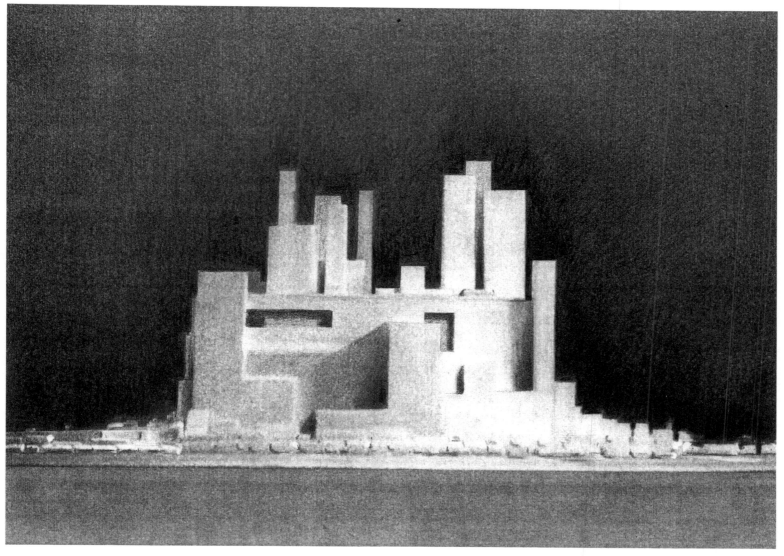

Lamps for the collection "Amnesias (and other places)"
(collaborator Augustus De Vree, 1992).

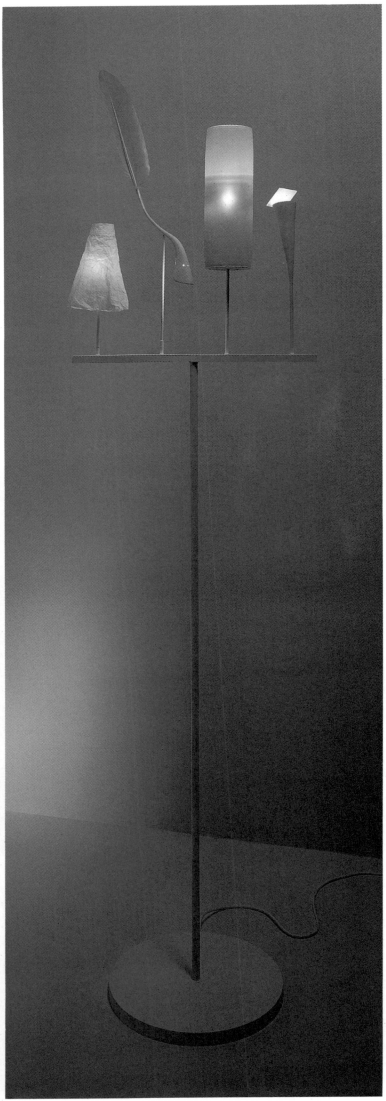

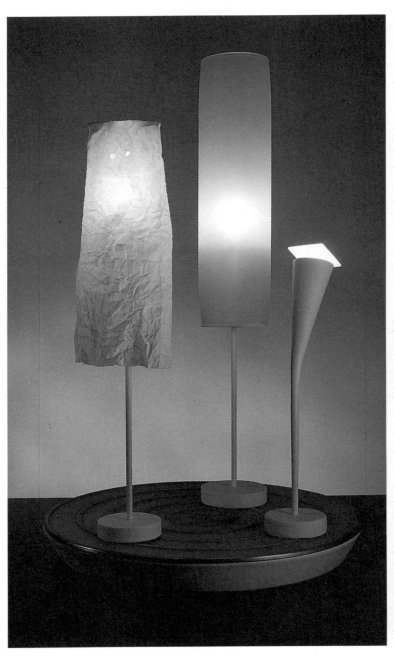

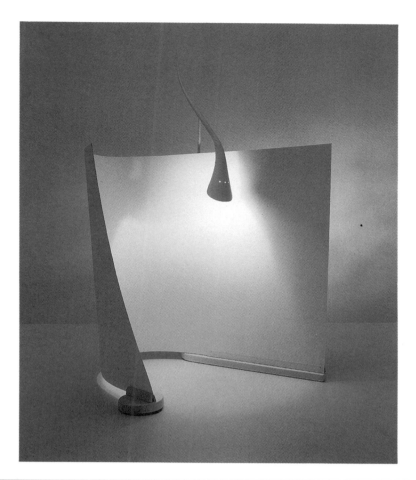

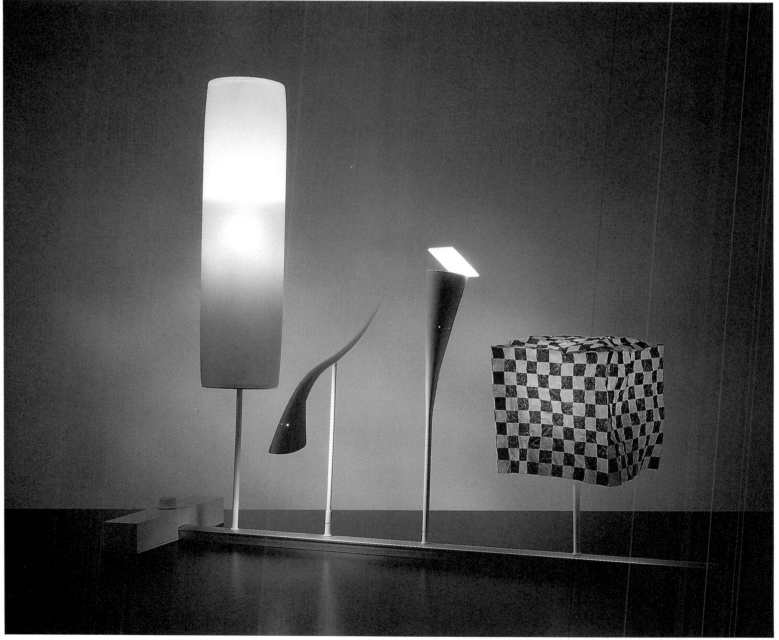

Andrea Branzi, architect and designer, was born and graduated in Florence and now lives and works in Milan.

Until 1974 he belonged to Archizoom Associati, an early avant-garde group of international fame, whose designs are now in the Historical Archives of Communication of the Institute of Art History at Parma University, directed by Prof. Carlo Quintavalle. Since 1972 he has been concerned with industrial and experimental design, architecture, city planning, and cultural promotion.

PRINCIPAL EXHIBITIONS

General coordinator of the International Design Section at the 15th Milan Triennale, he also had one-man shows at the 14th, 16th, 17th, and 19th Triennali. He was invited to the Venice Biennale in 1976, 1978, 1980, and 1984. He has had one-man shows at the Museum of Modern Art in New York (as part of the exhibition "Italy, the New Domestic Landscape," coordinated by Emilio Ambasz), the Lijbaan Centrum in Rotterdam, the Cayo in Buenos Aires, the Musée Saint Pierre in Lyon, the Palazzo dei Diamanti in Ferrara, Documenta in Kassel, the Musée des Arts Décoratifs in Paris, the Tokyo Desing Agency, the Musée des Arts Décoratifs in Montreal, and the Design Gallery in Milan.

His works are in the permanent collections of numerous museums and private collectors.

In 1977 he coordinated the major exhibition "Il Design Italiano degli anni '50" at the Centrokappa in Noviglio (Milan). He edited and introduced the book of the same name published in 1979.

In 1990 he was General Commissioner (with François Burckhardt) and designer of the exhibition "Les Capitales Européennes du Nouveau Design: Barcelone, Düsseldorf, Milan, Paris" at the Centre Georges Pompidou in Paris and then at the Düsseldorf Kunstmuseum.

In 1991 he staged the exhibition "Il Dolce Stil Novo (della Casa)" at the Palazzo Strozzi in Florence, where the work of some of the world's best interior designers was on show.

In the same year he was appointed Strategic Consultant for the Interieur Biennial Exhibition at Kortijk (Brussels), the first permanent show of European design, and organized (with Nicoletta Branzi) the exhibition "La lunga Tovaglia del XX secolo" on the theme of table settings from the Unification of Italy to the future.

DESIGN AND ARCHITECTURE

Particularly active in the field of industrial and experimental design since the start of his career, he has worked or is still working with the major Italian industries in the sector, such as Cassina, Poltronova, Zanotta, Alessi, Up&Up, and Marcatré.

He has worked closely with Alchymia, Memphis, and Zabro on New Design.

He is carrying out a research program – "Citizen Office" – for Vitra (Zürich) on the future of the office (with Ettore Sottsass and Michele De Lucchi).

He is director of the Domus Design Agency, a Tokyo-based company set up in 1991 by the Mitsubishi Corporation, Uchida Yoko, and Domus Academy, for the promotion of design in Japan, in collaboration with a pool of one hundred leading Japanese industries.

During the seventies he was a member of CDM (Consulenti Design Milano), together with Massimo Morozzi, Clino Trini Castelli, Ettore Sottsass, Alessandro Mendini, and Gianni Cutolo. Over that period CDM carried out the first research into primary design and the soft structures of the environment, and published two manuals of environmental design (Decorattivo 1 and 2, Milan) and three on color design for industry (I Colori dell'Energia 1975, I Colori Prechimici 1976, I Colori dell'Ambiente 1977, Milan).

In those years he was chief consultant to the Centro Design Montefibre, the first center for raw material design.

With CDM, he also designed the coordinated image and the landscape for Leonardo da Vinci (Fiumicino) airport in Rome.

In 1987 he was commissioned to draw up the project for the new Gallery of Modern Art and the Reclamation Plan for the block of San Francesco in Arezzo.

In 1988 he won the international competition of ideas for the layout of the urban area around the Berlin Wall, and second prize in the one for the west waterfront of Manhattan (staged by the New York Art Society).

In the same year he won the competition for the layout of the historic center of Castel di Sangro (L'Aquila) and was commissioned to design the new cemetery in Carpi with Tullio Zini.

In 1990 he drew up Mitsubishi Corp. (with Isao Hosoe, Clino Castelli, and Tullio Zini), a meta-project for a mixed development on an area of 17 hectares in the bay of Tokyo.

In the same year he designed a pavilion for the Universal Exhibition of Greenery in Osaka. In 1991 he was appointed coordinator of the consultancy group for the implementation of the Development Plan for Arezzo. He also worked at Quinto Bassano, in Sesto Fiorentino (Florence).

THEORETICAL AND TEACHING ACTIVITIES

He has written articles for major Italian and foreign journals. For three years he wrote a regular column on new movements in architecture and design for *Casabella* (1972-75). From 1983 to 1987 he edited *MODO*, the magazine of architecture and design. He has been editorial consultant to Idea Books and is now editorial consultant to *Interni Annual* and Passigli Progetti.

His activity as a theorist and essay writer is extensive.

An anthology of his theoretic writings (*Moderno, Postmoderno, Millenario*, Milan) came out in 1980.

In 1984 his book *The Hot House - Italian New Wave Design*, with an introduction by Arata Isozaki, was published in Italy, the U.S.A., Britain, and France.

In 1986 a book cataloging his work on the new home environment, *Domestic Animals*, with an introduction by Pierre Restany, came out in Italy, the U.S.A., and France.

In 1988 he published *Learning from Milan* in the U.S.A. and *Pomeriggi alla media-industria* in Italy. A revised and expanded version of the same work is about to come out in France, under the title *Nouvelles de la Metropole Froide*, with a preface by François Bruckhardt.

In 1990 a collection of his projects for the courses in Urban Design that he taught in 1986/87 was published in the Domus Academy's series of illustrated essays.

An anthology of his most important projects, from 1966 to 1991, with an introduction by Germano Celant, will come out shortly in New York.

Andrea Branzi is the only Italian author in this field whose books are published by the Massachusetts Institute of Technology. He has given lectures as a visiting professor at major universities in Italy, France, the Netherlands, Britain, the U.S.A., Japan, Argentina, Brazil, and Canada.

In 1983 and 1984 he lectured at the Faculty of Architecture in Palermo; his lectures have been published in *Merce e Metropoli*, Palermo. In 1983 he founded the Domus Academy, the first international postgraduate school of industrial design, fashion design, and design direction; he has been its cultural director and is at present its vice president, holding foundation seminars. Domus Academy represents a new model of teaching and has developed the theory of post-industrial design.

In 1989 he coordinated the first seminar on the teaching of design in Italy at the CCI of the Centre Pompidou in Paris.

From 1986 to 1990 he served on the EC Commission for the development and promotion of design in Europe, for which he proposed the work program "The European Home" and compiled a theoretical paper on the ecology of the artificial world (*The Munich Charter*, 1989).

He has been appointed by the French Ministry of Culture as a member of the Board of Administration of the Ecole Supérieure de Design "Les Ateliers" in Paris and of the work group for the development of design in France.

AWARDS

With Archizoom Associati, he won the silver medal in the Yamajiwa competition for lamp design (Tokyo) in 1969.

In 1978 he was awarded the Compasso d'Oro for his research into primary design with CDM.

In 1983 he won, with Domus Academy, the International Prize at the first Biennial Design Exhibition in Buenos Aires, and was cited for the Compasso d'Oro.

In 1987 he received the Compasso d'Oro Special Award in recognition of his activity as a designer and theorist.

In 1989 he was awarded the Certificate of Commendation of the Robert Maxwell Prize by the Royal College of Art in London for his essay *Seven Theses on Design*.

In 1991 he won, with Up&Up, the Baden-Württemberg prize for the "Quadrio" stone table.